HOW TO READ
AFRICAN TEXTILES

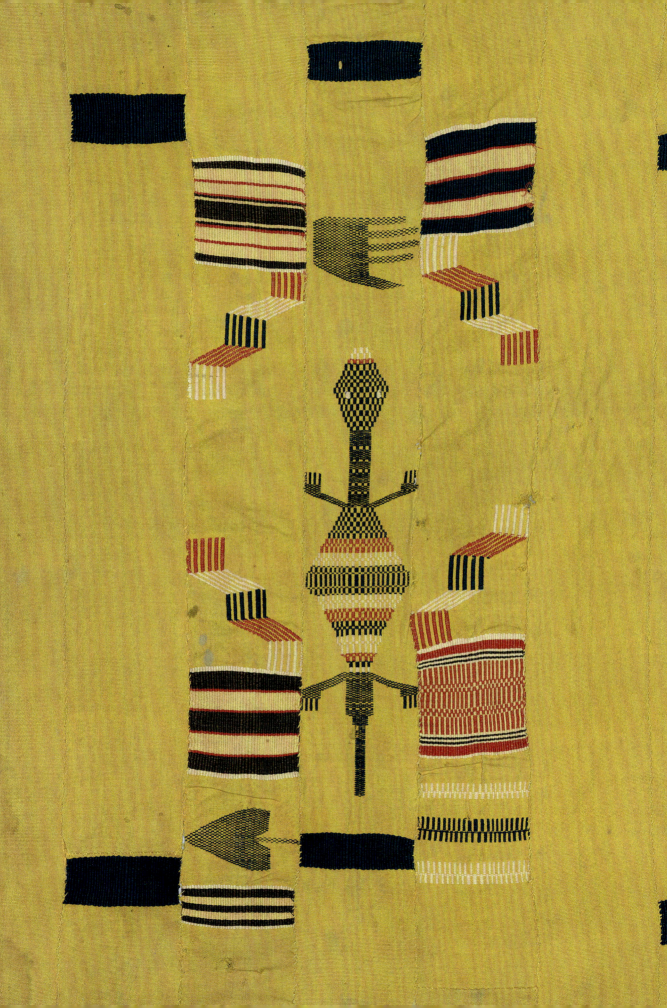

HOW TO READ
AFRICAN TEXTILES

Christine Giuntini and Jenny Peruski

The Metropolitan Museum of Art, New York
Distributed by Yale University Press, New Haven and London

This publication is made possible by The Peter Jay Sharp Foundation.

Published by The Metropolitan Museum of Art, New York
Mark Polizzotti, Publisher and Editor in Chief
Peter Antony, Associate Publisher for Production
Michael Sittenfeld, Associate Publisher for Editorial

Edited by Cecilia Weddell
Production by Paul Booth
Designed by Rebecca Sylvers, Miko McGinty Inc.
Image acquisitions and permissions by Josephine Rodriguez
Map by Geoffrey Wallace

Works illustrated in this publication are in the collection of The Metropolitan Museum of Art unless otherwise noted. Photographs of works in the collection are by the Imaging Department, The Metropolitan Museum of Art, unless otherwise noted.

Additional photography credits: fig. 1: Abiodun, 2004. Image © The Metropolitan Museum of Art, photo by Teri Aderman; fig. 2: Corbis Historical, photo by Nik Wheeler; front cover, back cover, figs. 3, 7, 8, 13, 14, 16, 18, 21, 23–25, 28, 29, 32, nos. 1–5, 7–10, 14, 15, 17, 18, 20–27, 29–33, 37–40: Image © The Metropolitan Museum of Art; figs. 4, 26: Photograph by Eliot Elisofon Photographic Archives, National Museum of African Art, Smithsonian Institution; fig. 5: BLM Collection / Alamy Stock Photo; fig. 6: Science Photo Library, photo by Mark De Fraeye; fig. 10: © Seydou Keïta / SKPEAC. Courtesy The Jean Pigozzi African Art Collection. Image © The Metropolitan Museum of Art; fig. 11: © David Binkley and Patricia Darish; fig. 12: © Coralie Rabadan. Courtesy of the artist; nos. 6, 11–13: Image © The Metropolitan Museum of Art, photo by Peter Zeray; fig. 15: © Carol Beckwith / Angela Fisher; fig. 17: Courtesy of Sarah Lamb; fig. 19: Courtesy of the Peabody Museum of Archaeology and Ethnology, Harvard University; nos. 16, 19, 28, 34, 35: Image © The Metropolitan Museum of Art, photo by Kathy Dahab; fig. 20: Courtesy of Susan Kloman; fig. 22: New York Public Library, Schomburg Center for Research in Black Culture, Jean Blackwell Hutson Research and Reference Division; fig. 27: Museo delle Civiltà-Roma. Image © The Metropolitan Museum of Art; fig. 31: © Sarah Errington / Eyeubiquitous / Hutchison; no. 36: © Elias Sime 2025. Image courtesy of the artist and James Cohan, New York. Image © The Metropolitan Museum of Art, photo by Peter Zeray; fig 33: Courtesy of Simon Peers

Typeset in DTL Documenta and Shift by Tina Henderson, Miko McGinty Inc.
Printed on FSC-certified 150 gsm Arctic Silk Plus
Separations by Professional Graphics, Inc., Rockford, Illinois
Printed and bound by Ofset Yapimevi, Istanbul

Cover illustrations: front, Royal man's kente (prestige cloth) (no. 16, detail); back, Stitch-resist indigo shawl or wrapper (no. 8, detail)

Additional illustrations: p. 2, Man's wrapper (no. 14, detail); p. 6, *Henaare* (man's festival tunic) (no. 6, detail); p. 8, *Elégègè pupa* (woman's prestige wrapper with red band) (no. 23, detail); p. 12, *Wando* (trousers) (no. 19, detail); pp. 28–29, *Bògòlanfini* (mud-dyed cloth) (no. 3, detail); pp. 60–61, Man's kente (prestige cloth) (no. 17, detail); pp. 114–15, *Ncàk* (ceremonial skirt) (no. 31, detail); pp. 146–47, *Lamba akotifahana* (mantle with supplementary-weft designs) (no. 39, detail)

The Metropolitan Museum of Art endeavors to respect copyright in a manner consistent with its nonprofit educational mission. If you believe any material has been included in this publication improperly, please contact the Publications and Editorial Department.

Every effort has been made to track object provenances as thoroughly and accurately as possible based on available scholarship, traceable transactions, and the existing archaeological record. Despite best efforts, there is often an absence of provenance information. Provenances of objects in The Met collection are updated as additional research comes to light. Readers are encouraged to visit metmuseum.org and to search by an object's accession number for its most up-to-date information.

Copyright © 2025 by The Metropolitan Museum of Art, New York

First printing

All rights reserved. No part of this publication may be reproduced or transmitted in any form or by any means, electronic or mechanical, including photocopying, recording, or any information storage and retrieval system, without permission in writing from the publishers.

The Metropolitan Museum of Art
1000 Fifth Avenue
New York, New York 10028
metmuseum.org

Distributed by
Yale University Press, New Haven and London
yalebooks.com/art
yalebooks.co.uk

Authorized Representative in the EU: Easy Access System Europe, Mustamäe tee 50, 10621 Tallinn, Estonia, gpsr.requests@easproject.com

Cataloguing-in-Publication Data is available from the Library of Congress.
ISBN 978-1-58839-791-1

CONTENTS

Director's Foreword 7

Acknowledgments 9

Note to the Reader 10

Map 11

INTRODUCTION 13

WESTERN SAHEL 29

WEST AFRICAN COASTAL FORESTS 61

CENTRAL AFRICA 115

EAST AFRICA 147

Sources 170

Further Reading 176

Glossary 177

Index 178

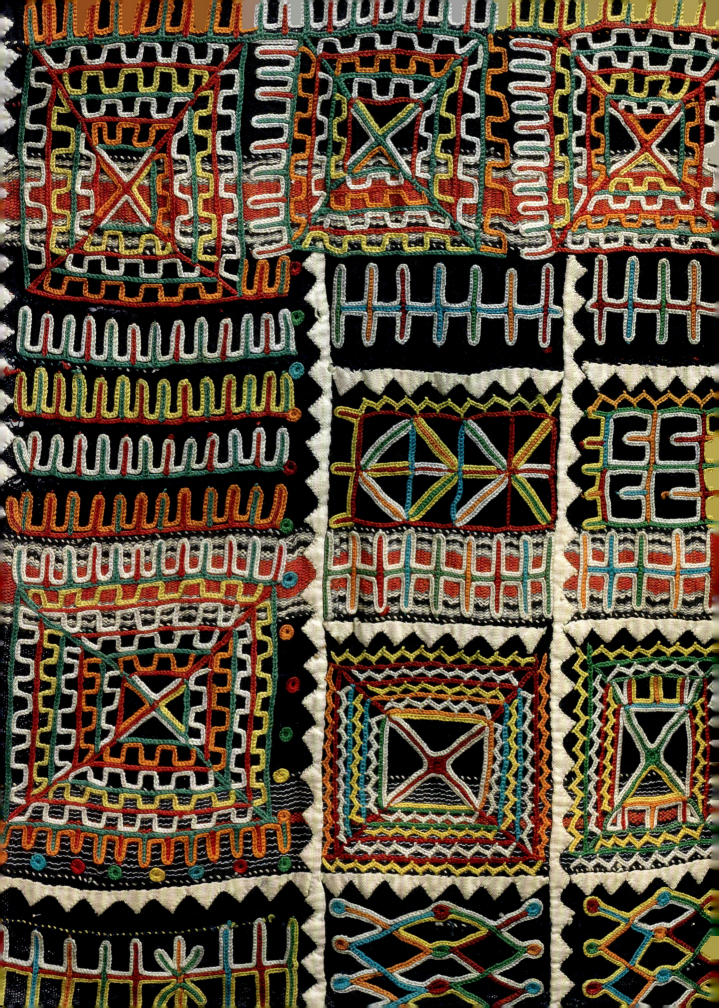

DIRECTOR'S FOREWORD

The impressive collection of African textiles at The Metropolitan Museum of Art primarily spans the eighteenth to the twenty-first century and includes works in media ranging from silk and cotton to raffia and tree bark. These fabrics speak to individual aesthetics, communal histories, and global trade and connectivity. While these extraordinary creations now hang in galleries explored by visitors from around the world, in the following pages Christine Giuntini and Jenny Peruski illuminate how they were activated in African societies as personal adornments, apotropaic emblems, and architectural embellishments.

The textiles featured in this book were all acquired after 1969, when The Met committed to showcasing art from Africa, Oceania, and the Americas to educate New York audiences about these regions and to valorize the skill and ingenuity of their artisans. The initial gift for this collection, by Nelson Rockefeller, included some seven hundred masks, textiles, ceramics, and sculptures from Africa.

The collection has since been supplemented by the contributions of countless donors. Among them is William B. Goldstein, MD, whose generous donation of Kuba textiles and ongoing support of textile purchases has allowed The Met to build an exceptional collection that reflects the breadth and quality of fiber arts production across Africa. The following donors enriched the Museum's holdings of West African textiles: Pascal James Imperato, Labelle Prussin, Susan and Jerome Vogel, Holly and David Ross, Robert and Anita LaGamma, and Eve Glasberg and Amyas Naegele. The African textile collection expanded further through the generosity of the Richman Family Foundation, Bryce Holcombe, Howard Barnet, Roda and Gilbert Graham, John B. Elliott, Hasnaine Yavarhoussen, Ellen Stern, the Clyman family, Mariana and Ray Herrmann, Samuel and Gabrielle Lurie, David Bernstein, Julie Jason, Ilona Eken, and Leila Laoun. We gratefully acknowledge these donors for making possible the diverse selection of works presented here and in the Michael C. Rockefeller Wing.

How to Read African Textiles is the thirteenth book in the Museum's How to Read series. These richly illustrated volumes introduce readers to the remarkable works in the vast Met collection, helping them look closely at techniques, materials, and styles to learn about their histories and meanings. Like the other titles in the series, this book illuminates a vital topic in the history of art: the social, religious, and political relationships engendered by the creation and use of African textiles. It is made possible by The Peter Jay Sharp Foundation, with our sincere thanks.

Max Hollein
Marina Kellen French Director and CEO
The Metropolitan Museum of Art

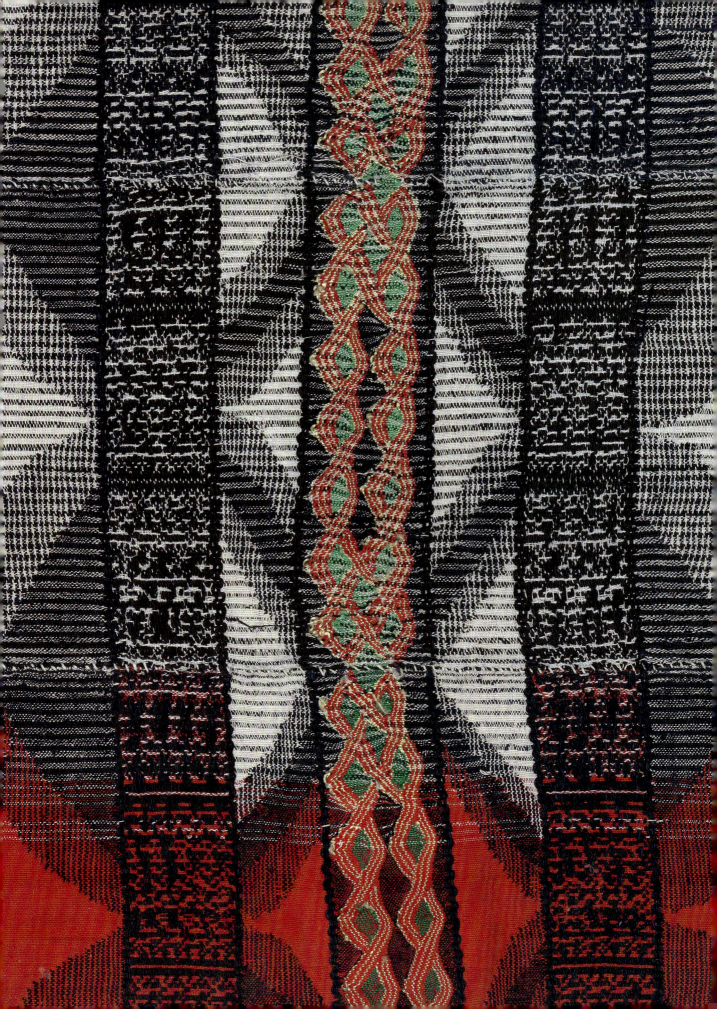

ACKNOWLEDGMENTS

This book is the result of an intensive period of research and writing that could not have been achieved without the support and generosity of numerous individuals both within and without The Metropolitan Museum of Art. First and foremost, we would like to thank Alisa LaGamma, Ceil and Michael E. Pulitzer Curator for African Art and Curator in Charge of the Michael C. Rockefeller Wing, for encouraging us to write this book and for supporting our research. For their assistance with preparing objects for photography, we thank our dedicated colleagues Lauren Posada and Karri Vaughn. David Rhoads and the collections team coordinated textile movement, for which we are grateful. We also acknowledge Imani Roach and Deborah Oratokhai for sharing their indispensable knowledge of Yoruba textiles, languages, and cultures. Max Hollein, Marina Kellen French Director and CEO, endorsed this publication from its early stages.

We are indebted to a number of artists and intellectuals outside The Met who dedicated their time and expertise to reviewing our writing, sourcing photographs, and contributing and providing insight into their own research. We are grateful to Meskerem Assegued, Duncan Clarke, Patricia Darish, Maï Diop, Bernhard Gardi, Pascal James Imperato, Simon Peers, and Susan Vogel for sharing their scholarship and experience. We also thank fiber artists Joël Andrianomearisoa, Nike Davies-Okundaye, Abdoulaye Konaté, and Martin Rakotoarimanana, as well as fashion designer Duro Olowu, for agreeing to be interviewed for this and other projects related to the 2025 reinstallation of the Michael C. Rockefeller Wing.

Our research would not have been possible without the exceptional staff of the Thomas J. Watson Library, who not only delivered books and accommodated interlibrary loan requests, but also sourced auction catalogues and processed new book purchases to assist in this project. We are indebted to the Imaging Department for the high-quality photographs, previously existing and newly commissioned, that capture the exquisite depth and dimensions of the textiles presented in these pages. Our exploration of these dazzling creations has been further aided by the notes, correspondence, and publications of former curators and scholars, especially Kate Ezra and Yaëlle Biro.

In the Publications and Editorial Department, we acknowledge Mark Polizzotti, Peter Antony, and Michael Sittenfeld, who responded with enthusiasm to the idea of adding a volume on African textiles to the How to Read series. We are very grateful to our editor, Cecilia Weddell, for helping us shape and refine this book. Her patience and attention to detail made the editing stage of the project feel manageable. We would also like to thank Josephine Rodriguez for sourcing the many photographs in the book, and Paul Booth for ensuring the stunning presentation of images and text. The engaging design of this volume is the work of Rebecca Sylvers at Miko McGinty Inc. We have The Peter Jay Sharp Foundation to thank for making this publication possible.

Finally, we express deep gratitude to the donors who have made working with such an exceptional and expansive collection possible. William B. Goldstein, MD, in particular, has been a steadfast supporter of the Michael C. Rockefeller Wing over many decades, contributing both objects and funding to the expansion and care of our textiles collection.

Christine Giuntini and Jenny Peruski
Conservator and Assistant Curator, Arts of Africa
The Michael C. Rockefeller Wing

NOTE TO THE READER

The word *textile*, which once referred to loom-woven cloths with interlaced structures, is used in this volume to refer to many kinds of flexible fabric created with different structures and by different technologies.

Language is a key facet of understanding the complex and diverse associations with textiles across the African continent. While the authors are not specialists of the more than two thousand distinct languages spoken by communities throughout Africa, every effort has been made to incorporate local terminology as it relates to the featured works. The majority of terms use the conventional transliterations and spellings in published scholarship in the corresponding fields. A number of textiles were created in communities that speak Arabic or speak languages written with Arabic script; transliterations for those terms are based on the system set forth in the *International Journal of Middle Eastern Studies*. ʿAyn and *hamza* are marked, but macrons, dots, hooks, and other diacritical marks are omitted. Several entries are dedicated to Yoruba creations, and the spellings of the terms in these entries are based on the *Dictionary of Modern Yoruba* by R. C. Abraham.

The many sources consulted in the preparation of this book are presented on pages 170–75, with an asterisk marking sources of direct quotations. Recommendations for further reading can be found on page 176.

Height precedes width in object dimension lines. Unless otherwise noted, all directional language describing parts of a textile (upper, lower, left, right, and so on) refers to the work as it is oriented in the accompanying images.

While many of the artistic practices discussed throughout the book continue to the present day, ongoing conflicts and instability in some regions have made it difficult to determine whether certain fiber arts traditions have been maintained. In such instances, we have used the past tense, but we encourage readers to research these topics for the most up-to-date information.

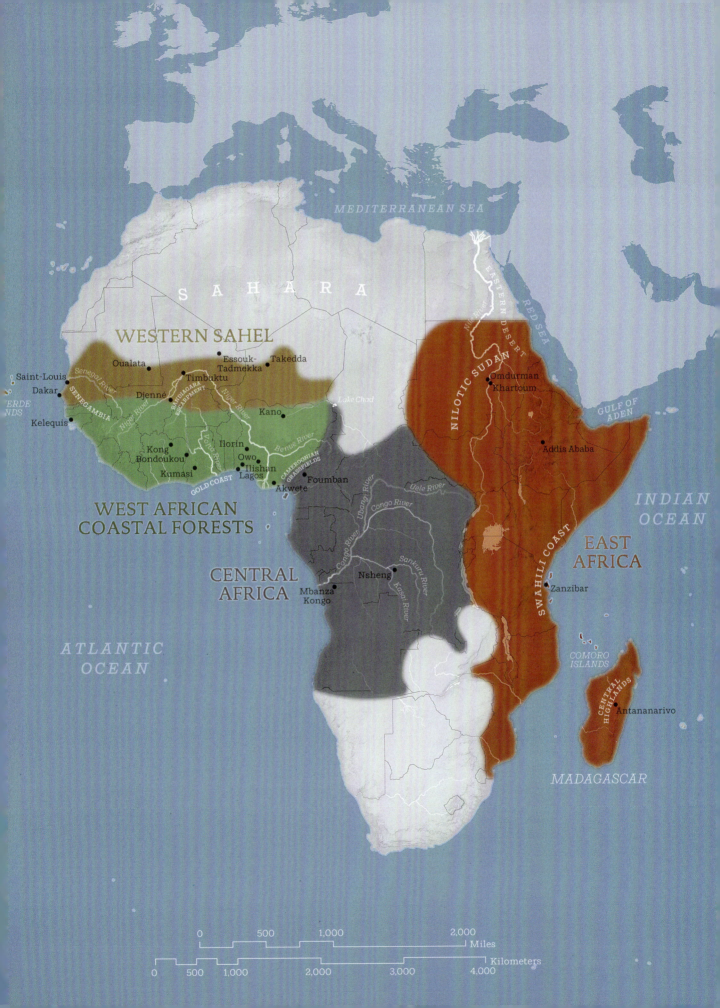

INTRODUCTION

Textiles mediate almost all moments of life, from the soft blankets that swaddle newborns to the garments and weavings used to shroud the dead. The thriving personal and cultural associations with cloth and clothing are further enlivened through occasions ranging from weddings to political and religious ceremonies, where customary clothing is expected. The billions of dollars expended on runway shows, celebrity clothing for red-carpet events like the Met Gala, and fashion publications like *Vogue* and *GQ* highlight the enduring salience of clothing as a medium of status and expression. Similarly, the conspicuous display of lavish handwoven *dàńdógó* and *agbádá* robes (see nos. 21, 22) at events like the concluding rite of Ọdún Ọba honoring the authority of Ila-Ọrangun's *ọba* underscores how textiles have continued to affirm political authority (fig. 1). However, these more ceremonial or elite practices often overshadow the primacy of textiles at all levels of society in communities across the globe.

Until the British developed water- and steam-powered spinning and weaving machinery in the late eighteenth century, the mass production of yarns and textiles could hardly have been imagined. Indeed, the internal combustion engine, powered by fossil fuels (and usually coupled with the exploitation of labor in many parts of the globe) has reduced to a trifling amount the cost of producing fabrics for clothing ourselves and furnishing our spaces for life and work. For the preceding twenty thousand years, however, textile making depended entirely on human labor, ingenuity, and time. In all yarn- and fabric-producing cultures, successive generations developed, maintained, and expanded the specialized, practical knowledge and skills necessary for this work. Among these tasks are the labor-intensive processes of sowing and harvesting crops, gathering wild plants, minimizing pests, and transporting raw products to the locations where they were transformed into the final product through a variety of highly developed human-operated technologies. Within this preindustrial context,

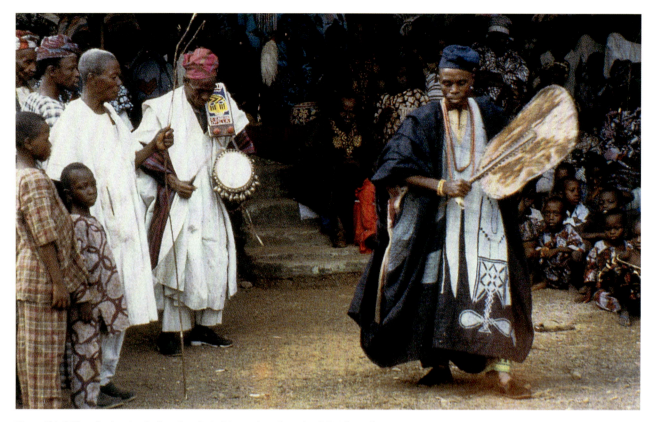

Fig. 1. Chief Ọbasolo dancing before the *ọba* in his ample indigo-dyed *dàǹdógó*, Ila-Ọrangun, Nigeria, 1984

even unembellished, utility fabrics and simple, untailored garments would have held significant social and economic value.

Apart from scholars such as historians, anthropologists, and economists, individuals in contemporary societies have little memory of the price once commanded and the awe (and envy) inspired by the most fashionable and luxurious handmade cloth and clothing. Specialized farmers, spinners, weavers, dyers, embroiderers, and tailors contributed to the creation of fabrics that could be endlessly adapted to communal and individual needs, variously serving to clothe the body, distinguish architectural space, protect the physical and spiritual well-being of the wearer, and convey the wealth and authority of the owner. Lightweight and flexible, textiles could be transported over vast distances where they were embraced by new clienteles and could serve as inspiration for local makers eager to adapt their styles and skills to the most current fashions. The objects featured in this book attest to the inventive imagination of artisans across the African continent, as well as the avid and discerning appetite for fashionable handcrafted cloth and clothing among consumers. In Africa, like everywhere else, profound social, spiritual, and economic value has been attached to both locally produced textiles and those imported from across the globe.

Dress, Fashion, and Self-Representation

The dressed body is among the most potent and visually immediate forms of expression about one's individual and communal identity. Many of the creations included

here served as items of personal adornment, conveying messages about the wearer's class, authority, generation, gender, parental status, ethnicity, religion, and cosmopolitanism. The fashion choices of African societies have always been adaptable, and artisans and consumers regularly modify their tastes as new motifs, styles, materials, and techniques are introduced through trade and migration and as historic forms of dress are rediscovered and made anew. Drawing attention to these complex processes, this book seeks to emphasize the geographic and temporal specificity of these cyclical transformations. Textiles and fashion not only reflect, but also instantiate regional and global relationships, familial ties, social hierarchies, and community values.

Through the twenty-first century, the social, economic, and political power of clothing has been reinforced by sumptuary laws in many communities throughout sub-Saharan Africa (as elsewhere), limiting certain forms of expression to a select few. For instance, among nineteenth-century coastal East African populations, head coverings and footwear were the prerogative of wealthy, freeborn elites, while enslaved individuals and their descendants were largely restricted to cheaper, plain fabrics that were wrapped and arranged in a manner that exposed more of their bodies. Similarly, Arab-Andalusian historian al-Bakri recorded that in the eleventh-century court of the Ghana Empire (ca. 700–1300), tailored or sewn garments were permitted for only the king and his immediate successor. Such regulations aimed not only to represent social distinctions but also to reinforce and reproduce them in daily life through public displays of difference.

While sumptuary laws could be maintained for a period, shifting political structures often eroded their efficacy. The prestige of privileged attire could make such items desirable to a diverse clientele, and artists and consumers often found creative ways to reinterpret forms and designs to increase profitability and circumvent regulations. Historian Laura Fair notes that in coastal East Africa, the abolition of slavery in 1897 provided the impetus for women to transform their dress, "abandoning cloth associated with servility and increasingly adopting a new form of cotton piece-good, known as a *kanga*," a brightly colored and patterned cloth (see no. 37). The *kanga* was successively embraced by populations throughout much of eastern, southern, and Central Africa in the twentieth and twenty-first centuries, leading to new visual and material relationships, as evidenced by the vibrant red, black, and white *kanga* wrapped around the hips and legs of a Zulu bead worker (fig. 2). Relatedly, the collapse of the Ghana Empire and rise of the Mali Empire (ca. 1240–1645) allowed for a wider adoption of tailored clothing. By the fourteenth century, any high-ranking man could wear cut-and-sewn trousers, although, scholar Jody Benjamin writes, "no one was permitted to wear bigger pants than the emperor, whose own were said to be made of twenty pieces of cloth." Throughout recorded history, dress and fashion have been continuously renegotiated and reinvented to express and give shape to changing social, political, and economic circumstances.

Art historian Victoria L. Rovine has aptly observed that "African fashion production, past and present, tells vivid stories about local histories and global networks of goods and images." These "stories" are worn and expressed in everyday clothing, which can communicate direct, easily recognizable messages as well as oblique, nuanced ideas. Textile wrappers in the forms of Ghanaian wax prints and East African *kanga* often carry names and convey explicit meanings, although their interpretation may vary depending on how viewers choose to "read" and respond to them—in many cases, the intended recipient of such a message may deny that they understood it while simultaneously purchasing a wrapper to counter the original commentary. Other textile stories are more enigmatic, requiring deep cultural and historical insights to be understood. Among Yoruba populations of present-day Nigeria, narrow-band, handwoven cloths known as *aṣọ òkè* (nos. 20–22) do much more than simply clothe the body. They also carry messages about wealth, cultural identity, and ancestral ties. At a grander scale, the easy transport and widespread trade of textiles has led them

to visually and materially document historical and ongoing relationships that connect communities in Africa to one another and to the wider world.

African consumers have long been discerning about the fabrics they purchase and wear. Individuals and communities have selectively adopted, adapted, and/or rejected new styles, materials, and techniques as suited their needs. For example, the widespread popularity of Indian cotton textiles in eastern and western African markets in the eighteenth and nineteenth centuries led American, British, French, and other European manufacturers to mass-produce cotton fabrics in similar styles. These imitations were highly desirable despite their cheaper fabrication, although African consumers set these examples apart through their naming and the contexts of their wear. A cheap, plain white cotton cloth imported to East Africa from New England—referred to as *merikani* after its American point of origin—was considered casual everyday attire for enslaved and formerly enslaved individuals. In contrast, sumptuous multicolored cottons and imported silks were worn by wealthy merchants and the ruling elite.

The increased availability of local and imported materials also created new avenues for self-expression. The introduction to South Africa of large quantities of glass beads in vibrant hues, beginning in the late 1800s, led female artisans to develop an array of beadwork fashions that celebrated and emphasized the human figure. Those artisans further employed beads to elaborate on and transform historic items of dress. *Umbhaco* skirts are one example of this diversification of fashions (fig. 3). Supplied with beads, mother-of-pearl buttons, and a thick cotton fabric known as *ibhayi*, twentieth-century Xhosa artists transformed traditional leather *isikhakha* skirts into contemporary apparel that integrated new trade goods. Their innovation is but one example of the dynamic, cyclical, and inventive textile fashions produced throughout Africa.

Raw Materials

The raw materials used to create fabrics throughout Africa flow from the environmental diversity of the continent. This brief discussion is necessarily restricted to the plant and animal resources used in the works featured or mentioned in this book, which include bast fibers derived from plant stalks and trunks, palm leaves, cottonseed hair, sheep's wool, and silk produced by moths.

The earliest forms of clothing are believed to have been made from animal skins and bark cloth. Trees from the Moraceae family (ficus and mulberry species) are

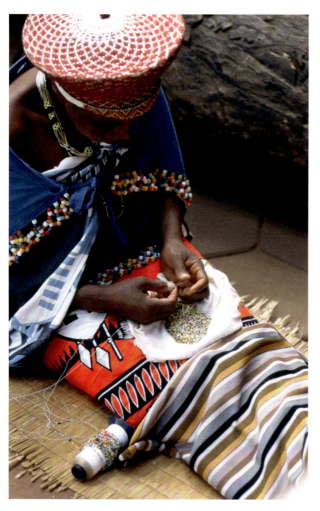

Fig. 2. A Zulu woman stringing beads while wearing a beaded blue shawl over her shoulders and a red, black, and white *kanga* around her waist, South Africa, 1995

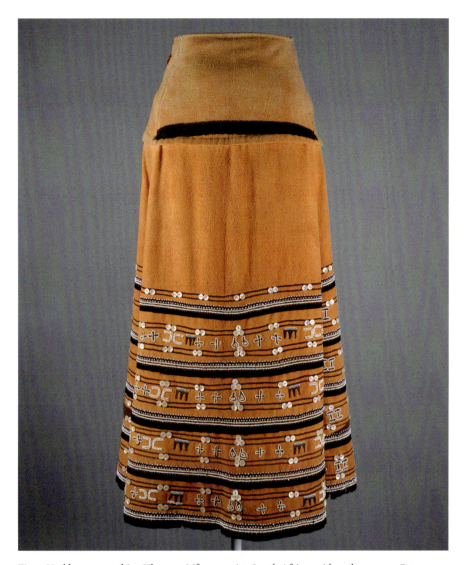

Fig. 3. *Umbhaco* wrap skirt. Xhosa or Mfengu artist. South Africa, mid-20th century. Cotton, wool, glass beads, shell, ocher pigment, 75½ × 37¼ in. (191.8 × 94.6 cm). Purchase, Gilbert and Roda Graham Gift, 1993 (1993.373)

found throughout Africa and are preferred for bark-cloth production. The bast fibers from these trees are separated from the hard plant material surrounding them and softened through processes like fermentation, soaking in alkaline solutions, and beating. As the fabric worn by revered ancestors, bark cloth carries spiritual and protective meanings in many communities. Among the Kuba it was used, in addition to raffia, for dressing the dead. The refined multipanel Mangbetu bark cloth (no. 27) was created to distinguish the elite status of the chief for whom it was made.

Raffia palm species are indigenous to tropical Africa. They thrive in swamps, wetlands, and riverine areas of the savanna throughout West and Central Africa. Although

archaeological evidence is inconclusive and minimal clothing is needed in the tropics, scholars hypothesize that processed raffia leaf fibers were once likely to have been widely used to create fabrics for elites or for community events. However, when the Portuguese arrived at the Senegambia region in 1444, cotton goods already dominated interregional trade. Yet when they arrived at the Central African city-state of Mbanza Kongo in the late 1580s, they found elites dressed in beautifully crafted raffia fiber garments woven, dyed, and finished by technically advanced methods, suggesting a deep regional history. Much further inland, the Congo Basin experienced no European intrusions until the end of the nineteenth century, and many of its communities were able to maintain their raffia-weaving traditions well into the twentieth century. Raffia cloth, clothing, and accessories were admired and eagerly collected during the colonial era with many finding their way into museum collections.

The *Hyphaene thebaica* species of doum palm is native to the northern half of Africa, from Mauritania in the west to the Eastern Desert of Egypt and Sudan. These drought-tolerant plants grow in arid regions wherever groundwater is present. For millennia, their thick leaves have been harvested by communities for making sturdy baskets and mats. The mats created by the seminomadic Beja people are used to cover their movable dwellings and as decorative structures that define space within those dwellings (see no. 34).

To date, the earliest confirmed sub-Saharan sheep's-wool textiles are from the archaeological sites of Iwelen, Niger (eighth century) and the Bandiagara caves in Mali (eleventh through eighteenth century). Whether these fabrics were trade goods and/or elite local products remains unknown. In the Macina region of Mali's Inner Niger Delta, upriver from Timbuktu, Fulani communities raise Macina coarse-wool sheep. The origin of these animals has not been established but some specialists believe they are related to North African stock. The thick and durable wedding hanging (no. 4) and personal covering (no. 5) featured in the Western Sahel section, both products of Fulani *maabube* specialists, provide

protection against the abundant mosquitoes and cold nights of the Sahel dry season.

Both *Gossypium herbarium* and *Gossypium arboretum* cotton species have been cultivated in West Africa. Colonial sources reported finding *G. herbarium* growing as wild perennials in forest regions. Art historian Colleen E. Kriger has determined from archaeological, oral, and written sources that there were at least two cotton-producing centers located in the Sahel region, both active since at least the tenth century: a western center extending from the Senegambia drainage eastward toward the Inner Niger Delta, and a mid-Sudan center surrounding Lake Chad. Cotton's durability and washability surely accelerated its spread across West Africa through well-structured trade routes and market towns. Most of the fabrics and garments discussed in the Western Sahel and the West African Coastal Forests sections of this book are fully or partially created from cotton, which today is the most common textile fiber in West Africa.

Whether harvested from wild or domesticated moths, silk is *the* luxury fiber worldwide. In rural Nigeria, the collective nests spun by different species of social caterpillars in the genera *Anaphe* and *Epanaphe* are the source of wild silk. Their large communal cocoons are collected by local people and seasonal pastoralists and brought to markets where they are purchased and processed into yarn by the wives of weavers. The labor involved at all production stages ensures that wild-silk yarns are reserved only for the creation of the highest-quality cloths. Male Hausa specialists use these wild-silk yarns, known as *tsamiya*, to embroider traditional caps and gowns, such as *riga* (see no. 18). Yoruba weavers integrate wild-silk (*sányán*) yarns, in varying quantities, into the narrow-band cloth used for male and female garments. In the Tapia Forest of central Madagascar, local people harvest the cocoons of wild *landibé* moths (*Borocera canjani*), whose silk is processed, spun, dyed, and woven into burial shrouds by female specialists. At present, in Nigeria and Madagascar, indigenous moths are under sustained existential threat from overharvesting and loss of habitat.

Bombyx mori silk, first domesticated in China during the fourth millennium BCE, was widely traded across Afro-Eurasia by the fourteenth century. Two unrelated silk cloth fragments excavated in the market town of Essouk-Tadmekka in northern Mali, dated to the tenth or eleventh century and the thirteenth or fourteenth century, support medieval Arab historians' descriptions of silk in ancient Ghana and Mali. Silk yarn and cloth from India were traded in market towns along the East African coast since the first millennium, if not earlier. From the seventeenth century, silk arrived to West African markets in and beyond the Sahel from Europe. Silk was so desired in many African communities that it was imported in spun and reeled forms (see nos. 16, 21–23, 39, 40) and as yardage.

Creating Cloth, Color, and Pattern

Closely examining fabrics allows specialists to understand something of their production methods and materiality, which in turn offers insights into the creative processes that determine why fabrics look and feel the way they do. Practical skills and technical knowledge in the textile arts can be acquired by attending classes or workshops led by contemporary practitioners of artisanal processes. Reading contemporary and historical texts and attending specialist lectures provides a broader perspective through the arc of time. Practical and historical awareness can help us see why and how makers transcended the limits of existing technologies to increase the sophistication of their products.

Each object discussed in these pages is testament to a particular set of spinning, weaving, patterning, and assembly skills. The creation of these works generally requires the talents of several specialists who employ techniques that have been in place for centuries; makers may also incorporate mass-market goods such as mill-spun yarns, cloth, and trimmings such as glass beads. Given the multitude of traditional and newly developed tools and processes employed for textile making in Africa, only a small sampling can be presented here.

All but two of the objects in this book (nos. 13, 27) were created in full or in part from handwoven or factory-produced cloth. Of these, twenty-seven were woven on handlooms dressed with either hand- or machine-spun yarns.

All woven fabrics are constituted of the relationship between warp and weft. "Warp" refers to threads held in tension, and "weft" refers to threads passed (or "picked") over and under the warp. Because picking individual yarns by hand is tedious, looms were developed to facilitate the weaving process. Specialists characterize looms by two features: their shedding mechanism, which raises and lowers warp threads to create openings (the "shed") for the weft to pass through, and their warp orientation.

All but one of the looms mentioned in this book employ either a single-heddle or a double-heddle shedding mechanism—the exception is the treadle loom of contemporary Merina weavers (see fig. 33). A heddle is a tool for organizing and repositioning warp threads to facilitate the passage of the weft. A single-heddle loom relies on a rod that holds a single heddle set and raises every other warp. A shed rod, placed behind the heddle rod, is used to lift the remaining warps. These are worked in alternation to weave a cloth with an over-one-under-one structure known as plain weave. A removable sword or beater is used to pack the weft yarns against the warps. The foundation and pattern of the Akwete wrapper (no. 24) were created on a vertical-warp variation of this loom with an additional rod used to lay in the pattern wefts; those of the *lamba akotifahana* (no. 39) were created on a horizontal-warp single-heddle loom with sticks possibly added for patterning. Both looms used a circular warp that was wrapped, under tension, around the loom frame. The six Central African raffia cloths (nos. 28–33) were woven on single-heddle looms that were differently oriented and tensioned according to the local tradition. In figure 4, the weaver appears to be using his weaving sword to clear the open shed prior to inserting the weft.

Twenty of the examples featured here were woven on a horizontal double-heddle treadle loom, an apparatus used across West Africa to create a wide variety of woven cloths. Regional variations abound in loom

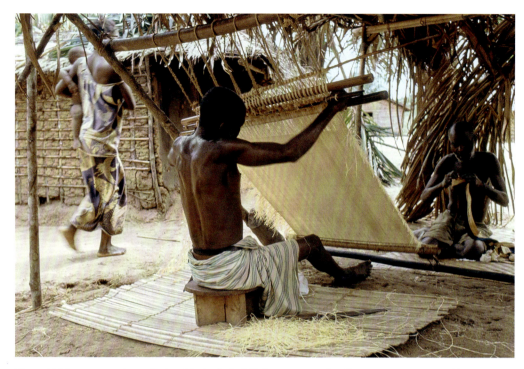

Fig. 4. A Kuba man opening a shed on his single-heddle loom, Nemwele village, Democratic Republic of the Congo, 1970. The set of string heddles is suspended above the sword/beater and the loom bar is above the heddles.

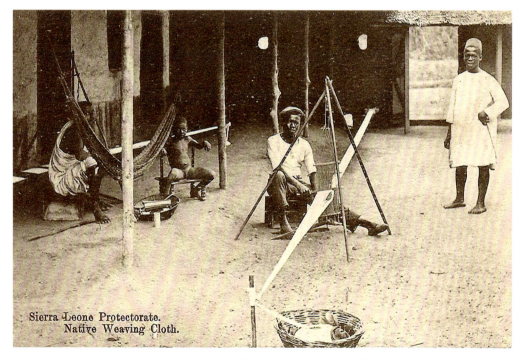

Fig. 5. A Mende or Vai cotton weaver at work alongside a double-heddle tripod loom, Sierra Leone, before 1915. He holds the reed beater in his right hand while his right foot works the treadles. The unwoven warp is held in tension by a peg next to the basket holding its loose ends. The woven cloth extends behind the weaver into a second basket.

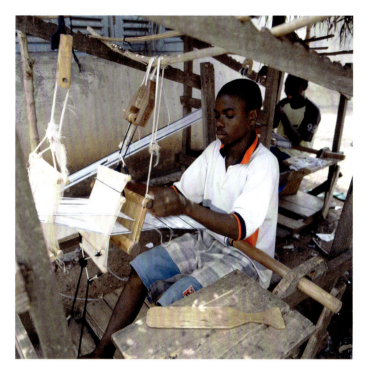

Fig. 6. A young Asante man weaving a kente cloth on a handloom fitted with two sets of double heddles, Ntonso, Ghana, year unknown

construction, setup, size and type of pulley mechanism, the position of the weaver in relation to the loom, and the method and location for holding the woven cloth. Double-heddle looms have these common features: the web (width) is narrow, rarely over thirteen inches across; the long warps are carefully measured around warping devices, cut, organized onto the shedding mechanism, and secured to a cloth bar; and the warp is held under tension by a drag stone or similar device. The two sheds alternate by means of foot pedals (treadles) attached to an overhead pulley system; a suspended reed beater is usually added for maintaining the even spacing of the warps during weft insertion. Some variations to these details can be seen in the photograph of a Mende or Vai tripod-loom weaver sitting alongside the warp and holding the beater in his right hand (fig. 5). A photograph of an Asante weaver shows the loom fitted with an overhead beater, along with one additional double-heddle set that allows the weaver to create both warp- and weft-face bands and handpicked patterns (fig. 6).

There are many means of surface patterning. Designs can be created on yarns prior to being woven. Contrasting yarns can be organized and interlaced to create patterns during the weaving process. Pattern can also be applied to the finished cloth. The effects of surface patterning can be subtle, relying on differences in texture and the play of light, as seen on the naturally colored *Bombyx mori* silk embroidery embellishing a Middle Niger boubou of mill-woven white cotton *bazin* (no. 2) or the wild-silk embroidered patterns of a Hausa *riga* (no. 18), which extensively cover a similar mill-woven cotton *bazin*. Although created more than one thousand miles to the southeast, a Bushong overskirt (no. 32) relies on a similarly nuanced sensibility. The handwoven cloth was embroidered and assembled, then subtly colored with a light red plant or mineral pigment rubbed into the surface of the cloth. Other patterns can be eye-popping, such as those created by Asante and Ewe weavers using bright multicolored mill-spun yarns, with ever-increasing novelty. These thin, evenly spun yarns, introduced to the

INTRODUCTION 21

region in the nineteenth century, are the driving force behind the efflorescence of their traditions. The smooth and even tension of the striped, multicolored, warp-face foundation weave provides an ideal surface for adding weft patterns.

When dyeing yarns and fabrics was undertaken entirely by hand, creating patterns by means of a single dyestuff contrasted against the natural fiber color was typical. At least thirteen objects in this book privilege one of the two once-widespread natural dyes in Africa: indigo blue and iron-tannin brown. Evidence of past and present-day indigo dyeing can be found throughout much of West Africa and Cameroon, documented as having been disseminated, in part, by Soninke clans migrating east and south after the fracture and decline of the historical polities of Ghana in the eleventh century and Mali in the late sixteenth and early seventeenth centuries. Their descendants are traced to Dyula, Yarse, and Marka communities, among others. The fold-resist patterned, indigo-dyed wrapper (no. 15) was likely inspired by the textiles of female Dyula specialists who prepare the indigo in ceramic pots. Although synthetic indigo has largely replaced the labor-intensive natural product, the cultural and spiritual meaning found in the preparation of natural indigo continues to be preferred by some practitioners, including the contemporary fiber artist Aboubakar Fofana. State support for handcrafted fabrics from countries like Mali and Senegal has been essential to maintaining historic, time-consuming processes in the age of fast fashion. Today, fiber and fabric artists harness traditional and modern technologies in their efforts to retain profitability, react nimbly to fashion shifts, and expand markets.

Fiber Arts and Other Media

Textiles have never existed in isolation. They have occupied a unique place in art historical discourse for the ways their global exchange has facilitated cross-cultural and transmaterial interaction. This is evident in early comparisons of African textiles to other media—for example, nineteenth-century European explorers and diplomats expressed their admiration for Malagasy

akotifahana (see no. 39) by comparing them favorably with vibrant stained-glass windows. The intersections between textiles and wood carving, photography, architecture, and design, among other media, are essential to understanding their profound historical and ongoing significance across the globe.

The looms employed to weave many of the fabrics in this book could themselves be the subjects of complex artistic elaboration. Among Baule, Guro, and Senufo populations in present-day Côte d'Ivoire and Burkina Faso, sculptural heddle pulleys have been designed to accent a master weaver's loom, where they facilitate the movement of the heddles. Positioned at eye level, these sculptures infuse the rhythm of daily work with beauty and private pleasure. The heddle-pulley genre affords sculptors an opportunity to demonstrate their mastery of a vast repertoire of techniques and imagery. Special attention is paid to the appearance of the pulley in profile, evident in the expressive geometric designs applied to the coiffure, neck, and temples of a Baule heddle pulley with opposing faces (fig. 7). Some motifs replicate well-known masks or devotional figures, while others draw from the natural environment or the carver's imagination. With planar dimensions, a hooked trunk, and minute patterning, the intricate detail of the heddle pulley with elephant underscores the sculptor's ability to play with two- and three-dimensional abstraction (fig. 8). Such visual and technical ingenuity complements and parallels the creative efforts of many of the weavers featured in this book.

Once complete, textiles circulate widely in open-air markets and within family collections. The contrasting patterns and colors of thousands of fabrics on display create a vibrant visual composition within the wider urban setting of commercial centers such as the Kejetia Market in Kumasi, Ghana (fig. 9). Individuals might store their recent purchases in trunks or wardrobes containing previous acquisitions of locally and globally produced cloth, textile heirlooms, and even family portraits. Art historians Lisa Aronson, Duncan Clarke, MacKenzie Moon Ryan, and Patricia Darish have reported on this phenomenon among Ijo and Yoruba communities in present-day

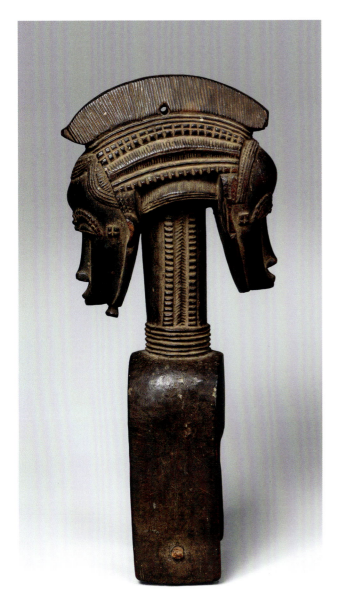 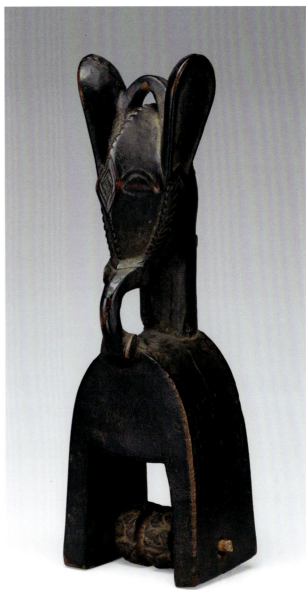

Fig. 7. Heddle pulley with opposing faces. Baule artist. Côte d'Ivoire, ca. 1900. Wood, 10¾ × 3¼ × 4½ in. (27.3 × 8.3 × 11.4 cm). Anonymous Gift, 2015 (2015.485.2)

Fig. 8. Heddle pulley with elephant. Baule or Guro artist. Central Côte d'Ivoire, 19th–mid-20th century. Wood, 7¼ × 2½ × 2½ in. (18.4 × 6.4 × 6.4 cm). The Michael C. Rockefeller Memorial Collection, Bequest of Nelson A. Rockefeller, 1979 (1979.206.22)

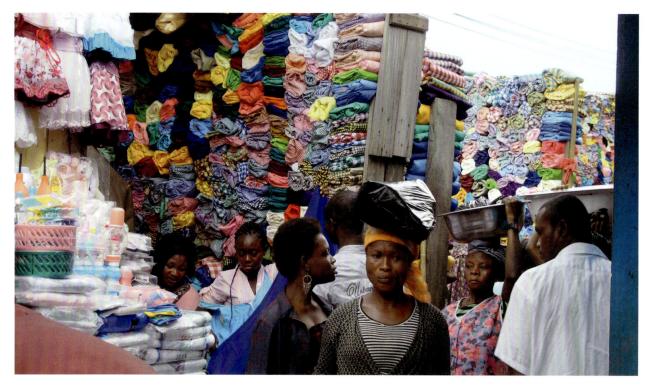

Fig. 9. Rows of stacked, rolled fabrics in the bustling Kejetia Market, Kumasi, Ghana, ca. 2013

Nigeria, East African consumers, and the Kuba of Central Africa, respectively. These collections were sources of great pride for families, who maintained knowledge of any names or histories associated with their textiles, reciting them upon opening the trunks and revealing their contents.

Family photographs, both those stored in trunks and those displayed throughout the home, further speak to the meanings and contexts of textiles. The high-contrast, symmetrical compositions of Malian studio photographer Seydou Keïta's mid-twentieth-century images highlight how textiles mediated self-expression. In a portrait of three young women (fig. 10), the subjects' matching or near-matching ensembles of vibrantly patterned, tailored dresses are complemented by identical poses and hairstyles as well as beaded jewelry. This carefully crafted scene is completed with a finely woven, light-hued cloth elaborated with geometric and vegetal patterning and a tasseled fringe. The image simultaneously captures how textiles are used in the thoughtful construction of individual and group identity and preserves and reproduces textile aesthetics through the photographic medium.

The meticulous ensembles of the three young women further illustrate the relationship between woven clothing and other forms of wearable embellishment. Elaborate coiffures, headgear, jewelry, and even weaponry frequently featured alongside many of the custom-tailored garments discussed in this book. For instance, the Kuba *mapel* (no. 30) may have been complemented by a small cap affixed to the wearer's hair with a long metal pin and a plaited raffia belt into which an *ikula* "peace" knife could be inserted. Similarly, the stitch-resist wrappers donned by *signares* (see no. 8) might be worn with gold earrings, silver anklets, red slippers, and other local and imported textiles. These lavish

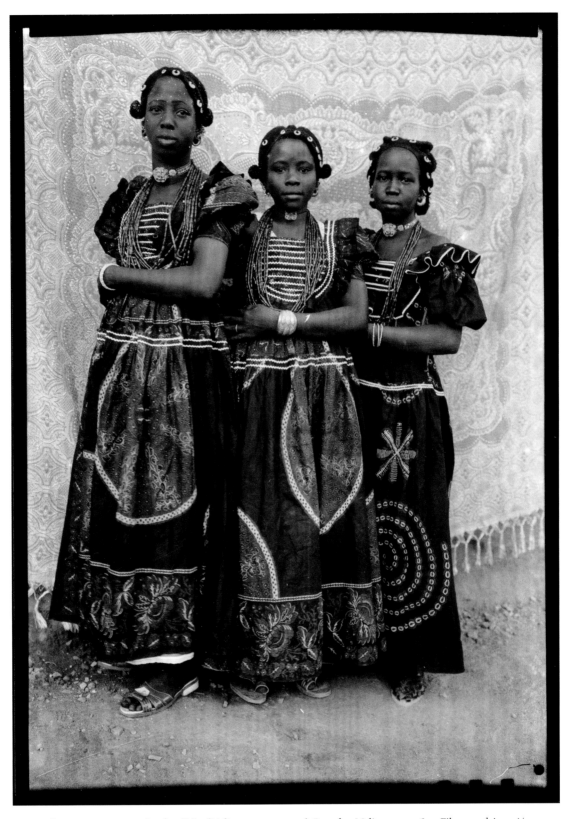

Fig. 10. Three young women. Seydou Keïta (Malian, ca. 1921–2001). Bamako, Mali, 1950s–1960s. Film, emulsion, 7½ × 5⅛ in. (19 × 13 cm). Gift of Susan Mullin Vogel, 2015 (2015.499.1.1)

accoutrements added to the visual impact of painstakingly handwoven and embellished clothing.

The skills and patterns associated with textiles have also been translated into an array of other creations. Nowhere is this more apparent than in the renewable fiber arts of Central and East Africa, where hand-plaiting is responsible for constructions ranging from architecture to basketry to decorative panels. Such refined forms have often been produced along gendered lines, with men responsible for more functional, unadorned elements like storage vessels and domestic architecture, and women for aesthetic forms like the *insika* wall screens of the Tutsi. Among the most complex and dynamic of these traditions are Kuba architectural structures. The long, rectangular buildings are constructed from a framework of wooden poles to which panels of plaited palm midribs and other plant fibers are added to create the walls (fig. 11). The elaborate interlace patterns woven into these panels mirror the ornamentation of Kuba raffia textiles (see nos. 29–32). The intersections between weaving and the built environment are further exemplified by the various textiles in this book that were displayed to define and ornament architectural space.

Exploring the relationships among materials is a hallmark of contemporary fiber artists such as Abdoulaye Konaté (no. 1), Elias Sime (no. 36), and Joël Andrianomearisoa (no. 38), among others. Drawing upon the complex histories of textile production and display, their individual works and broader installations employ multimedia approaches to consider critical issues related to the environment, industrialization, labor, religion, literature, and global politics. Through continued meditations on these topics, Konaté, Sime, and Andrianomearisoa build upon enduring traditions that position textiles in relation to other materials and techniques.

How to Read This Book

Spanning the eighteenth century through the present day, the fiber arts featured in the following entries attest to the diversity of long-standing and newly developed textile traditions across sub-Saharan Africa. Forty exemplary objects from The Met collection are organized geographically into four sections: the Western Sahel, the West African Coastal Forests, Central Africa, and East Africa. These geographical distinctions should not be understood as hard divisions between these regions—as you will see in the following pages, there are many continuities and connections to witness in the weaving techniques, embellishments, and styles employed by artisans throughout sub-Saharan Africa.

Moving from the Niger Bend region of Mali westward to coastal Senegambia, the textiles of the Western Sahel speak to the deep histories of trans-Saharan and transatlantic trade that have informed West African artistic production. The section on the West African Coastal Forests begins in Sierra Leone and traces east through southern Mali and Burkina Faso, down into present-day Côte d'Ivoire, Ghana, and Togo, and concludes with a series of seven textiles produced by Hausa, Yoruba, and Igbo communities in present-day Nigeria. The creations represented within this tropical region underscore the geographic and temporal specificity of particular weaving traditions while simultaneously highlighting the connections between textile arts across the region. The entries addressing Central Africa begin with the Cameroonian Grassfields chiefdoms in the north and conclude with Mangbetu, Dengese, Kuba, and Mbun populations of present-day Democratic Republic of the Congo and Angola. Variously created from cotton, raffia fiber, and pounded bark, these examples, replete with bold patterning and refined finishes, foreground the

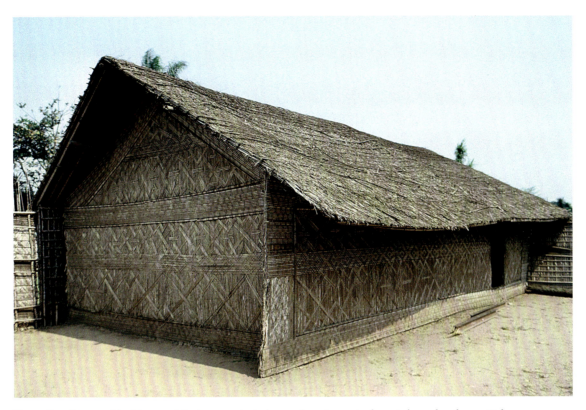

Fig. 11. Guardhouse with elaborate plaited geometric designs at the entrance to the *nyim*'s royal enclosure, Nsheng, Democratic Republic of the Congo, 1982

expressive ingenuity of Central African artisans. The final section presents selections from East Africa, as far north as the Eastern Desert of Sudan and as far south as Madagascar, exemplifying the diverse functions, materials, techniques, and even clientele engaged by artisans in this broad region.

The forty works featured in this book cannot fully represent the textile traditions across the African continent. A comprehensive survey of African fiber arts, if such a study were indeed possible, would yield multiple volumes. Rather, these creations are carefully selected highlights from The Met collection, which is weighted toward West, Central, and East African arts, leaving southern African fabrics largely unrepresented in this book. Moreover, because The Met collection of African arts was established in 1978, the selection privileges works that could be purchased or received as gifts from the last quarter of the twentieth century onward. Within this temporal and geographic scope, the following textiles capture the incredible range of fiber arts of sub-Saharan Africa and the family ties, economic networks, and political relationships animated by their creation and use.

WESTERN SAHEL

1

Bleu no. 1

Abdoulaye Konaté (Malian, born 1953)
Mali, 2014
Cotton, dye, 7 ft. 8⅛ in. × 12 ft. 1¼ in. (234 × 368.9 cm)
Purchase, William B. Goldstein and Holly and David Ross Gifts, 2015 (2015.94)
Recorded provenance: Acquired from the artist, 2014

I am inspired by historical techniques that I make my own.
They are a cultural resource that all artists may draw from.
—Abdoulaye Konaté

Abdoulaye Konaté's compositions explore the range of associations textiles evoke in Mali and across the Sahel. Childhood memories formed in his hometown of Diré, located on the northern bank of the Niger River, are a primary source for Konaté's creations. Long-enduring West African artistic traditions provide further inspiration, as do the artist's personal interests in the roles of faith, conflict, and the HIV/AIDS epidemic in contemporary society. Konaté formally trained as a painter in Mali and Cuba, and decades later he founded a fine arts program in Bamako to mentor a new generation of artists in Mali. His ambitious creations, realized with a team of assistants over the course of many months, have been presented at the Centre Pompidou in Paris and at major contemporary art venues in Dakar, Kassel, Milan, and Venice.

Konaté has been experimenting with textile creations since the early 1990s, when he developed multimedia installations with textile panels serving as architectural backdrops to more central displays. In recent decades he has probed the protective and aggressive duality of fabric through references to a style of tunic worn by Mande hunters, in which layered surfaces were activated through the incorporation of amulets, animal and plant matter, and other elements tied to important moments in the life of the wearer (see no. 11). In his varied explorations of the textile medium, Konaté employs and manipulates the expressive capacity of cloth in regional and global sign systems.

Konaté's artistic practice is particularly invested in color. Many of his compositions serve as meditations on the wide range of greens, reds, blues, and yellows that are embedded in (or flow from) the landscapes of West Africa and that are used in the arts of various communities throughout the Sahel. He continually returns to blue because of its omnipresence in the natural environment and in man-made products. It is the color of the sky as reflected in the life-affirming seasonal waters that turn the arid Sahel plain into a fertile landscape. Indigo also remains an important ingredient in West African arts and medicines. Derived from indigenous plants until the dawn of the twentieth century, indigo has been widely used across North Africa and the Sahel region for centuries if not millennia. Global demand and its once labor-intensive production made it central to trade networks.

Drawing upon these various referents, Konaté has described blue as such a powerful color that he feels it "absorbing [him] little by little" as he works with it. In *Bleu no. 1*, Konaté explores the color across the full

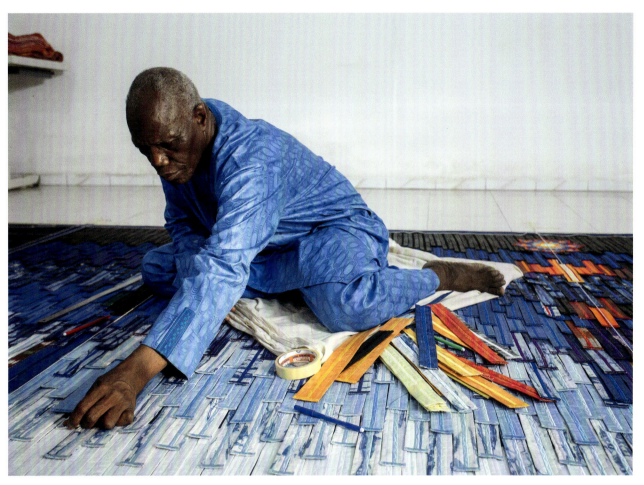

Fig. 12. Abdoulaye Konaté assembling a composition created from *bazin* cloth while wearing an ensemble also made of *bazin*, 2021

spectrum of its intensity. This piece is constructed from high-quality, mill-woven cotton *bazin*—a damask fabric favored in Mali for prestigious and fashionable dress—that Konaté cut into hundreds of narrow strips. He further transformed this raw material by using synthetic dyes to create a range of indigo shades. He then organized and attached these strips to form a large-scale assemblage that presents accents of red and yellow against a sea of rich to subtle blues (fig. 12). Through his agile variation of the strips' lengths and their placement within the composition, Konaté imbued the work with a musical, rhapsodic quality.

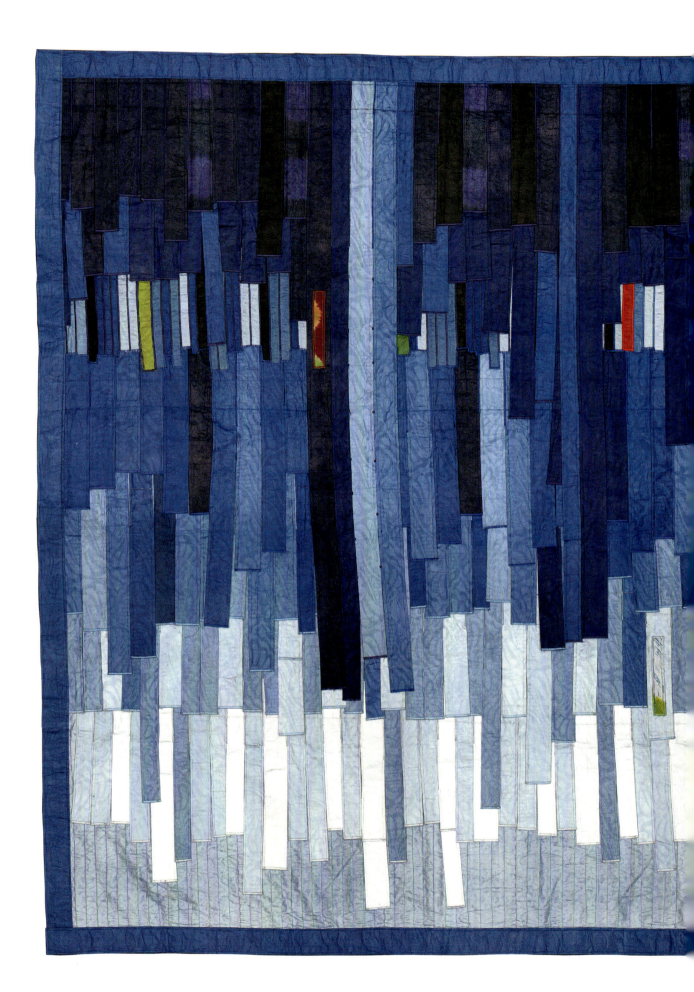

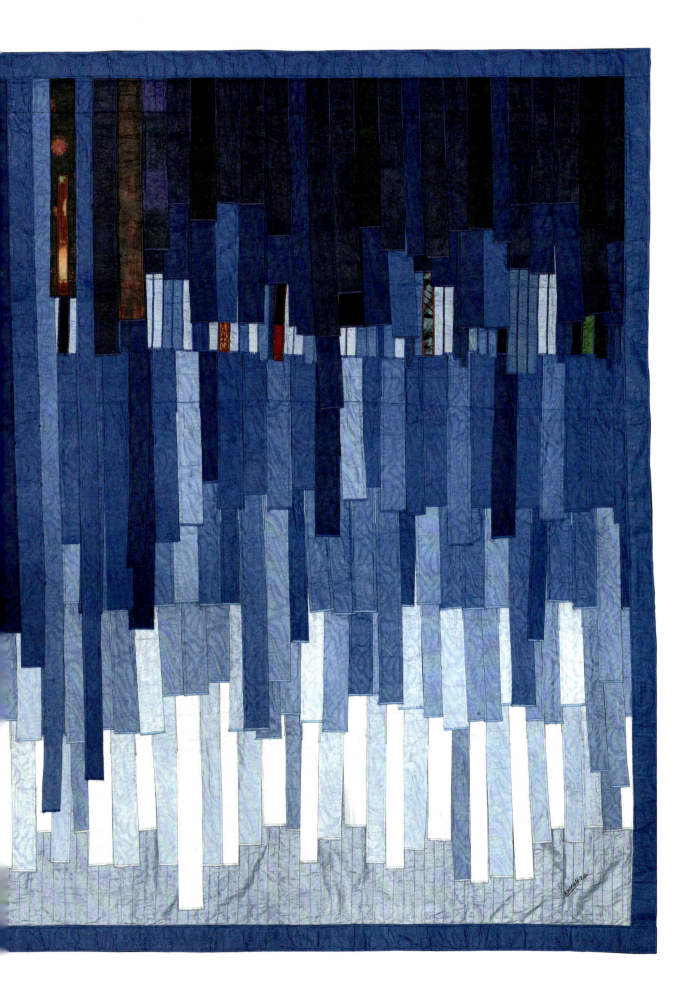

2

Boubou *kasaba* (woman's robe)

Malian artist
Djenné, Mali, early–mid-20th century
Silk, cotton, 45½ × 63½ in. (115.6 × 161.3 cm)
Gift of Labelle Prussin, 1997 (1997.446.4)
Recorded provenance: Acquired by
Labelle Prussin in Djenné, Mali, 1970;
Labelle Prussin, Pomona, NY, 1970–97

For the past 150 years, the term *boubou*—a French corruption of the Wolof word *mbubb*—has been used to describe an ample flowing outer garment, worn over other clothing by men and women in Mali and regions farther west. Boubous have been romanticized in the West as garments suffused with elegance and chic, and they have been the subjects of extensive studies analyzing and categorizing their varied types, technical characteristics, and symbolic meanings. White flowing garments became fashionable across the Western Sahel by the early seventeenth century, after the Songhai Empire was defeated by the Moroccan Saʿdi dynasty in 1591. The invaders brought with them white robes, which distinguished them and their families from the indigenous populations. Their white robes stood in contrast to the primarily indigo-dyed cotton clothing worn throughout much of West Africa. As individuals in this region increasingly converted to Islam between the seventeenth and nineteenth centuries, they adapted this new form of dress to proclaim their religious devotion and to align themselves with the new Muslim elites.

Based on a diagram published in 1921 by Auguste Dupuis-Yakouba, a French colonial official and ethnographer, this garment can be identified as a boubou *kasaba* because the sleeves and body are of equal height. This is distinct from the better-known boubou *tilbi*, whose format includes a small insert at the lower end of each sleeve that creates a division between the sleeve and the lower circumference of the garment. Both types of these

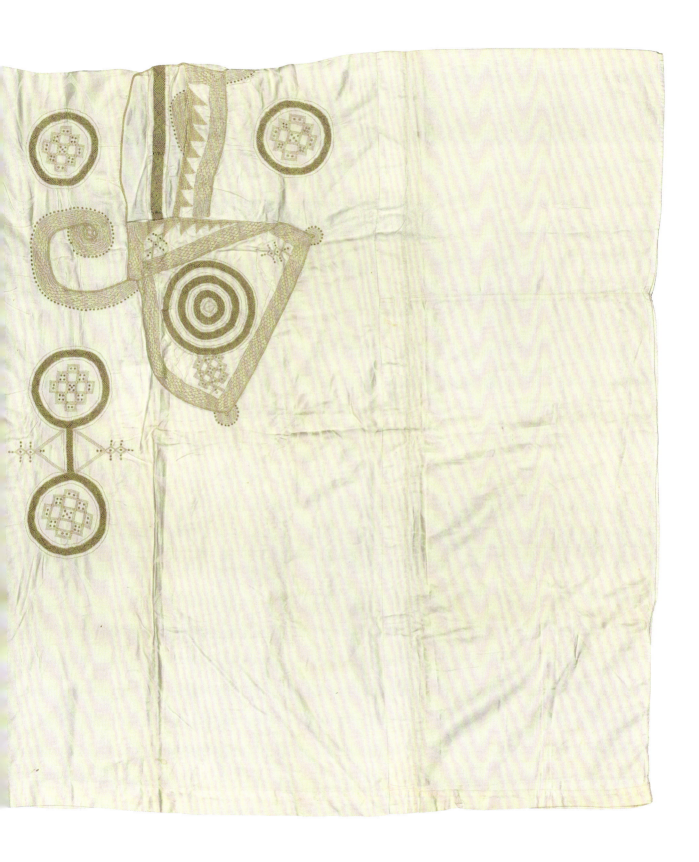

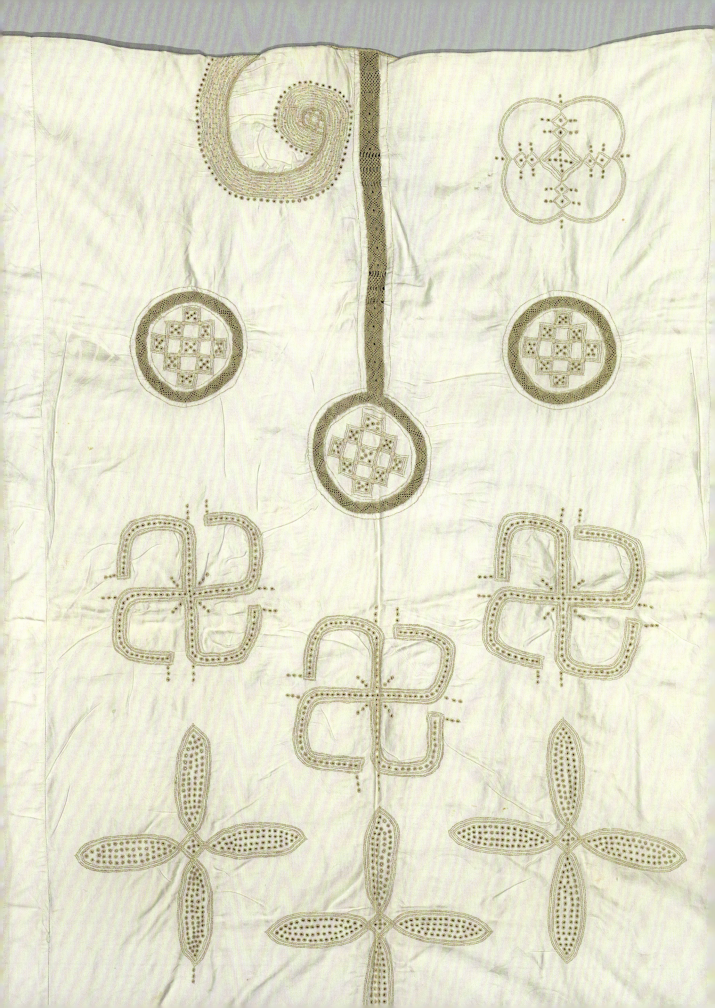

delicately embroidered white robes could be made for betrothed women—they were commissioned by a bride's mother and paid for by her groom.

Art historian Labelle Prussin purchased this boubou in 1970 from an elderly woman in Djenné, Mali. Prussin noted that the knotted silk needle lace (*tichbok*), worked between cut-out sections of the garment, was fashionable at the time among elite Muslim women in the urban centers of Oualata, Djenné, and Timbuktu. This boubou is an impressive example of the hand-embroidered garments favored by these women. The foundation fabrics are European, mill-woven cotton damask, or *bazin*, patterned with undulating plantlike forms. Tightly woven from fine mercerized yarns, the smooth, yet contrasting, satin-weave faces remain reflective after decades of use, indicating that the fabric was of the highest quality. The imported off-white silk used in the embroidery and the skill with which it was applied are further indications of the expertise and time that went into this garment. On the front, voided and embroidered needle-lace motifs surround the neck, chest, and pocket that is placed over the heart. The back is embellished more symmetrically, from the neck to the hem. The labor of the needlework on this boubou surely took more than a year to complete, a feat made even more astonishing by reports that the needle-lace patterns were once worked without the aid of a tensioning device to stabilize the cut fabric during embroidery.

The elaborate patterning in this and other examples of boubou conveyed messages about the faith, status, and gender of the wearer. The repeat grid pattern, here inscribed within circles, is an especially potent motif employed by Muslim communities throughout the Sahel. Variously known as *khatim* (Arabic), *xaatim* (Wolof), or *hatumere* (Pulaar), this symbol protected and empowered the wearer by numerically aligning her with esoteric forces. The number five appears prominently within the *hatumere* on this garment. Five is an auspicious number for its association with the Prophet Muhammad and the four members of his immediate family. Additionally, "five also translates into four points and a center, a spatial construct that implies a square, much like the Kaaba at Mecca." The wide spiral motifs extending across the chest and down the back derive from the Arabic letter *waw* (و). Within a western African context, this spiral element served as an ideogram for women's objects and spaces, which affirms the robe's connection to its female former owner.

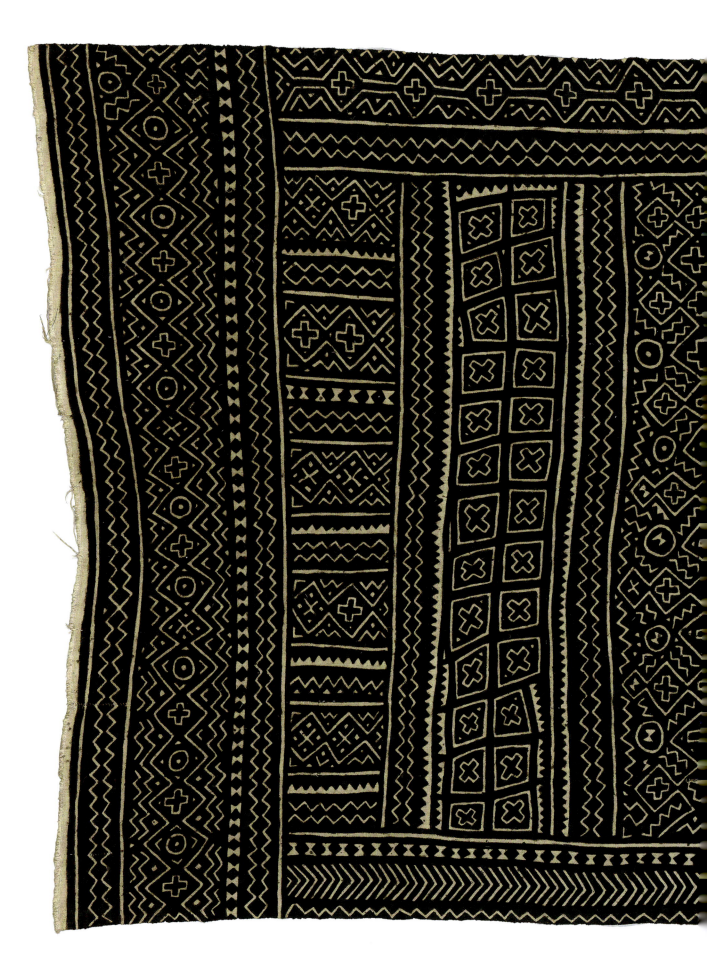

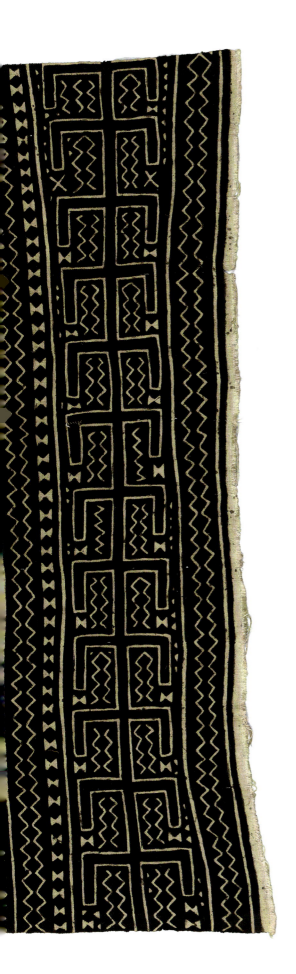

3

Bògòlanfini (mud-dyed cloth)

Gneli Traoré (Bamana, ca. 1923–2002)
Samantara, Mali, 1969
Cotton, dye, 63 × 72 in. (160 × 182.9 cm)
Gift of Dr. and Mrs. Pascal James Imperato, 2014
(2014.245)
Recorded provenance: Acquired by Pascal James
Imperato from the artist in Samantara, Mali, 1969;
Pascal James and Eleanor M. Imperato,
New York, 1969–2014

The term *bògòlanfini* ("mud applied to cloth") refers to a type of textile developed by Bamana women in what is now southwestern Mali. *Bògòlanfini* are created from locally woven cotton textiles hand-painted by female specialists to create a deep-black ground from which a variety of unpainted geometric patterns stand in contrast. They are worn as women's wrappers or cut and sewn into men's shirts. In recent decades, *bògòlan* (mud-dyed) creations have been the subject of dramatic technical, stylistic, and functional innovation. Contemporary artists experiment with design formats and the relationship between ground and pattern to create a wide array of compositions. Simultaneously, designers mine *bògòlan* styles, applying similar earth-toned geometric designs to objects ranging from hats to notebooks to housewares. Gneli Traoré is an early innovator of the practice and among those who shepherded the transition from labor-intensive *bògòlanfini* to the proliferation of *bògòlan* styles from the 1980s onward. Notably, she abandoned the customary format that called for a strict division between border and center (see fig. 13) in favor of more complex and diverse patterning. She further experimented with painting the design itself with mud dye, rather than painting the background to leave the design in relief.

The creation process for traditional *bògòlanfini* begins with cotton, which is handspun by women and

WESTERN SAHEL 39

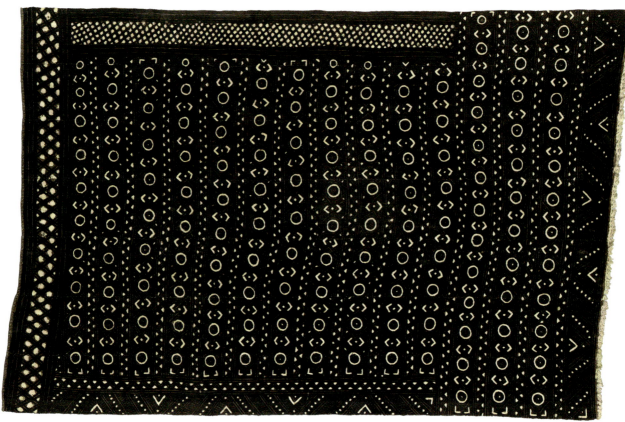

Fig. 13. *Bògòlanfini* (mud-dyed cloth). Bamana artist. Mali, first half of 20th century. Cotton, dye, 37 × 57$^{11/16}$ in. (94 × 146.5 cm). The Michael C. Rockefeller Memorial Collection, Bequest of Nelson A. Rockefeller, 1979 (1979.206.190)

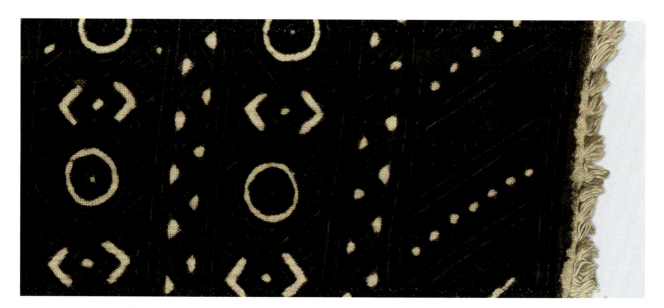

Fig. 14. Detail of the *bògòlanfini* in fig. 13, showing the varying widths of the lines held in reserve

40 WESTERN SAHEL

handwoven into narrow bands by men. The white, plain-weave, warp-face cloth is then purchased, cut, and assembled by a female practitioner. In this instance, Traoré created this elaborate display piece on twelve bands sewn together along their selvages. After assembly, *bògòlanfini* artisans wash and dry the cloth before submerging it in a tannin-containing mordant bath made from local leaves, which temporarily colors the cotton fibers yellow. The deep black dye is also created from locally harvested leaves, which are pounded and mixed in water with fine black mud and allowed to ferment. Changes in the odor of this mixture alert the artist to when this mud-derived "paint" is ready to be applied to the cloth. The artist uses a flattened reed or metal spatula to carefully apply the mixture over most of the cloth's surface, leaving delicate patterns in reserve. Once dried, the mud is removed. To achieve a darker background, the dyed surface is covered with further applications of mud mixture. Once the desired dark shade is achieved, the yellow color may be removed by treatment with mild caustic solutions. The crisp contrast between the dark and light fields has led some scholars to incorrectly state that the reserved patterns are created through the application of a resist, but it is in fact the result of a skilled artist's meticulous application of dye. The finest *bògòlanfini* cloths are valued for the artist's ability to vary the width of the sections left in reserve between fine and thick white lines (see fig. 14).

Bògòlanfini artists maintain knowledge of a wide array of motifs and patterns that are employed to convey important values or evoke historic moments in Bamana communities. One of the seven pattern variations Traoré uses in her composition is *bama*, which appears in the wide column at right and is dominated by the abstract representation of a crocodile. This powerful reptile features prominently in Bamana aphorisms and folktales. It is recognized for its superior wisdom and has been understood as a mediator in disputes or conflicts. Filling

Detail of no. 3

the horizontal band along the top is the *Koumi Diosséni kandjan* pattern that honors Koumi Diossé, a heroic figure from Beledougou, Mali, who led an unsuccessful revolt against French colonial rule in 1915.

Knowledge and expertise of the *bògòlanfini* tradition has historically been inherited by female specialists. Traoré learned the art from her father's youngest wife, Djitio Soucko, who had been instructed by her own mother. Traoré's legacy continues through the work of her daughters, Awa and Sira, and her sons, Oumar Almamy and Lassana.

4
Arkilla kunta (wedding hanging)

Fulani *maabo*
Mali, first half of 20th century
Wool, cotton, dye, 4 ft. 2 in. × 13 ft. 6 in. (127 × 411.5 cm)
Gift of Labelle Prussin, 1997 (1997.446.1)
Recorded provenance: Acquired by Labelle Prussin from a Hausa trader in Accra, Ghana, 1963;
Labelle Prussin, Pomona, NY, 1963–97

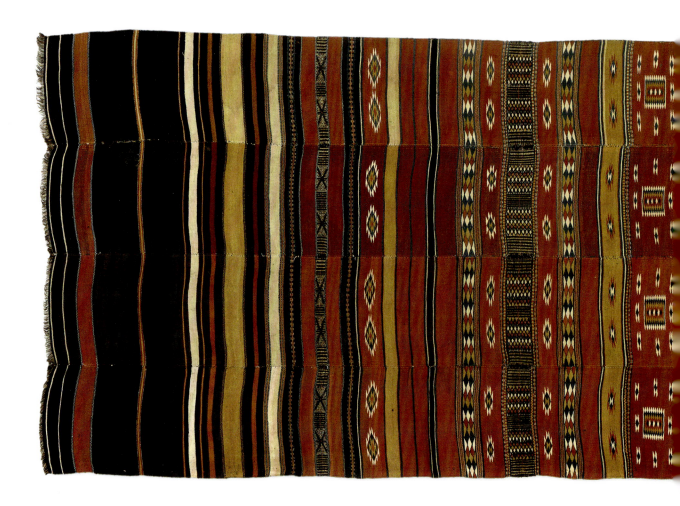

Arkilla kunta are commissioned by families on the occasion of a daughter's wedding. Presented during the ceremony, the textile serves as the most visible symbol of a marriage contract. Suspended over the marital bed, it forms a tentlike intimate space, deters mosquitos, and provides warmth during the cold nights of the Sahel dry season. These monumental works are woven by an all-male group of Fulani pastoralist weavers known as *maabube* (singular *maabo*) from wool yarns spun and dyed by women. The family commissioning these majestic creations hosts a *maabo* and his family within their domestic compound for the five to seven weeks needed to weave it—an enormous expense, requiring the purchase of the necessary yarns, the provision of extra food and secure accommodation, and often additional gifts. Families thus frequently commission a second, less elaborate *arkilla* to be made at the same time, which they might give to a poor family or sell to offset the costs of their purchase.

Arkilla kunta are one of a variety of woolen textile types woven by *maabube* specialists for local and regional consumption. Reaching up to eighteen feet in length, the *maabube*'s elaborate productions are traded widely within West Africa and beyond. They serve varying functions in the communities to which they travel—some are

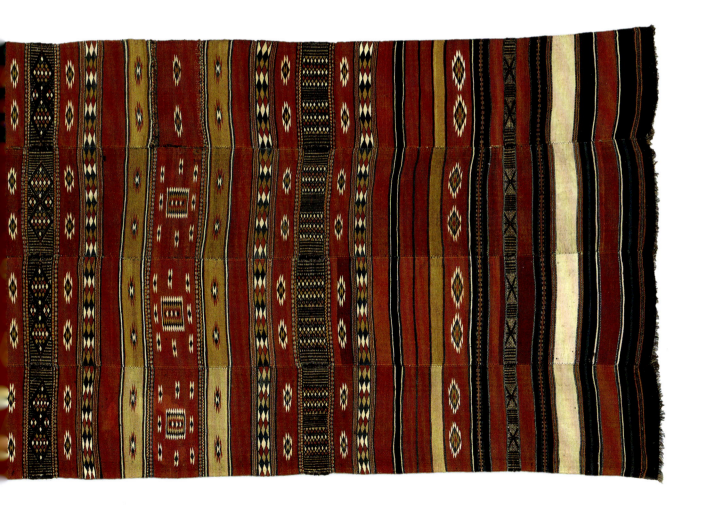

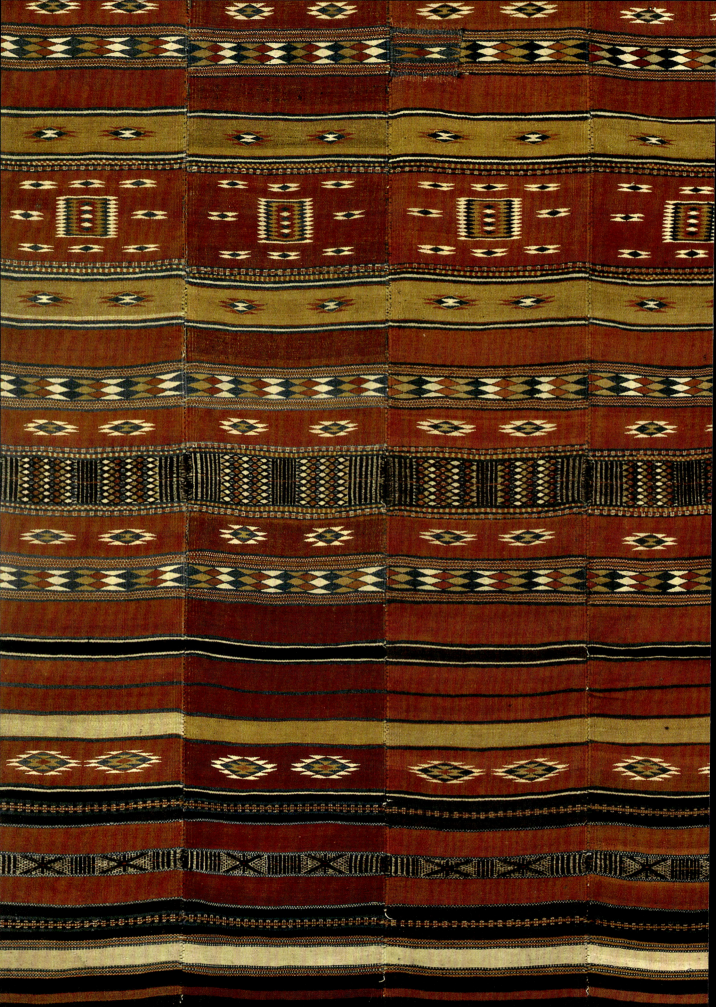

used as blankets, while others may be suspended to divide and embellish architectural space. The Akan in present-day Ghana refer to these woven-wool textiles as *nsaa*, which they historically acquired in exchange for enslaved individuals and kola nuts. Among this clientele, *nsaa* have taken on religious significance and are thought to distinguish the sacred from the profane. The fabric became integral to separating public areas from the space of a divine leader.

A complete *arkilla kunta* consists of five tapestry-woven bands, most likely produced on a single set of warps. Four of the bands are similarly patterned; the fifth, unfortunately missing in this example, would traditionally continue the proportions and colorways of the other four but contain fewer, more simplified patterns. These bands are among the widest woven in West Africa—the widths of this example range from twelve and one-quarter to thirteen inches. The four bands consistently repeat narrow rectangular fields of brick red, pinkish ocher, rich browns, and two shades of blue patterned with geometric motifs. The differently colored fields are separated by groups of thin, multicolored lines. After the cloth is removed from the loom the individual bands are cut to size and assembled selvage to selvage. The weaver's skill is revealed through the alignment of color and pattern fields that create vertical stripes when the cloth is displayed horizontally.

Heavy *arkilla kunta* blankets are woven on brown wool warps. This contrasts with *arkilla kerka*, an extremely fine wool textile closely related to the *kunta* but woven on cotton warps. No longer produced, the *kerka* was once the most expensive and prestigious form of wedding hanging produced by *maabube*. On this *arkilla kunta*, cotton yarns are strategically employed to punctuate design elements. Discontinuous cotton wefts are used to create the white triangles that outline the dark-blue wool diamonds to form "eye" motifs. These cotton wefts also appear in the larger rectangles and the smaller diamonds within the thicker supplementary-weft-patterned bands. Oxidation and soil have now dimmed what must have been a sharp contrast between the deep hues of the dyed wool and the bright, undyed white cotton. Little documentation of the specific meanings of the motifs exists, but it has been proposed that they may speak to nomadic migrations undertaken by the Fulani.

5

Khasa, or *kaasa* (personal covering)

Fulani *maabo*
Mali, mid-20th century
Wool, cotton, dye, 4 ft. 6½ in. × 8 ft. 10 in. (138.4 × 269.2 cm)
Gift of Michael Katakis, from the Collection of Kris L. Hardin Ph.D., 2017 (2017.732.1)
Recorded provenance: Acquired by Kris L. Hardin in Kano, Nigeria, 1989; Michael Katakis, Carmel, CA, by 2017

Those who have ever experienced a hot and humid summer might be surprised to learn that this thick, exuberantly patterned wool textile was produced in torrid central Mali using wool from sheep that were pastured in the Inner Niger Delta. Although climate change has made their occupation increasingly difficult to sustain, Fulani people living in this region represent the largest community of seminomadic and nomadic sheepherders in the world. Textiles woven from handspun sheep's wool have been the focus of sustained artistic expression over many centuries. Fulani men born into the *maabube* artisanal group serve as highly skilled weavers and griots—musicians and poets who perform narratives about the history of the community and region—a vocational pairing that suggests a link between textiles and storytelling.

Maabube weavers produce two primary categories of woolen textiles: *khasa* blankets and *arkilla* hangings, which can both be further divided into various subcategories. *Khasa* are used primarily as personal coverings. Individuals in the Niger Bend region and beyond have worn them as outer garments and employed them as blankets to protect against the cold, wind, and mosquitos. The various geometric patterns woven into *khasa* reinforce connections between weaving and narration, drawing from natural and man-made elements of the immediate environment as well as abstract ideas. Some motifs are thought to refer to mosque architecture, while others give visual form to female fertility. These patterns thus serve as visual references for community values and beliefs.

The earliest surviving versions of this genre of white-ground wool textiles were more sparsely patterned. More

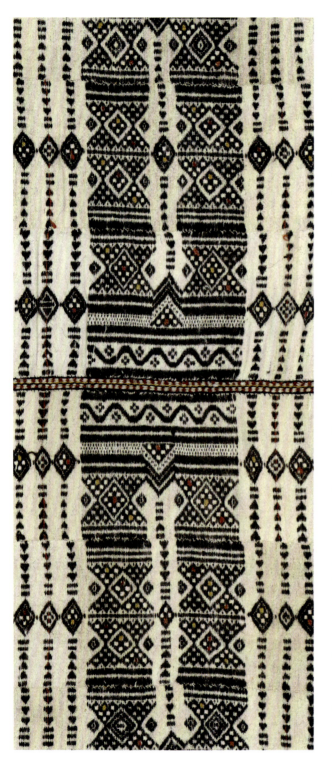

recent *khasa*, like this example, frame a dense array of motifs between two brick-red border bands. The center field features three registers of diamond- and triangle-based motifs and strategically placed dots of red and ocher, all created by continuous and discontinuous supplementary-weft structures. The white weft field between these major motifs is filled with smaller diamonds and dashes, which are all horizontally aligned. The expertise of this *khasa*'s weaver would have been made evident after the female patron who commissioned the work delivered the uncut roll or rolls of fabric to another male specialist for assembly. When he cut and sewed the narrow bands together edge to edge, the carefully balanced composition of motifs was revealed to perfectly align across the breadth of the assembled cloth.

Over the past fifty years a small group of scholars has recorded the unvarying structural details and assembly processes of wool *khasa* blankets, along with variations in their design. Among the common structural features is the joining together of six wide, weft-face panels, which are arranged into two groups of three on either side of a narrow, separately woven, often multicolored warp-face band. In this instance, the wide panels average nine inches across, and the narrow band a mere five-eighths of an inch. To the long sides of the blanket, a sturdy plaited band three-eighths of an inch wide was added to protect the fragile weft selvages from being quickly damaged by abrasion. The unwoven cotton warp ends are twisted together in small groups, which are sequentially plied together into a sturdy cable that creates a durable finish. Some specialists have noted that this treatment of the warp ends is unique among textiles produced within contemporary West Africa. However, the process of cabling unwoven warp ends can be found in certain types of Late Antique tapestry-woven wool garments preserved in Egypt, as well as in a rare eighth-century example from Iwelen, Niger. That this same technique is employed on such temporally and geographically distinct creations may highlight a continuity across textile traditions of western Africa and the Mediterranean world.

6
Henaare (man's festival tunic)

Wodaabe-Fulani artist
Niger, mid–late 20th century
Cotton, wool or synthetic fiber, dye, H. from shoulder to front hem 35 in. (88.9 cm),
W. across torso 11 in. (27.9 cm), W. across widest points 26 in. (66 cm)
Gift of Eve Glasberg and Amyas Naegele, 2013 (2013.1140.12)
Recorded provenance: Aboubacar Doubou, Niamey, Niger, by 2000; Amyas Naegele, New York, 2000–2013

Nomadic pastoralists, the Wodaabe migrate with their zebu herds freely across Niger, Nigeria, Chad, and Cameroon, traveling north in the rainy season and south in the dry season. They are largely organized according to kin groups, which maintain their own customs and migration patterns. A tiny subgroup within the larger Fulani populace, egalitarian Wodaabe communities place significant emphasis on personal aesthetics and comportment. Young men in particular "invest an enormous amount of time, energy, and money in order to live up to the ideal of male beauty." This attention to aesthetics translates to a range of body modifications, personal adornments, and treasured possessions. From birth, infants' noses and foreheads are smoothed and extended to achieve what is considered the ideal facial structure. By adolescence, young men are expected to apply dark eyeliner and lipstick daily. Men and women tattoo their bodies with various patterns that are also inscribed and embroidered onto *singa*, pretty material things including jewelry, mirrors, display calabashes, and clothing.

This richly embroidered *henaare* was created for a young man to wear during dance performances, such as those of the *worso* festival, a weeklong meeting of a Wodaabe clan held annually in the rainy season, usually between June and September (fig. 15). Over the course of *worso*, young men participate in various dances during which they compete for the attention of young women by showcasing their physical and performative beauty. The *gereewol* and *yaake* dances are considered the most important events of this community gathering and are the ones at which lavishly embroidered costumes feature

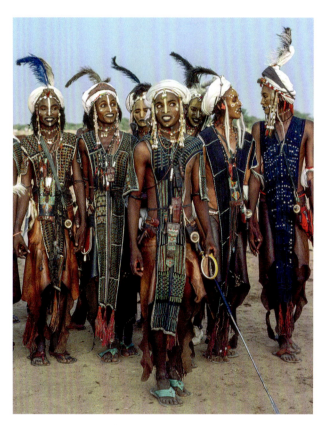

Fig. 15. Young men flashing their bright teeth and wearing *henaare*, feathered caps, and other festival attire to impress the female judges for the *gereewol* celebrations, Niger, 1993

most prominently. Both men and women may design and embroider such dance garments, although it is mostly women who practice the art.

Henaare generally employ the most narrowly woven bands created in West Africa. The body of this complex

WESTERN SAHEL 49

example is formed from four different handwoven textiles, all products of Hausa weavers in northern Nigeria, with widths ranging from three-quarters of an inch to two inches. Two have multicolored stripes of mill-spun yarns; the remaining two are composed of handspun indigo yarns. These fabrics were organized symmetrically and seamed along their selvages. Of particular interest is the panel added to one of the lower narrow ends, which was similarly formed with symmetrically arranged fabrics but turned ninety degrees so that the narrow bands run horizontally rather than vertically. The two epaulet-like projections extending the shoulder line are formed from a fifth fabric: a high thread-count, mill-woven, and indigo-dyed cotton.

This *henaare* was first assembled, then embroidered in bright mill-spun yarn, and subsequently finished with a white sawtooth border of cotton, also mill-woven, along the edges. The densely embroidered patterns were created with minuscule chain stitches; on the horizontal panel, the embroiderer also employed buttonhole stitches to create small eyelets. On garments like these, small and invariably symmetrical motifs are combined to create highly personalized compositions. These often mirror patterns tattooed onto the wearer's face and arms, thus marking the garment as an extension of the young man's body. Reproduced over the generations, such motifs appear on men's and women's festival wear alike. Their symbolism draws from aspects of daily life, such as winding roads, camps, evening stars, shepherds, and details of courtship. For instance, the conjoined cross patterning on the shoulder extensions of this costume refers to the rope with which Wodaabe livestock is bound. The embroidery was created without the aid of tensioning devices. The artisan's ability to achieve such dense, intricate patterning on such a loosely woven fabric—without the distortion of either—is a testament to her patient skill.

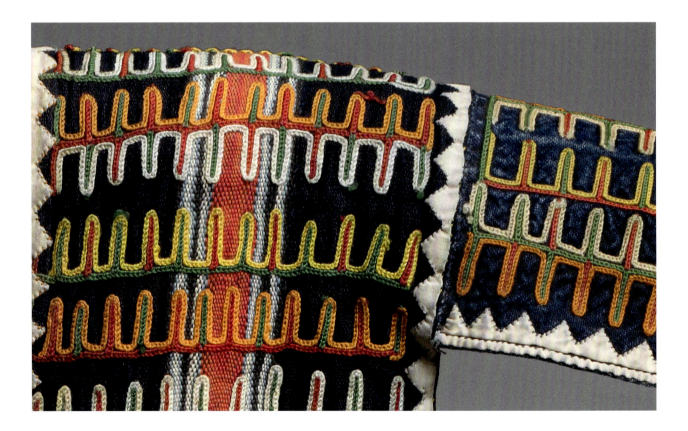

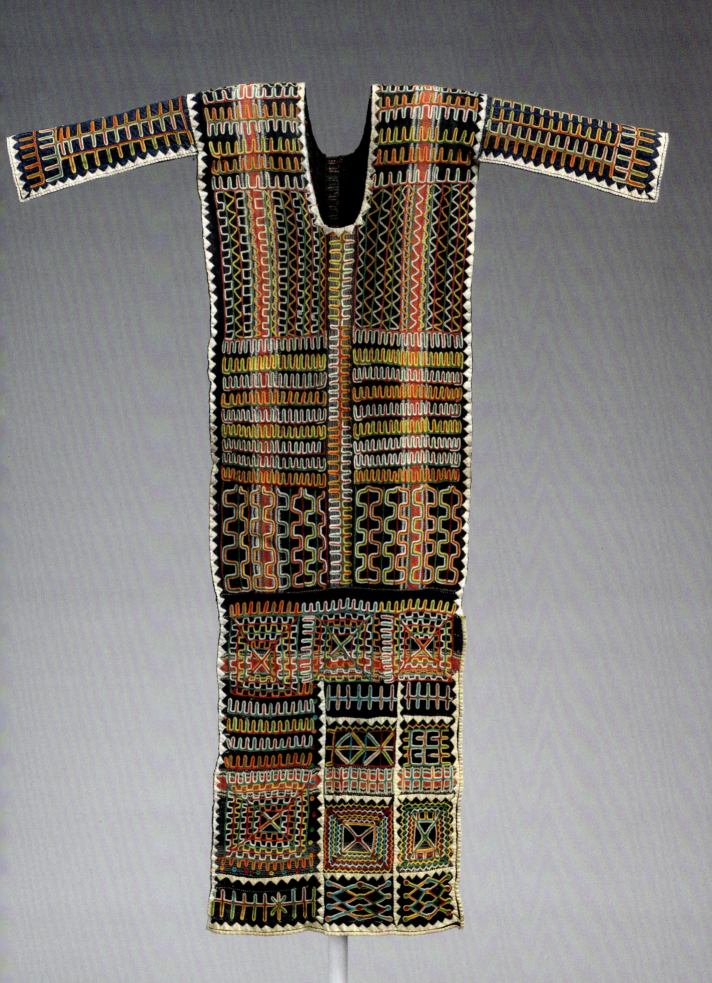

7

Sër-u-rabbal, or *sër-u-njaago* (woven wrapper)

Manjak artist
Senegal, 1960s
Cotton, dye, 48¾ × 73 in. (124 × 185.5 cm)
Gift of Dr. and Mrs. Pascal James Imperato, 2015 (2015.614.3)
Recorded provenance: Acquired by Pascal James and Eleanor M. Imperato in Dakar, Senegal, 1969; Pascal James and Eleanor M. Imperato, New York, 1969–2015

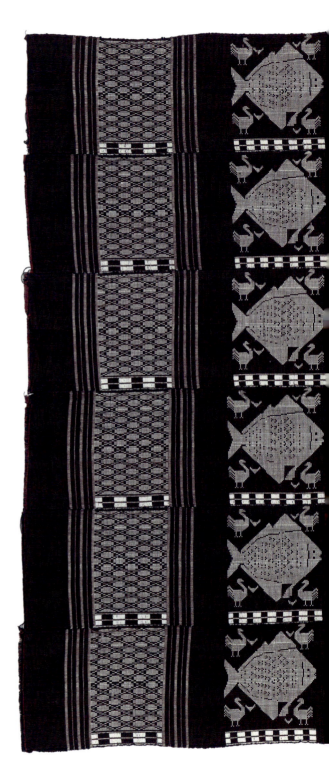

Manjak artists in Senegal produce some of the weavings most sought by local Wolof women, who value the sophistication of their designs. By the early colonial period, these women dominated the circulation of all types of cloth in the region, in part through their control over the spinning of cotton yarns used by Manjak weavers who were dependent on this product for their livelihood. Simultaneously, Wolof women were the primary consumers of locally and globally produced textiles, which served as tactile, visual forms of wealth and mediated important life events, including births, marriages, and deaths. Among these functions, *sër-u-rabbal* were conceived as protective shields that could be used to swaddle newborns, clothe the female body, and shroud the deceased—uses that underscore the continuities and connections between the living and the dead. These precious commodities were carefully guarded and were often passed down from mother to daughter as markers of maternal lineage.

Manjak weavers migrated to the Senegambia region by the eighteenth century, drawn by the economic prosperity connected to Portuguese trade. They brought with them a double-heddle loom fitted with a mechanism that allowed them to create complex supplementary-weft patterns. Their *sër-u-rabbal* creations are further distinguished by their thick weaves and dense patterning.

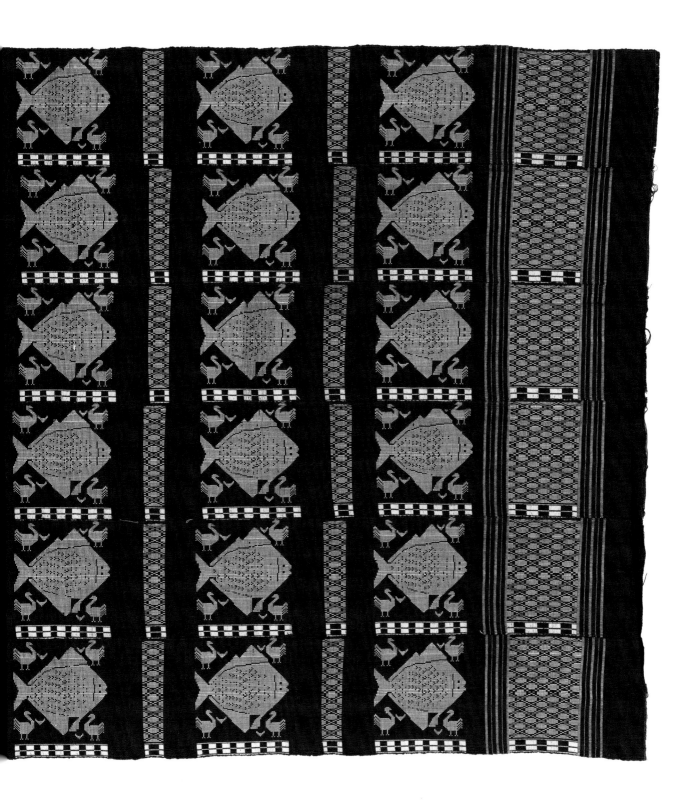

This design features a decorative geometric border at each warp end, which is filled with diamond-checkerboard patterns, capped with alternating stripes in the weft direction, and broken up by bicolored bands in the warp direction. Anchored between the borders, the central field is composed of a four-by-six grid divided by motifs that echo the border geometry. Within each grid block is a flat-bodied fish framed in the corners by four birds. The prominent inclusion of fish may allude to the trade and sustenance fishing on the Atlantic Ocean in which coastal communities engaged. Confronted, or facing, birds were and continue to be a ubiquitous decorative motif throughout the Mediterranean and western Asia. Accompanied by the small, boomerang-like element that aligns with their necks in three of the four iterations, such birds recall similar imagery found on textiles dating to as early as the fifth century.

This wrapper appears to have never been used. The warp ends remain sharp, as though they were recently cut from the loom. Two-ply, mill-spun cotton yarns are used for the warp and the weft. The closely set single warps alternate deep blue and burgundy, giving the cloth a shifting purple hue. These warps completely hide the tripled black wefts that create the plain-weave foundation. The continuous supplementary-weft patterning is created from white yarns, also tripled. Both

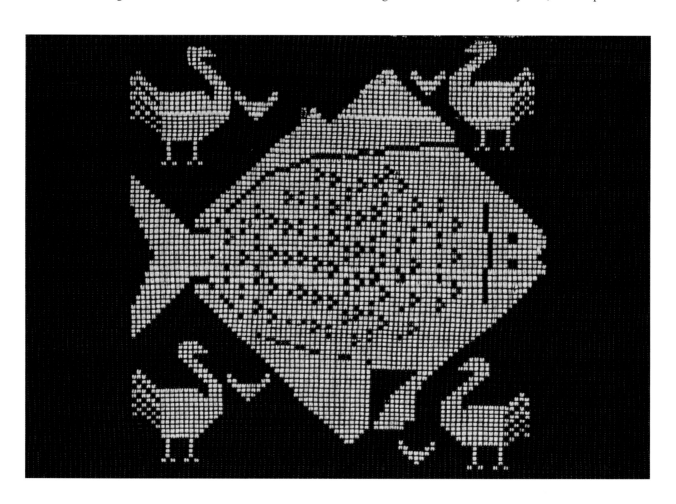

Fig. 16. *Sër-u-rabbal*, or *sër-u-njaago* (woven wrapper). Manjak artist. Kelequis, Republic of Guinea-Bissau, 1960s. Cotton, synthetic fiber, dye, 45¼ × 70 in. (114.9 × 177.8 cm). Purchase, The Fred and Rita Richman Foundation Gift, 2009 (2009.259)

the dense warp sett and the thickness of the tripled wefts contribute to the fabric's stiff feel and reinforce the protective associations of these textiles.

Sër-u-rabbal share many design and haptic similarities with the *panos d'obra* that were woven by enslaved artisans and their descendants in the nearby Cape Verde Islands during and after the era of Portuguese rule (1462–1975). Both are created by weavers who migrated or were forcibly relocated from Guinea-Bissau and formed distinct classes of artisans dependent on a wealthy ruling class. Within the Senegambian context, weavers may receive compensation not only through monetary payment but also by weaving additional lengths of fabric for their own use. An inventive example in The Met collection (fig. 16) was purchased from the wife of a weaver, who indicated that her husband had extended the warp of his commissions to leave a single extra band of each patterned fabric after it was cut. He repeated this process over six commissions, collecting the excess bands for his wife to sew into a vibrant "sampler" wrapper that highlights the range of designs he had mastered. Among his achievements is a distinctive crab motif, paralleling the aquatic imagery of this purple-and-white wrapper.

8
Stitch-resist indigo shawl or wrapper

Wolof artist
Senegal, early–mid-20th century
Cotton, dye, 55 × 98 in. (139.7 × 248.9 cm)
Purchase, William B. Goldstein Gift, 2016 (2016.723)
Recorded provenance: Acquired by Duncan Clarke in Ndiassane, Senegal, ca. 2001;
Duncan Clarke, London, ca. 2001–16

Lavishly patterned with rows of geometric motifs, Wolof stitch- or embroidered-resist fabrics were among the most prized possessions of *signares*, elite women in Saint-Louis, the historic capital of the French colony of Senegal and the capital of colonial French West Africa between 1895 and 1902. These elaborate, deeply dyed textiles proliferated between the late nineteenth and mid-twentieth centuries as wearable displays of wealth and status. Styled as wrappers and shawls, they were valued for their sharp detail and for the bold contrast between reserved white motifs and indigo-dyed ground. While coastal women were the most avid consumers of these garments, examples circulated throughout the Senegambia region as symbols of their owners' cultivated, urban refinement.

Resist-patterned, indigo-dyed fabrics have an enduring history throughout West Africa. Indigenous indigo-containing plants have long flourished in the region. Traditional plant-based indigo dyeing of cotton was once extensively practiced by female specialists in Soninke and Wolof communities, who dyed the fabrics in ceramic pots that were partially buried to offer stability and perhaps also to maintain a consistent temperature. An exception to this gendered division of labor exists in northern Nigeria, where well-organized and profitable indigo dyeing workshops are run by men. In Kano, indigo is dyed in more permanent clay pits, some reportedly more than five hundred years old.

Although the climate of West Africa is not conducive to the preservation of textiles, documentation exists for the production of indigo clothing, plain and patterned, since at least the eleventh century. An extensive cache of cotton fabrics was excavated between 1964 and 1971 from dry caves in central Mali. Dating to between the eleventh and eighteenth centuries, at least one of these archaeological examples gives evidence of a long history of resist-patterned, indigo-dyed cotton fabrics.

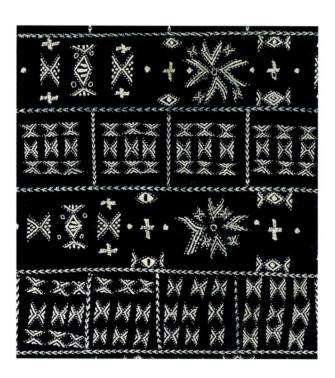

Resist-pattern dyeing is a method of ornamentation by which the absorption of dye on yarns or fabrics is selectively blocked by the application of substances such as wax or starch, or by different mechanical methods such as the binding or stitching of areas that are meant to remain undyed (as in this example). When the resist material is removed, it reveals a light or white pattern against the darker dyed ground. The resultant patterns can range from simple, rough circles with vague outlines, arranged in pleasing combinations, to finely detailed patterns achieved with precise, tiny stitches. Wolof artists' labor-intensive exactitude, coupled with the range of indigo shades that they achieved, rank their works among the highest examples of this art.

It has been widely reported that these artisans, like their Manjak counterparts (see no. 7), drew inspiration from motifs woven into *panos d'obra*, while more recent scholarship mentions additional inspiration drawn from Amazigh and North African designs. In this example, the patterned, mill-woven cotton foundation fabric adds texture to the deeply dyed cloth. Two panels were joined along their weft selvages to create the desired width. Before the fabrics were dyed, weft threads were removed from the cut ends, and the freed warp ends were then gathered into small groups, twisted, and plied into a delicate knotted fringe—a laborious and time-consuming task. Wolof artisans took design inspiration from narrow-band woven cloths by ordering their patterns in careful rows. Each warp end of this composition features a densely patterned border filled with alternating "stripes" composed of conjoined diamonds and stacked chevrons with a variety of striped, dotted, and nested fills. The field between these borders is populated with seventeen parallel bands, alternating darker and lighter. Those bands are filled with radiating geometric forms, including an exceptional twisting starlike motif with a contained yet mesmerizing energy.

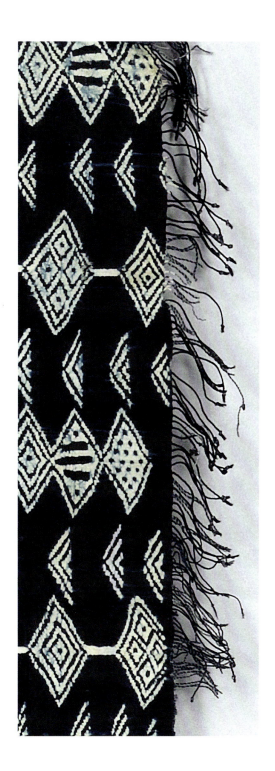

WESTERN SAHEL 57

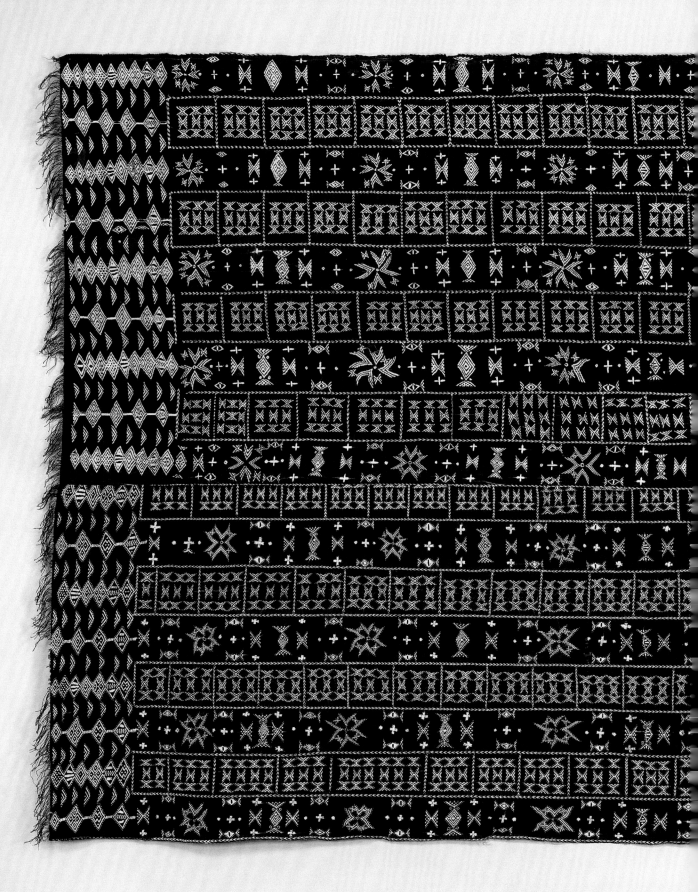

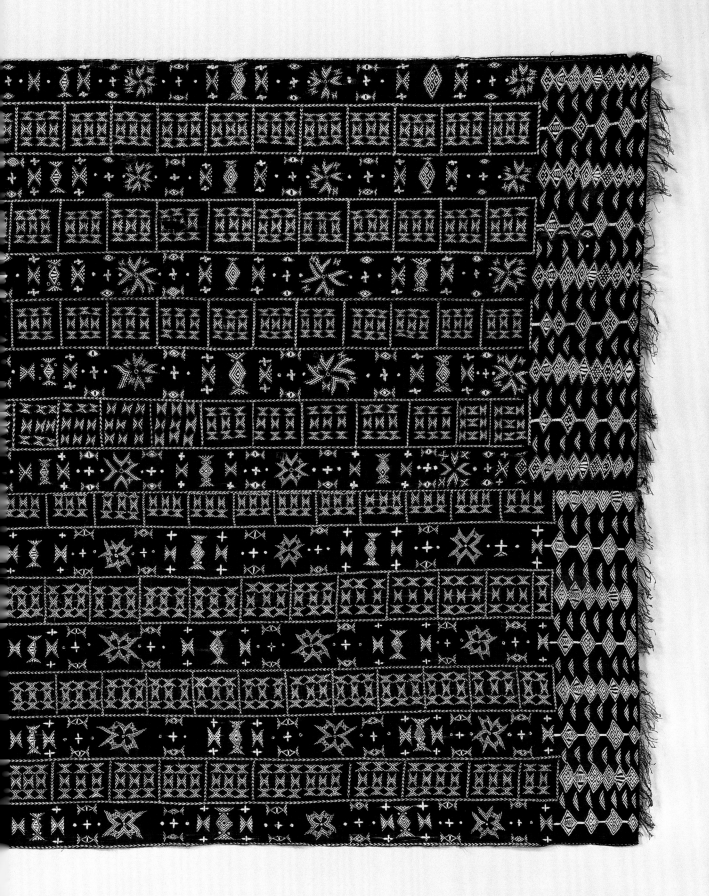

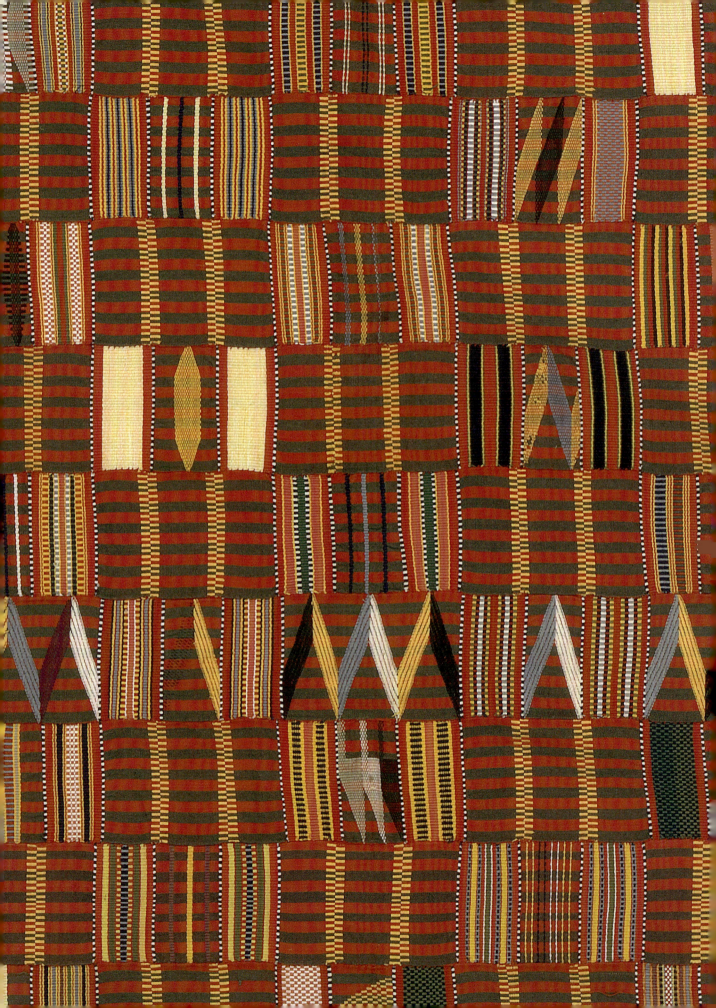

WEST AFRICAN COASTAL FORESTS

9
Kpɔikpɔi (prestige hanging)

Mende or Vai artist
Sierra Leone, early 20th century
Cotton, dye, 5 ft. 3 in. × 13 ft. 2 in. (160 × 401.3 cm)
Purchase, William B. Goldstein and Holly and David Ross Gifts, 2013 (2013.986)
Recorded provenance: Ulrike Montigel, Galerie Arabesque, Stuttgart, Germany;
Andres Moraga, Berkeley, CA; Clive Loveless, London;
Titi Halle, Cora Ginsburg LLC, New York, by 2013

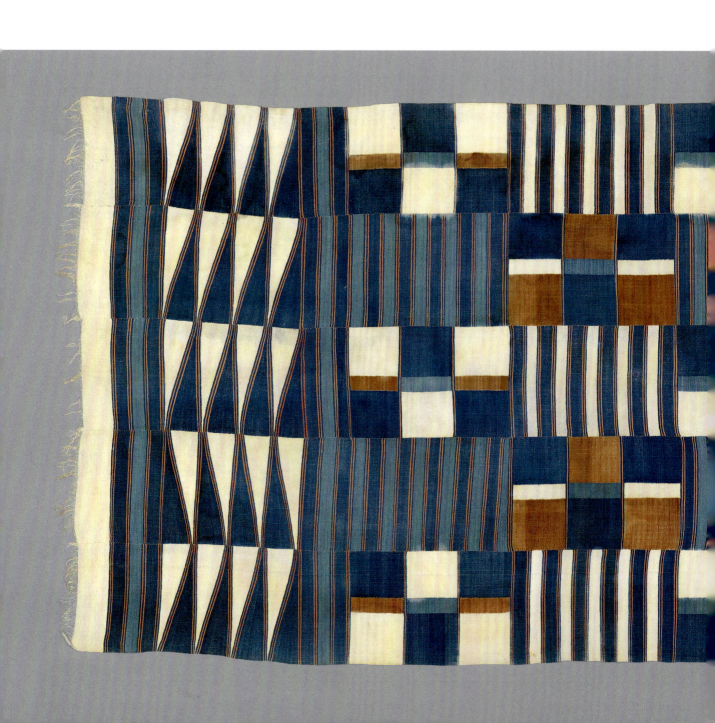

For many communities in present-day Sierra Leone, locally spun and woven cotton kɔndi-gulɛi ("country cloth") has mediated almost all aspects of daily life and special events. Native West African *Gossypium herbaceum* and introduced *Gossypium barbadense* cottons are farmed, harvested, and processed by local communities, although in smaller quantities now than in the past. In Sierra Leone, the average farmer may grow enough cotton for his personal country-cloth needs; wealthier farmers and elite families may grow and process additional cotton and produce excess cloth that they sell, gift, or save as heirlooms and funerary wealth. Farmers and their wives may both participate in harvesting the cotton, but the women are responsible for maintaining its range of natural hues, from a creamy white (*kwandei*) to a medium brown (*nduulu vandei*). Women are also responsible for spinning the fibers into yarn and dyeing the resulting product.

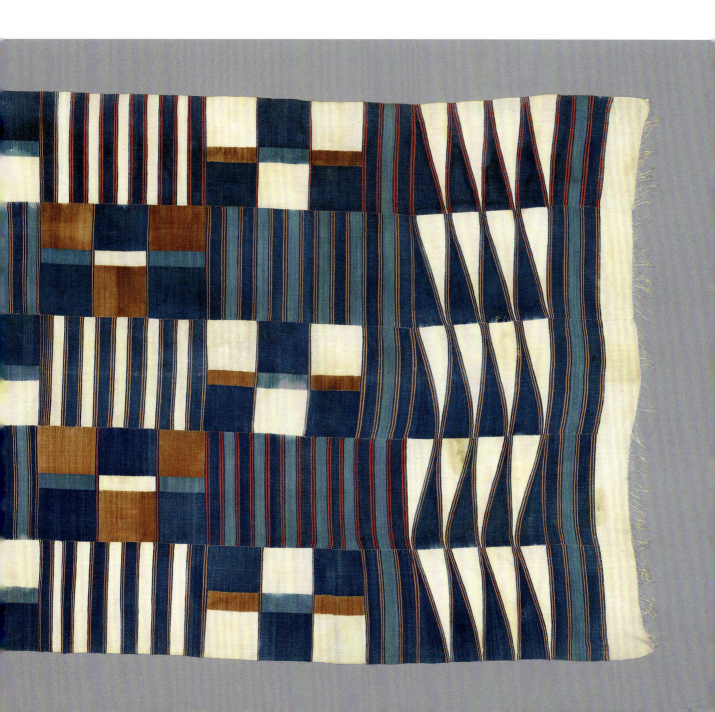

Weavers working on commission create both warp- and weft-face textiles from this yarn. The warp-face fabrics, sometimes patterned with blue or brown stripes, are worn as wrappers or cut and sewn into garments. Certain types act as medicinal and protective shields in the form of shirts and undershirts worn only by the most powerful members of a community. More elaborate and monumental cloths, woven with weft-face patterns, have been used to punctuate community celebrations of births, initiations, weddings, and deaths. The economic, social, and political value of kɔndi-gulɛi has translated to its use as a medium of exchange. Art historian Joanna Edwards's interviews with local chiefs, elders, and weavers in the 1980s highlight that kɔndi-gulɛi were historically used as payment for court fines and salaries, and continue to be used to solidify agreements or influence the outcome of arbitrations. The centuries-long histories of kɔndi-gulɛi mean that these local weavings can also serve as powerful bridges to the past. Elders within Mende and Vai communities collect these textiles with increasing frequency in the years leading up to their deaths. Buried with the deceased, kɔndi-gulɛi shepherd the transition from the realm of the living to that of the ancestors.

Large-scale and densely woven kpɔikpɔi are among the most prestigious textiles within the larger category of kɔndi-gulɛi. Such elaborately patterned weavings are commissioned by chiefs and other wealthy people to be hung as dramatic backdrops within their homes and during public celebrations (fig. 17). The cost of the handspun yarn needed to produce these sumptuous weavings means that they can be produced only by well-funded master weavers. Their monumental scale and powerful graphic quality are rivaled only by the wool textiles woven by Fulani *maabube* in the Niger Bend region. Like wool *arkilla* (see no. 4), kpɔikpɔi visually signal the transformation of an architectural space from everyday to ritual or celebratory use. This imposing thirteen-foot-long example features handspun and -dyed local cotton yarns alongside a red mill-spun cotton, which is sparingly used as an accent to separate larger motifs. Woven on a tripod loom (see fig. 5), the proportions and ordering of the different pattern blocks had to be carefully calculated to create such evenly matched lengths in the final product.

Neatly finished on both sides, this hanging has two identical faces. The design is composed of repeating blocks of stripes, rectangles, and triangles that resonate across the surface in a playful variation on the popular *ki gbembele* (checkerboard) pattern. The balanced composition at center is framed by a wide border of tessellated isosceles triangles in blue and white. The variations between the natural white and light brown hues of the cotton add further visual contrast. The cut warp ends of each band have been left unfinished to create a short fringe that is not further plied or knotted.

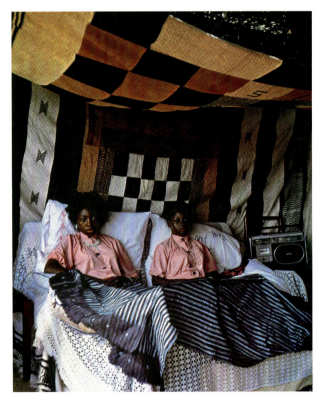

Fig. 17. Mende adolescents reclining in an enclosure draped with *kpɔikpɔi* cloths, marking the completion of their initiation into Sande society as adult women, Daru, Sierra Leone, 1980

10

Interior hanging

Mende, Vai, or Temne artist
Sierra Leone, early–mid-19th century
Cotton, wool, dye, 4 ft. 3 in. × 10 ft. (129.5 × 304.8 cm)
Rogers Fund, 1971 (1971.30)
Recorded provenance: Acquired by Joseph Upton in present-day Ghana, ca. 1870;
Joseph Upton, Salem, MA, ca. 1870–84; Annie Larrabee Upton (Mrs. Charles W. Rice), Salem, MA, 1884–1962;
Norman S. Rice, Albany, NY, 1962–71

Few textiles speak so readily to the wide circulation of people, technologies, designs, and commodities as this interior hanging. First documented in the 1870s along what was then the Gold Coast (present-day Ghana), it was purchased by Joseph Upton, a shipmaster and merchant for the Boston trading firm Roberts & Mansfield. While this geography might suggest it was made by Akan or Ewe artists, the hanging's dimensions, design format, weft-face structure, and use of thick handspun yarns make this attribution incredibly unlikely. Later analysis suggested a relationship with Fulani *maabube* weavings from the Niger Bend region, an idea further reinforced by the fact that the Akan were avid consumers of Fulani wool textiles. However, this attribution, too, raises questions due to the weaving's intrinsic qualities and choice of fiber. The fifteen bands from which this textile is composed are three and one-half inches wide, much narrower than those typically woven by *maabube* specialists, whose looms accommodate band widths of up to thirteen inches. Further, cotton is the primary fiber employed throughout the weaving. The highly skilled master weaver used small amounts of pink raveled wool, suggesting that those inclusions were harvested by deconstructing a dyed, imported cloth. The soft texture of the wool points to a European source rather than Macina sheep. The narrow widths, dense geometric patterning, supplementary-weft brocading, and use of handspun cotton yarns in this textile point instead to an attribution among the Mende, Vai, or Temne weavers of present-day Sierra Leone.

Likely a type of display cloth known as *kpɔikpɔi* (see no. 9), this horizontally oriented hanging would have been commissioned from a male weaver by a wealthy patron to embellish architectural and ceremonial spaces. The symmetrical design uses a typical color palette of white and beige cottons, three shades of indigo-dyed cotton, and the variegated pink raveled wool. The complex, balanced pattern relies on bilateral symmetry (across the horizontal and vertical axes), which is also found among other weft-face weavings from Sierra Leone. Encased between two wide, striped borders, the field is subdivided into nine rectangular units. The four corner blocks are filled with a checkerboard design, which predominates in many West African weavings and other creations. The central nine-part division of space is echoed in the center blocks of the upper and lower rows, where blue cross formations partition the rectangles into nine unequal sections. The remaining rectangles, woven

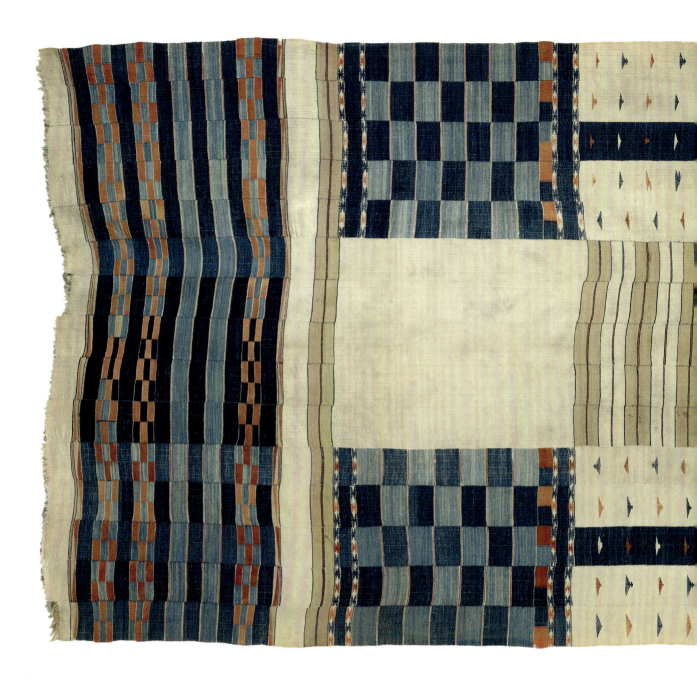

in lighter colors, create negative space between these dramatic framing elements.

This complex design was woven on a single warp measuring more than 150 feet in length, and conceptualizing and producing it required incredible skill and coordination. The almost perfect alignment of motifs may have been aided by a distinctive feature of the tripod loom (see fig. 5), which is still used in Sierra Leone today. Weaving with a tripod loom entails moving the tripod along the length of the warp as the weft is added, rather than the more common technology of rolling the fabric on a cloth beam. Instead, the weaver rolls the cloth after

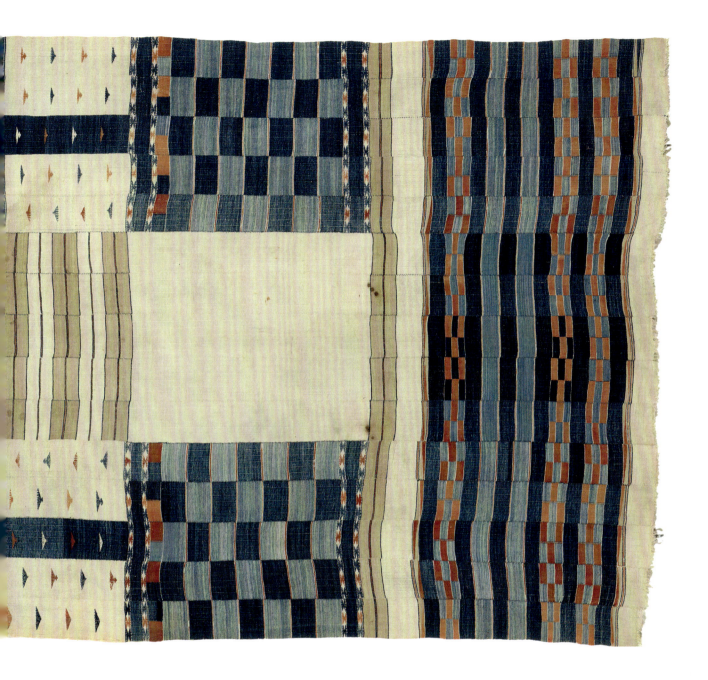

the desired portion of tensioned warp has been woven; this allows him to check the order, placement, and dimension of each motif as he works. In this example, a thick bundle of yarns appears between approximately every nine single warp yarns. A rare detail, these bundles are clearly used to align the smaller motifs in the weft direction. Such techniques only make it more astonishing that this elaborate pattern was created by a single weaver using simple measuring devices, his creativity, and his memory.

11

Donso duloki (hunter's shirt)

Mande *donso* (hunter)
Mali, early 20th century
Cotton, leather, animal bone and horn, cowrie shell,
unidentified plant and animal matter, dye, 29 × 28 in. (73.7 × 71.1 cm)
Gift of John B. Elliott through the Mercer Trust, 2000 (2000.160.57a, b)
Recorded provenance: John B. Elliott, Princeton, NJ, by 1997; the Mercer Trust, New York, 1997–2000

Donso hunters have stood apart in Mande-speaking communities as powerful, self-oriented men who commit themselves to an initiatory practice known as *donsoya*, during which they develop an impressive set of physical and supernatural skills by venturing into the wilderness beyond their towns. They serve as protectors and disruptors who are revered and feared in equal measure by their local communities. Their ambiguous status is highlighted during festivals, parades, and other social gatherings, when they dress in special shirts and caps often laden with an array of potent attachments, as in this example. When hunting they prefer simple, practical shirts and trousers that facilitate the quiet mobility necessary for stalking prey.

The foundation cloth of these loose-fitting festival garments is created from locally grown, spun, woven, and dyed cotton, which is considerably more expensive and symbolically laden than mill-woven cotton. This *duloki* is made from five bands five inches in width, which are seamed along their selvages, folded at the shoulder, and paired with two shaped underarm gussets that flare the shirt out toward the hem to allow a greater range of leg movement. A uniform mid- to dark-brown shade like this one is common, although surface patterning in the form of *bògòlan* motifs (see no. 3) may be present in other examples. Tailoring styles differ within *donso* communities: the garments exist in different lengths; some have a pocket centered over the chest; there are a variety of sleeve configurations, including sleeveless designs, as seen here.

The twisting leather tentacles that bristle across the surface of this cotton tunic are imbued with powerful protective forces that underscore the formidable abilities of its *donso* hunter-warrior creator. That electric dynamism is reinforced by the owner's additions of different kinds of attachments. First among these are leather amulets containing charms or potent ingredients, which may be bestowed by teachers upon the initiate. As the hunter gains prowess, essential relics of the hunt—such as horns, beaks, bone, teeth, and claws—are added as visible declarations of his success. Other attachments signify the acquisition of *daliluw* (useful bits of knowledge) about flora and fauna. Such knowledge may be gained through consultation with more senior hunters, sustained study of medicinal plants, or the hunting and killing of animals.

The layered and often wildly accretive surfaces of these garments simultaneously serve to proclaim the hunter's expertise and protect him from malevolent energies. They visually articulate his experiences and how he has exerted control over the unpredictable wilderness. The creator of this *duloki* stressed his ability to make order from disorder by symmetrically arranging his additions. That emphasis on order is further reinforced by the gridded geometry of the *hatumere* motifs impressed into the rectangular packets. Such designs draw upon religious knowledge to align the wearer numerically and geometrically with esoteric forces.

Materiality-driven research among Mande *donso* associations in Burkina Faso was initiated in the 2010s by visual anthropologist Lorenzo Ferrarini, who sought to understand *donso* practices by studying the simpler shirts worn by hunters when they enter the wilderness, rather than the more elaborate ceremonial garments. His research highlights that while some hunters continue to wear the more formal embellished tunics at festivals and social gatherings as a signifier of their elevated status,

68 WEST AFRICAN COASTAL FORESTS

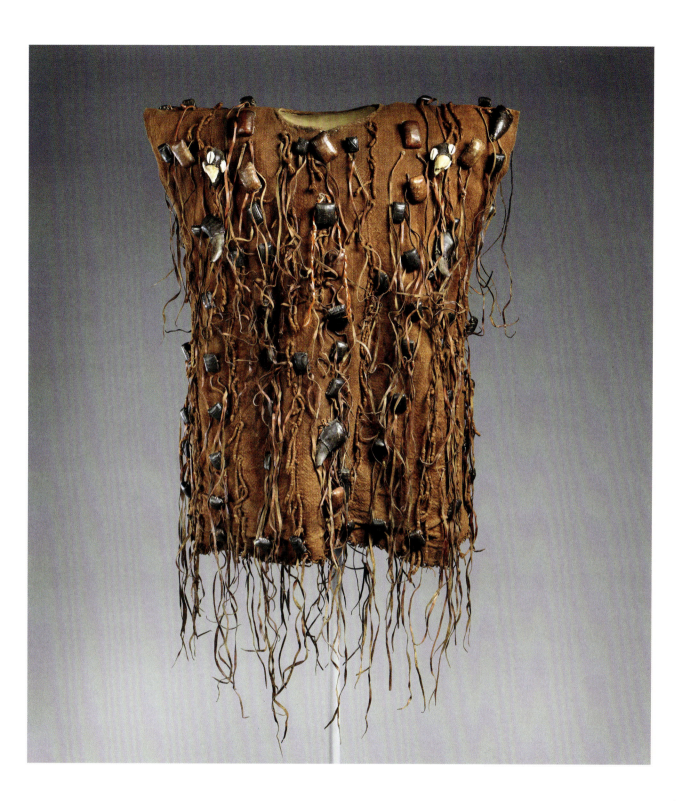

others reject such overt displays of power. They wear comparatively plain ceremonial shirts that mirror their work attire—thoroughly softened, abraded, sweat- and blood-soaked—with fewer, but extremely powerful, amulets, the most potent of which are likely to be hidden from view. These simpler *duloki* place a greater emphasis on the quiet but deadly powers harnessed by *donso* hunters.

12

Wrapper

Mossi, Maranse, or Marka artist(s)
Burkina Faso, mid–late 20th century
Cotton, dye, 42½ × 63¼ in. (108 × 160.7 cm)
Gift of Eve Glasberg and Amyas Naegele, 2013 (2013.1140.13)
Recorded provenance: Arouna Ndam, Foumban, Cameroon, by 2010; Amyas Naegele, New York, 2010–13

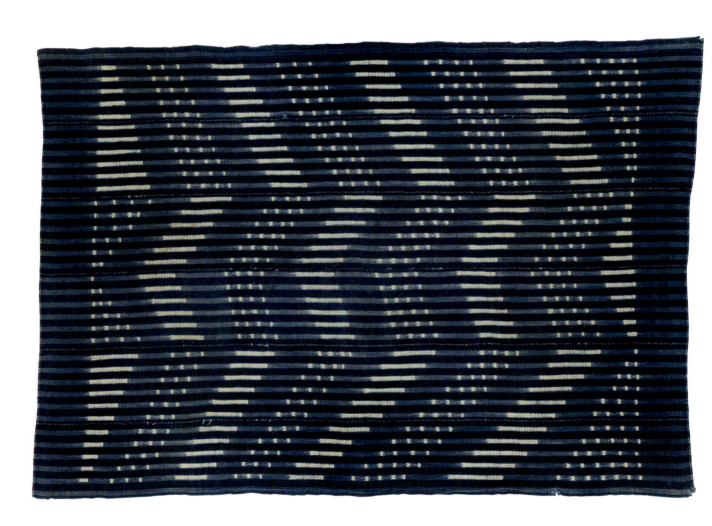

Wrapped around the waist, handwoven and indigo-dyed textiles serve as prestige items purchased by and gifted to women living along the upper reaches of the Volta River. While simpler versions might be worn as part of daily attire, women don finer examples embellished with linear and geometric patterning during important occasions, including births, marriages, harvest celebrations, and initiation ceremonies. Such highly valued garments are carefully stored when not in use. They can be passed down from mother to daughter over several generations, accumulating as important treasuries linking contemporary women with their maternal forebears.

This midcentury example features six warp-face bands seven inches in width, made from handspun and handwoven cotton. To weave each of these bands, the warp was set up with thirteen alternating stripes of white and indigo-dyed yarns and woven with a white weft. Counting across the cut-and-stitched bands reveals that their corresponding stripes contain the same number of warp yarns, suggesting that the wrapper was created from a single warp length. This probability is most clearly evidenced by comparing the two terminal indigo stripes along the weft selvages of each band—one has approximately half the number of warps as the other. After weaving, the striped cloth was rolled in the traditional manner and sold or passed on to other specialists for further elaboration.

Although narrow-band fabrics can be tie-and-dye patterned before being assembled into cloth, this wrapper must have been assembled before the patterns were added. The bands were cut into equal lengths and stitched together along their weft selvages. Rather being used to create a fringe, the warp ends were folded twice and stitched down. The white patterns were created by needle stitching and wrapping thick yarns around the warps of the thin white stripes. After this process was complete,

the entire cloth was overdyed in an indigo bath. In places where the fabric was stitched and wrapped tightly, the dye was unable to penetrate the white fibers. The resulting pattern, viewed horizontally as it would have been worn, consists of elongated zigzags composed of white dots and dashes across a ground of dark- and medium-blue striped cloth. The repetition and staggering of the pattern within this thoughtfully spaced composition creates an almost hypnotic oscillating effect, paralleling the rhythmic performances at which the wrapper might have been worn.

For at least a millennium, specialists have undertaken various types of indigo resist dyeing. At the time this garment was created, it is likely that synthetic indigo was the dye of choice, as it is less costly and time-consuming to produce than cultivated indigo. In West Africa several indigo-containing plants were known and exploited: *Philenoptera cyanescens*, an indigenous plant, and various *Indigofera* species thought to be introduced through trade. The natural product, extracted by crushing and fermenting the plant leaves, and the factory-synthesized version, introduced to the market in 1897, are members of the class of dyestuffs termed vat dyes. Chemically, both versions of the colorant are indistinguishable, although the plant-based product also carries compounds from other natural materials that may be identified during scientific analysis.

Women wearing similarly patterned indigo-dyed wrappers can be seen in relatively recent photographs from north-central Burkina Faso, but field research concerning the sociocultural significance of this type of cloth and the practitioners of indigo dyeing in this region is lacking. While some sources indicate that women dyers are the primary producers of regional indigo-dyed cloths, others have found evidence that men are now increasingly involved in pot dyeing in the Upper Volta region.

13

Man's wrapper

Dida artist
Southwestern Côte d'Ivoire, ca. 1900
Raffia palm fiber (possibly *Raphia vinifera*), dye,
62 × 76 in. (157.5 × 193 cm)
Purchase, William B. Goldstein Gift, 2009
(2009.308.1)
Recorded provenance: Bua Sylla, New York, by 2005;
David M. Lantz, New York, 2005–9

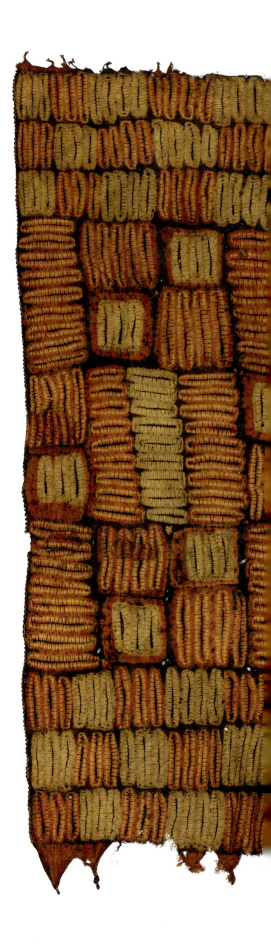

Hand-plaited into a single piece of fabric, this densely patterned raffia-fiber wrapper was produced by a female Dida weaving and dyeing expert probably living in the coastal Gôh-Djiboua District of Côte d'Ivoire. She undertook every stage of its preparation and construction, from setting up and hand-interlacing the raffia strands to tying and dyeing the organic motifs. While some Dida raffia-plaiting specialists also harvested, cleaned, and separated the raffia leaflets to obtain the fibers, others outsourced this delicate task, which required a light and dexterous touch, to children. The resulting stiff fabrics were worn as prestigious garments that attested to the social position of the wearers' families within their communities. Large-format cloths like this example were worn by men, who wrapped them around the body with the loose end draped over the left shoulder. Women donned similarly patterned garments that were cut and sewn into shirts or plaited into seamless tubular shapes and worn as a skirt bound with the help of a waistband (fig. 18). Such vibrant textiles were featured during major social events, including weddings, births, and the funerals of important individuals. They were also valued gifts marking important life events and could serve as compensation when settling disputes. Once acquired, these tactile, alluring garments were carefully maintained and passed down through generations as heirlooms.

 The fabric structure of Dida raffia cloth is distinct from other textiles produced in the this region. The Dida weaver does not use auxiliary devices to create tension on the individual raffia strands—instead, after tying the prepared strands to a stable support, she uses her hands and

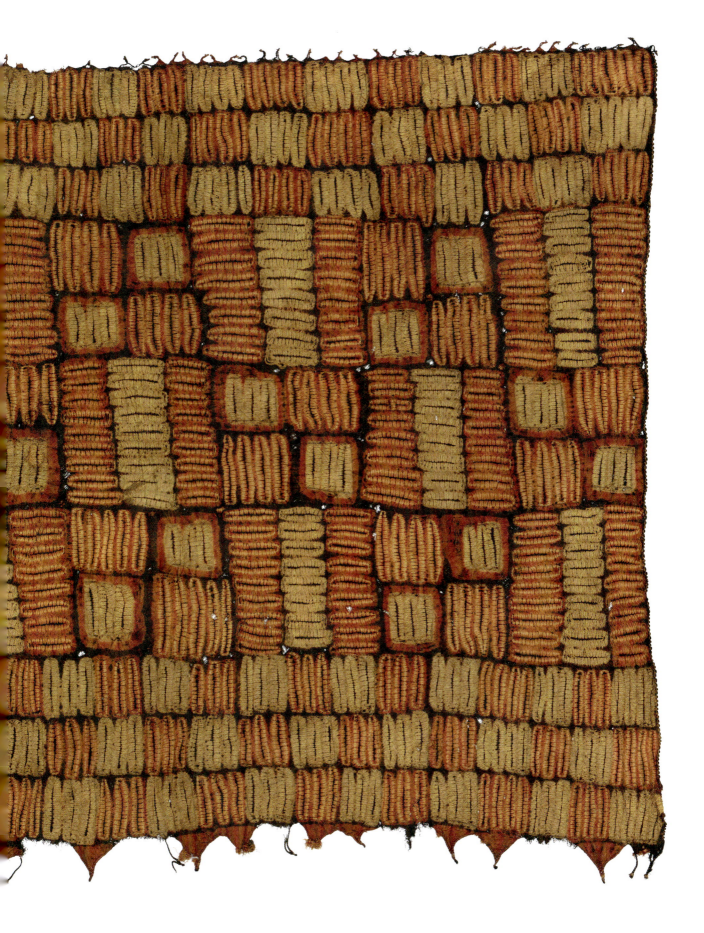

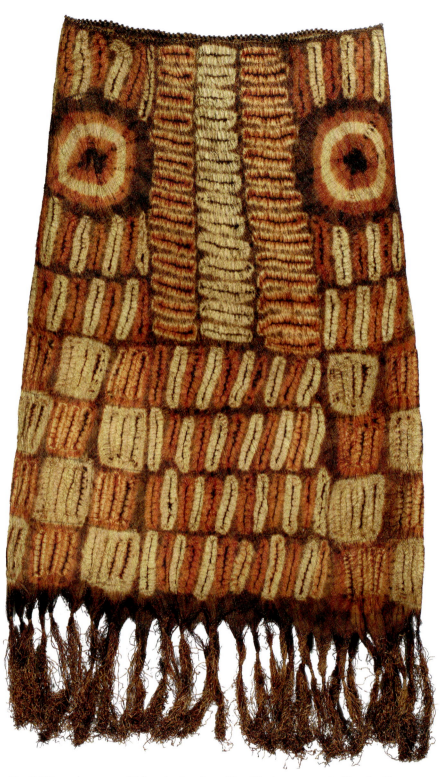

Fig. 18. Woman's garment. Dida artist. Southern Côte d'Ivoire, ca. 1900. Raffia palm fiber (possibly *Raphia vinifera*), dye, 43 × 28 in. (109.2 × 71.1 cm). Purchase, William B. Goldstein Gift, 2009 (2009.308.2)

feet to provide tension as she plaits them in an under-over sequence (fig. 19). To keep the odd and even strands separated from each other, she uses a simple string heddle, which holds one set of threads. Once the cloth has reached the desired dimensions, the edges can be secured using different tying-off and knotting techniques. The refined and secure binding of this example was created by carefully twisting and cording the edges to form irregular triangle shapes that are knotted at the lowest point. The prominent larger triangles mark the bottom of the garment.

The tricolored surface patterns were added to the finished fabric by first gathering, pleating, and tightly binding the cloth according to a planned design. The parts of the design that were to remain the color of the yellow-tan foundation fabric were bound, and the fabric was then dipped in a red-brown dye. The parts that were to remain red-brown were then similarly bound, and the cloth was dipped in a black dye. Once the dyeing was complete, the bindings were removed to reveal the elaborate checkerboard patterning of oblong and ovoid shapes. Unlike cotton fabrics, the stiff raffia maintains the peaks and valleys created by the tight stitching of the patterning process. This sharp three-dimensional surface was usually pressed out from the finished garment. Wearers often lined the raffia cloths with cotton to protect their skin from the stiff fibers.

While these valuable heirlooms were widely produced in the late nineteenth and early twentieth centuries, published reports from the 1970s and 1990s indicate that it was difficult to find women who could make plaited raffia garments or fully explain the techniques involved in their construction. In recent years, however, there has been a renewed interest in this vibrant tie-and-dye aesthetic among Dida communities. While the fabric structure of the contemporary versions appears distinct from the earlier examples, public social media posts feature celebratory attire with similar patterning, attesting to the continued salience of this historic tradition among communities in southern Côte d'Ivoire.

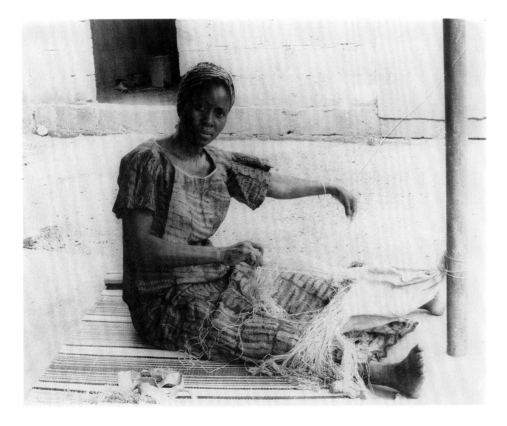

Fig. 19. Artist Rebecca Legah hand-plaiting a tubular raffia skirt while wearing examples of Dida tie-and-dye textiles, Divo, Côte d'Ivoire, ca. 1978

14

Man's wrapper

Abron, Kulango, or Dyula artist
Bondoukou region, Côte d'Ivoire, early 20th century
Cotton, dye, 5 ft. 6 in. × 9 ft. 4 in. (167.6 × 284.5 cm)
Purchase, Gift of Ernst Anspach, by exchange, 2007 (2007.388)
Provenance: Acquired by Duncan Clarke in Sampa, Ghana, 2006; Duncan Clarke, London, 2006–7

This vibrant wrapper, populated with representational and abstract motifs on a bright-yellow ground, was acquired near Bondoukou, a historic weaving and trading entrepôt since at least the seventeenth century. Contemporary art historical scholarship variously references Bondoukou weavings as a source and a product of regional textile traditions—simultaneously inspiring and drawing inspiration from Asante, Ewe, Baule, Fulani, and Dyula textiles that were traded through this commercial center. Indeed, one Asante oral tradition credits the introduction of the narrow-band treadle loom to a man named Ota Kraban, who traveled to the Bondoukou region and returned to his town of Bonwire with the new technology. Bondoukou weavers are also "cited as the source of simple blue and white warp-striped fabrics called *kyekye* that were highly prized by the Asante" and other neighboring groups. The trade at Bondoukou connected Ivory and Gold Coast communities with other important textile production centers farther north and west.

That interconnected history is evident in the techniques and materials employed in the creation of this wrapper. It was woven entirely of fine mill-spun cotton yarns. The twenty-two narrow warp-face bands that make up the ground are patterned with both a multicolored weft-face structure and with a handpicked supplementary-weft float structure. The specific combination of mill-spun yarns and weaving structures that rely on two sets of double heddles in this wrapper suggests a close relationship to the weaving traditions of the Asante and Ewe in present-day Ghana and Togo. However, unlike the more rhythmic, methodical organization of Asante and Ewe kente (see nos. 16, 17), this cloth juxtaposes repetition with spontaneity. The border patterning on each fringed end is composed of three rows of weft-face pattern blocks that alternate with two rows of discontinuous supplementary-weft pattern blocks. The five-by-twenty-two grid these columns of blocks constitute roughly follows bilateral symmetry, with the designs mirrored across a vertical axis. Careful study of the individual blocks, however, will reveal slight shifts in the orientation of particular colors and forms. For instance, comparing the left and right sides of the cloth, the grid

patterns in the blocks ten rows from the bottom vary the placement and number of red, green, and white squares.

The weaver further upset the garment's symmetry in the organization of the central design. The field is heavily weighted along the lower edge with two six-by-six patterned grids that are bordered at bottom by two terminal bands featuring undulating designs and more patterned blocks. Four differently sized reptilian creatures variably occupy the wide center space defined by two discontinuous blue "columns." The irregularity of the design is further exaggerated by the fact that the upper selvage is missing at least two bands that would have extended the patterning. In the remaining format, there are fewer blocks woven across the upper edge of the textile, and this less dense patterning creates an airy feel that is punctuated by the inclusion of small avian and reptilian forms. The overall effect is a dynamic interplay between balance and whimsy, similar to that employed on some Baule textiles (see no. 15).

This unique composition has only one other recorded corollary, a twenty-four-band, red-ground textile also acquired by art historian Duncan Clarke in northwestern Ghana near Bondoukou. While these two isolated examples display a comparable asymmetry, Clarke has discussed their relationship to a broader genre of blue-and-white wrappers also woven in this region. These "Bondoukou-style" wrappers have two distinct structural and aesthetic characteristics: a solid-colored foundation with minimal white (which generally appears in the selvage warps), and the presence of very narrow, weft-face rectangular motifs that span the height of the cloth in parallel or offset arrangements. Such strategies are also employed on this wrapper, which features a solid yellow foundation and narrow blue weft-face rectangles that appear in four aligned but discontinuous columns.

WEST AFRICAN COASTAL FORESTS 77

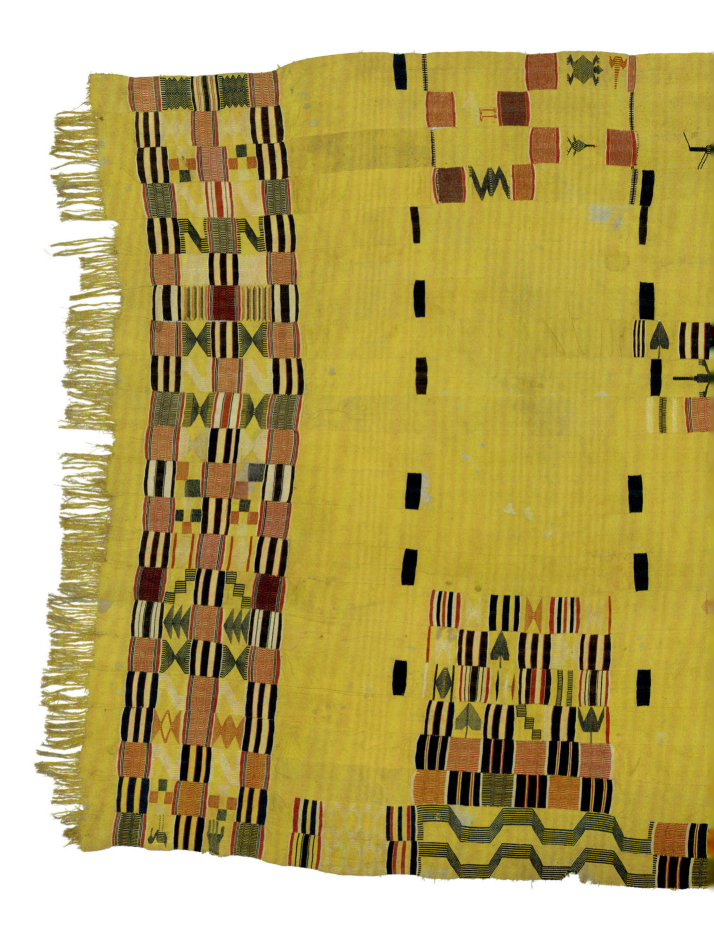

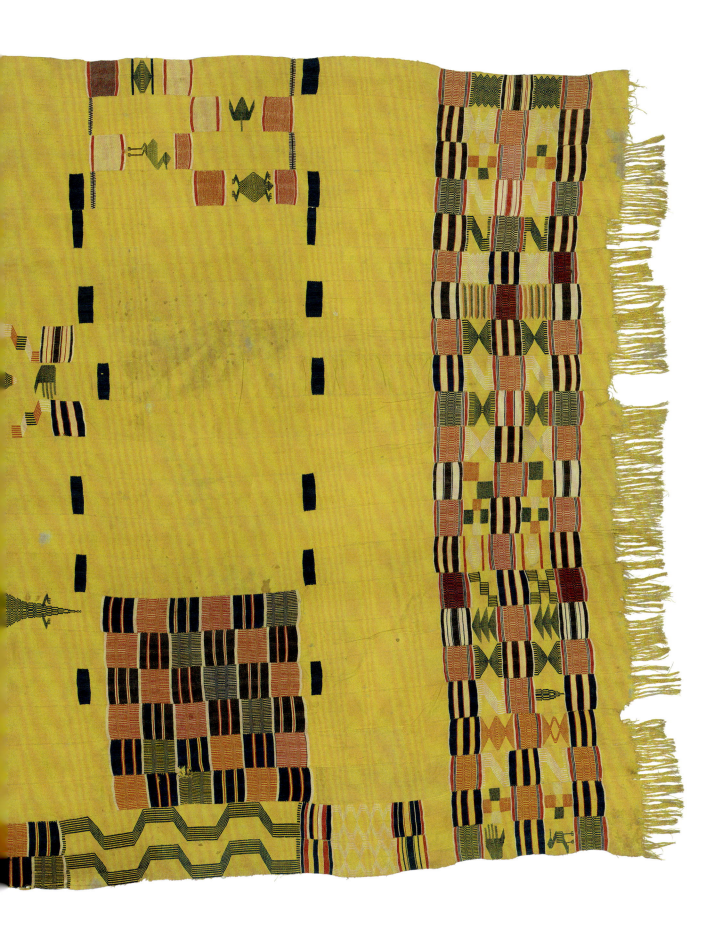

WEST AFRICAN COASTAL FORESTS

15

Man's prestige wrapper

Baule or Dyula artists
Côte d'Ivoire, ca. 1980–90
Cotton, dye, 62 × 96 in. (157.5 × 243.8 cm)
Gift of Jerome Vogel, 2013 (2013.1094.1)
Recorded provenance: Acquired by Jerome Vogel in Ouassou, Côte d'Ivoire, late 1980s or early 1990s; Jerome Vogel, New York, ca. 1990–2013

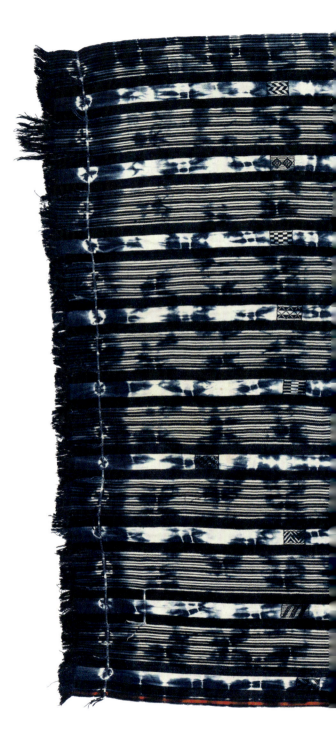

This luxurious and complex textile rewards sustained viewing. A first look will reveal the competing woven and dyed patterns. The foundation fabric comprises two alternating sets of warp-face bands that are three and one-half inches wide. One set is composed of narrow blue and white stripes and the other centers a wide white stripe between two indigo stripes. Layered over these is an impressionistic latticework design created from fold-and-dye techniques. Closer observation draws the eye to the subtle details of the garment. Centered along each of the wide white stripes are woven rectangular motifs. Each stripe carries its own distinctive geometric motif. In most of the stripes, these motifs repeat at four regular intervals, and their alignment creates four patterned columns running down the textile. This regularity of spacing is broken in two places: on the fourth and eighth white stripes (counting from the bottom). On the eighth, the weaver added a fifth instance of the rectangular motif slightly left of center. The fourth also contains five repeats of its motif, which are regularly spaced, but the entire band has been shifted so that the rectangles no longer align with the columns created by the other bands. The carefully measured visuals, and their punctuation by variable elements, simultaneously imbue the work with spontaneity and order. This balanced asymmetry is a core feature of Baule arts, which emphasize a contained yet playful harmony.

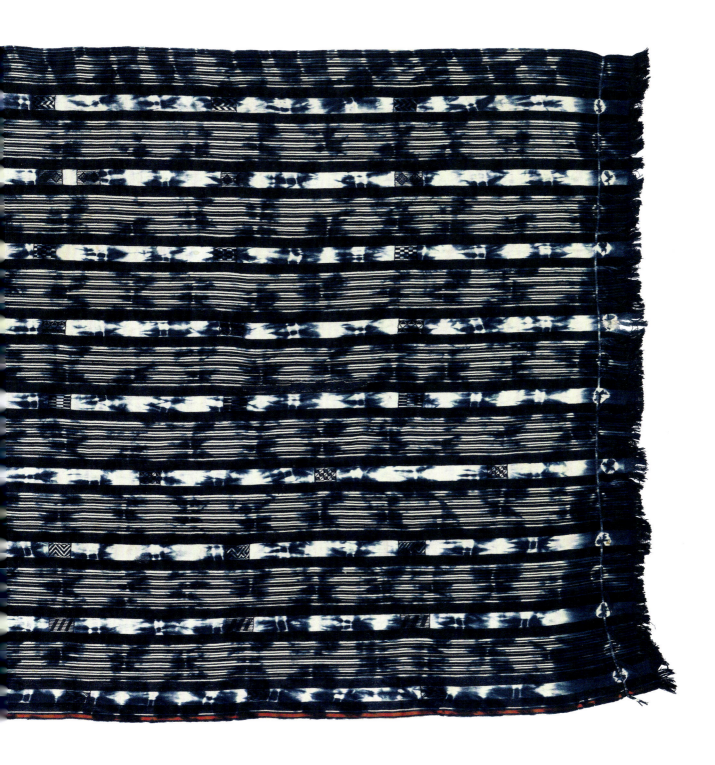

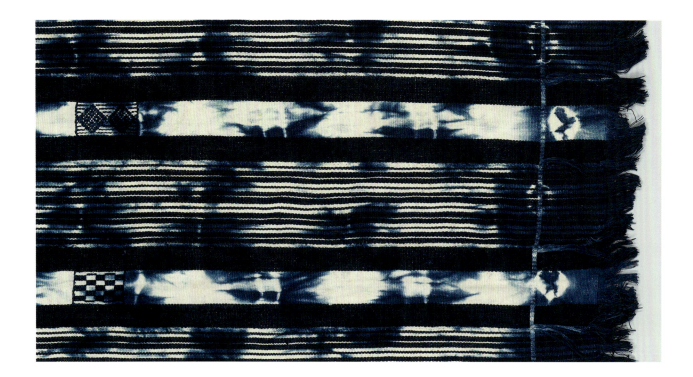

Complementing the layered aesthetics is an equally complex process of creation. The wrapper is woven with three warp sets. Two of these account for the majority of the bands. The terminal band at bottom replaces some of the white warp yarns with red yarns, which reveals that it was formed from a third warp set. All three sets use a combination of handspun, indigo-dyed yarns and refined mill-produced white and red yarns. The fuzzy indigo yarns and the smooth red and white yarns reflect light differently, creating subtle visual and textural variations. The geometric motifs were handpicked using handspun indigo yarn in a discontinuous supplementary-weft float structure—a time-consuming process that required intense concentration. The space for these motifs is set up and finished by a twined weft that roughly groups together the warp threads needed for the float patterns. The start and finish of each band is also emphasized by a twined finish across the weft. When the eighteen narrow bands were seamed together, the free ends of the twining were brought toward one face of the textile, then twisted and tied into tassels. Small tied bindings were added near the fringes to create the column of dots along the border. Finally, the cloth was folded according to a predetermined set of steps and secured into a bundle that was repeatedly dipped into an indigo bath to create the overdyed patterns.

This garment would have been worn by a man, wrapped around his body with the red stripe marking the bottom of the garment. Textiles have served as important markers of status among the Baule, who eagerly acquired locally and regionally produced cloth. Baule weavers thus took inspiration from a range of sources to reflect the changing demands of their consumers. The linear format and distinctive blocks of geometric patterning closely relate to kente textiles produced by the Akan (see no. 16), from whom many Baule communities claim ancestry. Weavers began integrating tie-and-dye patterning in the 1950s and 1960s, when they learned the techniques from Dyula weavers and merchants who had immigrated to the region. This synthesis of different traditions exemplifies how the exchange of craft habits in converging communities can bring about inspired creativity.

16

Royal man's kente (prestige cloth)

Asante-Akan artist
Bonwire, Ghana, ca. 1910–40
Silk, dye, 6 ft. 8¼ in. × 10 ft. 7½ in. (203.8 × 323.9 cm)
Purchase, William B. Goldstein, MD, Gift, and Julie Jason, Ilona Eken, and Leila Laoun Gift, 2023 (2023.329)
Recorded provenance: Baba Mahama, Accra, Ghana, by ca. 2002; Federico Carmignani Collection, Rome, ca. 2002–22; Kloman Art via Apice Fine Art Shippers, 2022

Kente are local handwoven textiles worn in Ghana and Togo, as well as among African descendant communities on special occasions. Among the Akan and Ewe, men wear a large-format version wrapped and rolled voluminously around the body, the loose end crossing over the chest and draping over the left shoulder. Women have more choice in draping formats and can combine the garment with other clothing. Traditionally, they wear a smaller version that is draped and rolled under the arms; a second wrapper may be added around the shoulders. Kente can also be used to ornament and section architectural space. In the highly elaborate Asante and Fante investiture ceremonies, kente cloths are not only worn by participants, but also used as coverings for furniture and chiefly conveyances. Within these Akan communities, early versions of kente were produced exclusively for the *asantehene*, or premier monarch. By the twentieth century, however, kente textiles and their aesthetics were widely embraced by individuals throughout Ghana, Togo, and their diasporas as symbols of enduring cultural heritage. In those contexts, kente serve as "precious treasures given on significant occasions and hopefully passed down from mother to daughter, uncle to nephew, father to son."

Kente are widely recognizable by their brightly colored checkerboard format of rectangular blocks woven with fine mill-spun yarns of cotton, rayon, and/or silk. They feature combinations of different woven structures, which can range in complexity from plain-weave, warp-striped blocks known as *ahwepan* to the more elaborate *asasia* structure, both present in this example. The intricate supplementary patterns of *asasia* are woven with an additional set of double heddles that gathers groups of six or eight consecutive warps into odd and even groups to facilitate the making of the handpicked, discontinuous-weft float patterns that hover above the warp stripes. The second heddle set also makes possible the weft-face blocks that conceal the foundation. Certain kinds of twill patterning may require a third set of heddles.

This silk kente is likely to have been commissioned by the *asantehene* for a high-ranking member of his family. The prestige of royal patronage is reinforced by its exclusive use of imported silk as well as the narrow multicolored stripes running along each edge of the twenty-four bands that constitute the kente. These stripes, with colors arranged in a red-yellow-red-green-red-yellow order, follow a pattern known as *Ammere Oyokoman*, after the ruling Oyoko clan. Applied exclusively to royal weavings, *Ammere Oyokoman* is credited as the first pattern created by the fabled progenitor of Akan weaving, Ota Kraban. This kente was never photographed in use, but similar versions were worn by Asantehene Prempeh II (fig. 20).

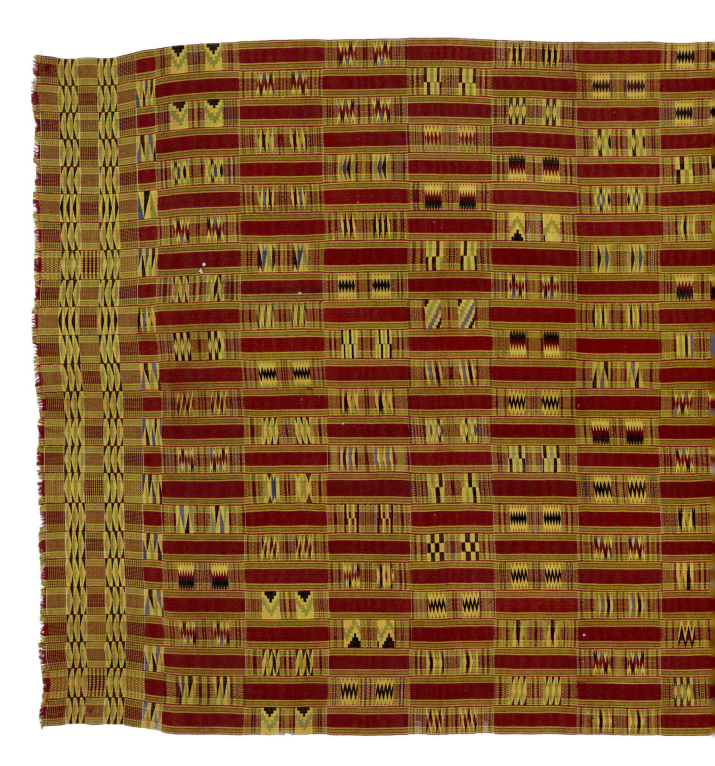

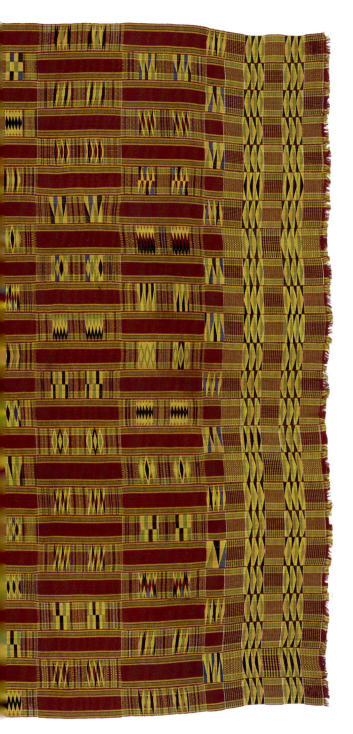

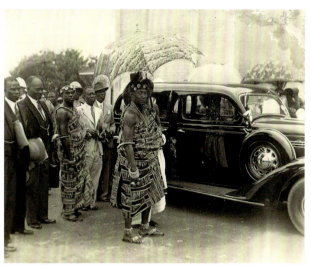

Fig. 20. Asantehene Prempeh II wearing a kente with the *Ammere Oyokoman* pattern, Accra, Ghana, ca. 1930s

While there is ongoing debate over the origins and preeminence of Akan weaving centers, oral histories relate that the knowledge and technology employed in the weaving of such refined textiles were traditionally maintained by a single family in the town of Bonwire, just outside the Asante kingdom's capital of Kumasi. Since the seventeenth century, Bonwire has been designated as a royal weaving center overseen by the *asantehene* and his family. While Bonwire remains a focus of royal patronage, more than forty towns and villages throughout this region are also known for textile production. Indeed, members of Akan communities have voraciously consumed textiles from across the globe, importing handwoven textiles from regional trading entrepôts such as Bondoukou and Kong as well as from more distant centers in the Niger Delta, Europe, and beyond. While these imported textiles also served important roles within and beyond the *asantehene*'s court, kente remain among the most salient symbols of Akan cultural heritage today.

17

Man's kente (prestige cloth)

Ewe artist
Ghana, ca. 1930–50
Cotton, silk, dye, 6 ft. 1 in. × 10 ft. (185.4 × 304.8 cm)
Purchase, Mariana and Ray Herrmann Gift, 2010 (2010.555)
Recorded provenance: Acquired by Musa Susoho in the Volta region of Ghana, by 2006;
purchased by Duncan Clarke in Kumasi, Ghana, 2006; Duncan Clarke, London, 2006–10

Ewe communities of present-day Ghana and Togo are responsible for the weaving of large-format, geometrically patterned kente. The expertise of these weavers is evident in their development of innovative figurative motifs and richly varied color palettes. Using mill-spun and -dyed yarns, they create juxtapositions of saturated hues that vibrate across the cloth. Some of the earliest surviving examples of such wrappers, now held in the National Museum of Denmark, were collected in the mid-nineteenth century by Edward Carstensen, governor from 1842 to 1850 of what was then the Danish Gold Coast. One of these cloths is notable as the earliest documented example of figurative motifs woven with a supplementary-weft float structure; unlike the more densely patterned contemporary Ewe textiles, the early cloth displays fewer, widely spaced motifs that appear only in every other band. Although that example is composed mainly of handspun yarns, it also incorporates mill-spun cotton, a commercial product that became the medium of choice for twentieth-century Ewe weavers, as evidenced by this midcentury kente.

This creative masterpiece is a tour de force of Ewe weaving. The cotton foundation features complementary red and green stripes. This high-contrast ground patterning refuses to play a supporting role in the composition, but instead adds to and competes with a variety of other design elements. The cloth is constituted of twenty-four bands three inches in width that are woven from cotton yarns, with small additions of reflective silk that catch the eye. Twenty of these bands include blocks of warp-face stripes alternating with blocks of supplementary-weft

patterning. The mathematical precision of the checkerboard pattern is subverted by the division of both sets of blocks into thirds: the warp-striped blocks are divided by two dentelated columns of bright-yellow silk, and the blocks with supplementary-weft patterns center their designs between two multicolored weft-face blocks. The weaver balanced this visual cacophony by dividing the design into four fields. He did so by inserting four bands with discontinuous-weft zigzag patterns—three within the body of the design and one as a terminal border at bottom. The overall visual effect is an improvised, rhapsodic design that ripples across the surface.

Within this rhythmic matrix, the artist interspersed an array of animal, human, and inanimate motifs, including birds, fish, elephants, interlocking hands, stools, and cameras. Both the Ewe and their Akan neighbors have emphasized the symbolic meanings of these various patterns. The relationship among knowledge, narrative, and weaving is central to understanding these textiles. Such elaborate creations not only underscore the status and taste of their wearers, but also convey important messages about community values, beliefs, and history. The woven designs distill Ewe proverbs into visual icons—the wise and powerful elephant, for example, is associated with kingship and authority, and interlocking hands signify peace. While visually captivating in combination, these motifs might also be referenced individually to reinforce particular narratives or ideas.

This connection between verbal and visual representation is also evident in Ewe and Asante oral histories regarding the origins of weaving. These traditions

86 WEST AFRICAN COASTAL FORESTS

attribute the knowledge of—and inspiration for—this craft to the spider. In the Ewe account, a hunter named Togbi Se sat under a tree to rest after a fruitless day. There he encountered a spider weaving its web. This served as inspiration for him to experiment with weaving when he returned home, where he reportedly invented a small triangular loom. In the Asante telling, the spider is known as Ananse, and he is credited with not only the introduction of weaving, but also the spread of wisdom and the development of folklore—offering a parallel between the weaving of threads and the weaving of words.

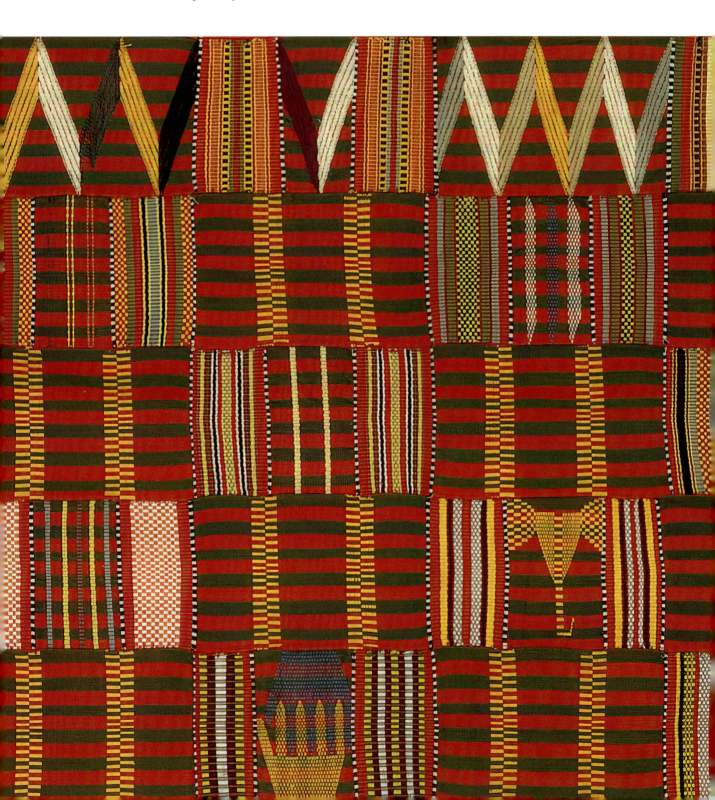

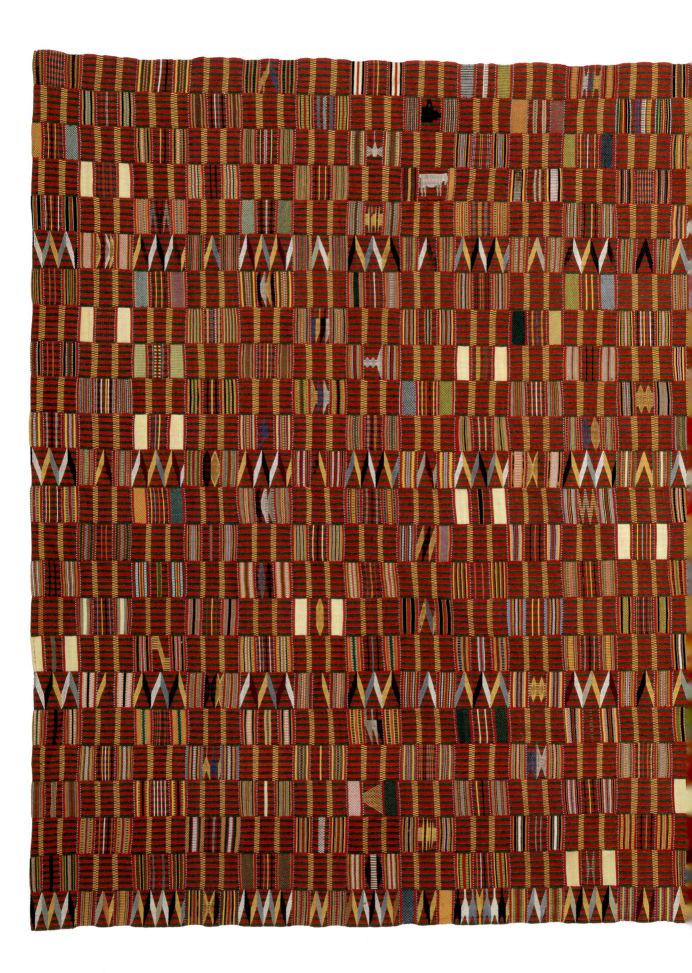

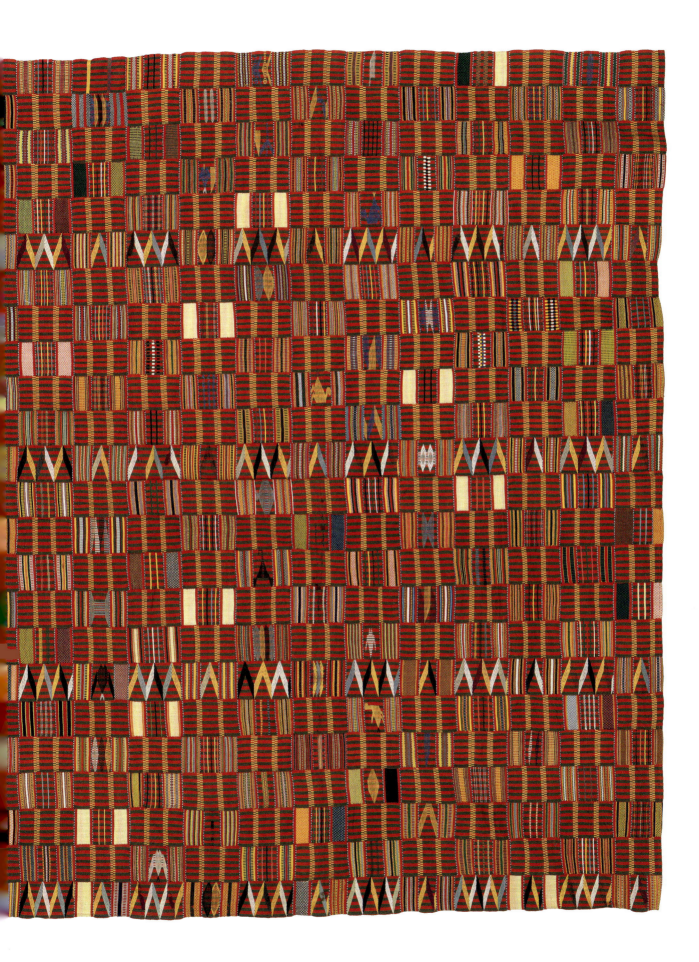

18

Baban riga (man's ceremonial robe)

Amadou Ahejo
(active second quarter of 20th century)
Kano, Nigeria, ca. 1940
Cotton, silk, 4 ft. 7 in. × 8 ft. 6 in.
(139.7 × 259.1 cm)
The Michael C. Rockefeller Memorial Collection,
Bequest of Nelson A. Rockefeller, 1979 (1979.206.279)
Recorded provenance: Alhaji Isa, Kano, Nigeria,
1940–ca. 1964; Mallam Bala Maidaraja, Accra, Ghana,
by 1964–65; Nelson A. Rockefeller, New York, 1965,
on loan to the Museum of Primitive Art, 1965–78

The Hausa term *baban riga*—literally, "father of the robe"—is widely used to refer to the voluminous tailored and embroidered garments worn on important occasions throughout much of present-day Nigeria. Also referred to as *agbádá* (Yoruba) and *ewo* (Nupe), they were introduced in the early nineteenth century when the Fulani Islamic reformer ʿUthman ibn Fudi (Usman dan Fodio) launched a religious war that began with the invasion of the Hausa Kingdoms. His newly formed Sokoto Caliphate then continued its military expansion into Nupe and Yoruba communities farther south. Within this orthodox Islamic state, members of the Fulani ruling class were distinguished by their "robes of honor," which served as visible displays of political allegiance and religious devotion. The practice was further extended by the diplomatic gifting of *riga* to prominent emirs and chiefs. By maintaining control over access to these valued symbols, leaders within the Sokoto Caliphate visually asserted their supremacy over their newly conquered dominions. The Sokoto Caliphate collapsed in 1903, but *riga* have remained discernible displays of political and religious authority within its former territory and neighboring communities.

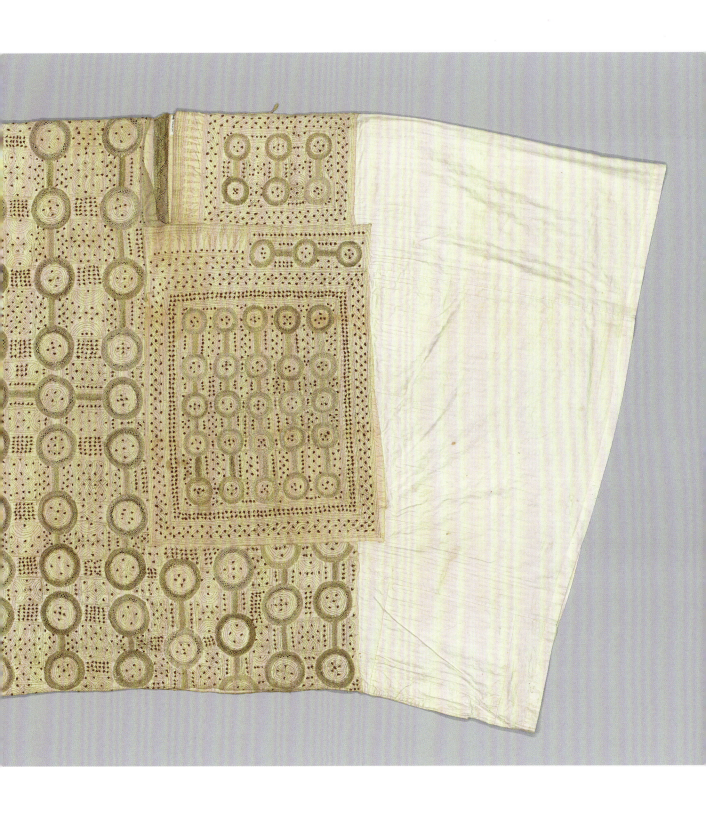

WEST AFRICAN COASTAL FORESTS

The materials and techniques used in the creation of this *riga* reflect the garment's history. It was reportedly made in northern Nigeria for Alhaji Isa, a Muslim who was likely a lower-ranking official in the Kano court. Elements of Hausa production are visible in the large circle embroidered on the lower back and in the placement of a separately embroidered false pocket on the proper left side of the front. This association is further reinforced by the type of silk used for the embroidery. The dull yellow-gray fiber appears to be *tsamiya*, the Hausa word for the wild silk extracted from communal nests of local *Anaphe* caterpillars. *Riga* embroidery made with this coarse material contrasts with the more delicate embroidery of Malian boubous, which relied on the imported, reflective white silk of the domesticated *Bombyx mori*.

While elements such as the placement of the pocket and use of wild silk align this robe with the recorded site of production, other factors closely parallel the boubou *tilbi* and boubou *kasaba* garments produced in the western trading towns of Oualata, Timbuktu, and Djenné (see no. 2). Similar to these Sahelian examples, the foundation fabric of this *riga* is a striped cotton damask imported from Europe. The faded remains of the mill or export stamp can be seen on the upper proper right sleeve. Its maker's familiarity with the Malian boubou genre is evident in the tailoring and seaming as well as in the challenging cutwork with inserts, known in Hausa as the *shabka mai yanka* technique of cutting voids in the cloth and filling them with knotted lace. Additionally, the conservative repeated embroidery patterns of most boubous and this *riga* place significant emphasis on grid formations and are dominated by four-dot and five-dot patterns set within openwork circles.

This *riga*'s visual and material connections to centers of textile production in the Western Sahel highlight the fact that many of the embroiderers of such luxury garments have been itinerant religious scholars who translate their vast knowledge of Islamic doctrine into visual rhetoric. Timbuktu has served as an important center of Islamic learning since at least the fourteenth century, attracting scholars, artisans, and merchants from across western and northern Africa. While little is known of the artist, Amadou Ahejo, the affinities between this *riga* and robes from the Western Sahel may indicate that he or one of his mentors studied in Timbuktu, or the connected towns of Djenné and Oualata, at some point prior to his embroidering this work in the Hausa region.

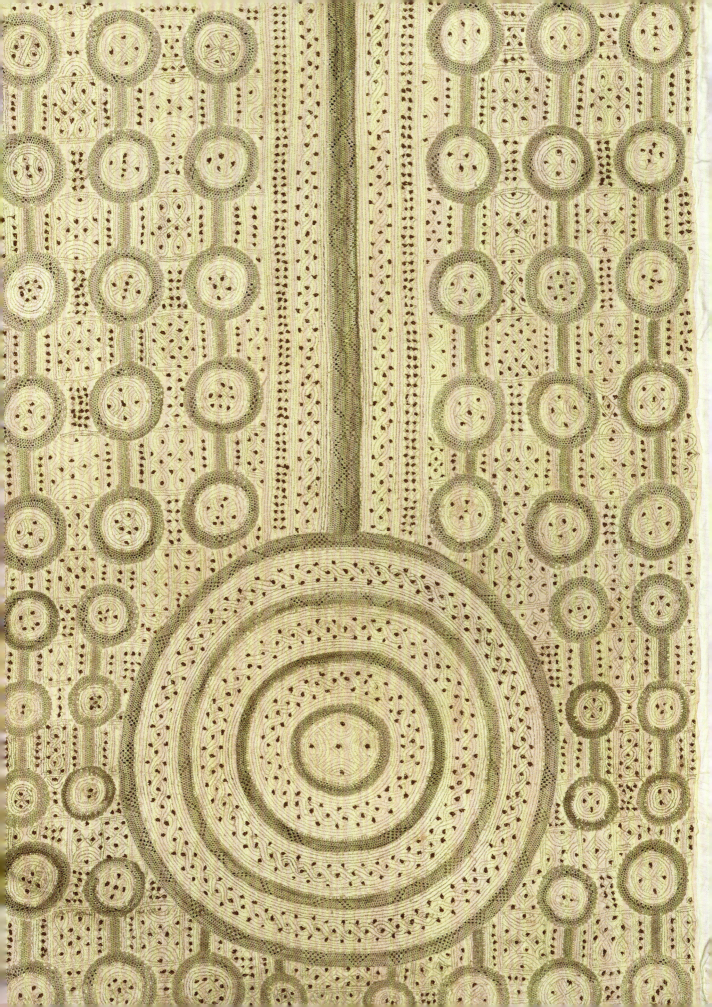

19

Wando (trousers)

Hausa, Nupe, and/or Yoruba artists
Nigeria, early–mid-20th century
Cotton, wool, dye, 37½ × 80 in. (95.3 × 203.2 cm)
The Bryce Holcombe Collection of African Decorative Art, Bequest of Bryce Holcombe, 1984 (1986.478.3)
Recorded provenance: Bryce P. Holcombe, New York, by 1984

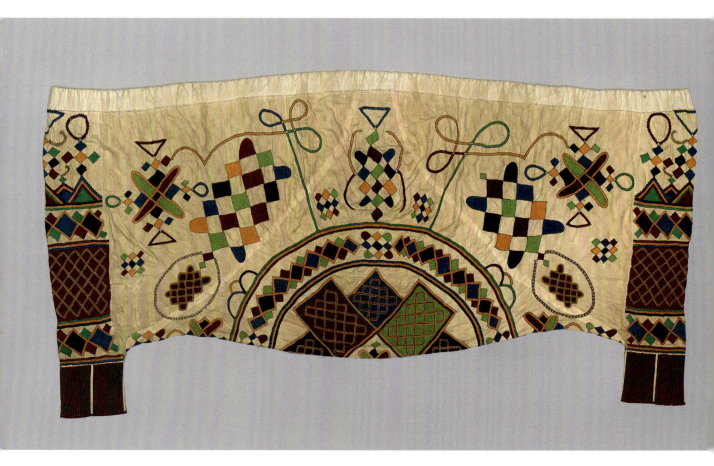

Elaborately embroidered *wando*—more specifically, *wando mai kamun k'afa* (trousers with ankle bands)—have served as prestige items for communities throughout Nigeria since at least the mid-nineteenth century. The luxurious, labor-intensive hand embroidery of these garments brought them into high demand among wealthy emirs, scholars, and traders. While Hausa elites are among their largest body of consumers, *wando* were also fashionable throughout Nigeria, both in the cosmopolitan center of Kano in the north and Nupe and Yoruba cities farther south. Trade and cultural exchange have played important roles in connecting these communities. Many embroiderers and weavers traveled widely across Nigeria and Niger, teaching new generations their craft regardless of ethnic affiliation.

Tailored and embroidered by skilled male practitioners, these refined trousers were assembled with a crotch gusset, then machine stitched with cased seams. A densely

embroidered ankle band is stitched to each narrow leg opening. The mill-woven off-white cotton fabric resembles prestigious imported damask, but is patterned using a skipped interlace structure that creates alternating rows of large and small rectangles distributed in checkerboard fashion across the plain-weave foundation. The embroidery on such elaborately patterned garments generally features variations of a widely used interlace motif, known regionally as the *arewa* knot. In this example, expanding iterations of the knot are connected to each other with somewhat whimsical twisting loops. The symmetry of the composition is broken by variations in the placement of the lively teal, green, purple, yellow, black, burgundy, and blue fills.

The trousers have a drawstring waist that, when gathered, condenses the width of the garment. On the body, the nearly fourteen feet of embroidered patterns would have become bunched and folded, changing the visibility of the elaborate designs. The embroidery would have been further obscured within the larger ensemble with which the *wando* were worn: a matching cap, slippers, tunic, and *riga* (see no. 18). The voluminous, flowing *riga* would have almost completely concealed the trousers beneath, only revealing them when the wearer, for instance, mounted a horse or participated in a public performance. The visual pleasure of the elaborate designs was thus primarily for the owner, who could take pride in his personal appearance knowing that he was dressed in a complete ensemble.

Tailored clothing has circulated widely across the Sahel since at least the fourteenth century. One of the earliest eyewitness accounts of their use was reported by peripatetic historian Ibn Battuta when he traveled through the region in 1352 and 1353. He reported that the regalia of the sultan of Takedda (in present-day Niger), as well as that of an emir in Timbuktu (in present-day Mali), included a robe, trousers, and a turban of dyed cloth. Archaeological finds further support these records. The earliest surviving pair of trousers from West Africa was excavated in "Tellem Cave Q" in the remote Bandiagara Escarpment region of present-day Mali. Constructed from many narrow bands of cotton, these fourteenth- or fifteenth-century trousers similarly employ a drawstring

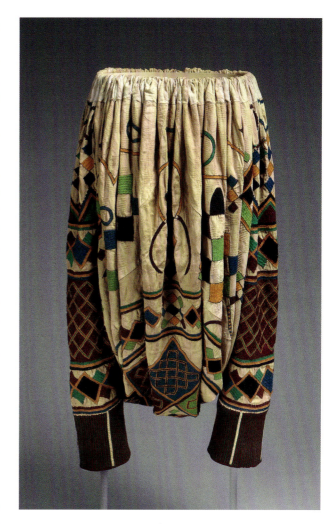

waist, hanging crotch gusset with cased seams, and narrow leg openings.

These early twentieth-century *wando* were heavily worn. The cotton waistband was likely replaced, judging by the sloppy workmanship and damage to the surrounding embroidery. The cotton foundation fabric has thinned from abrasion, and there are losses just above the ankle bands. Humidity, heat, movement, and perhaps washing have caused the wool embroidery to become felted. In some areas, the extent of the felting makes it difficult to analyze the individual embroidery stitches. However, a rather wide variety remain visible—including satin, chain, Roumanian, herringbone, braid, and knot—and attest to the skill of the artist.

20

Aṣọ òkè

Yoruba artist(?)
Nigeria, late 19th century
Cotton, 42 × 68 in. (106.7 × 172.7 cm)
Purchase, Marie Sussek and Roxanne and Guy Lanquetot Gifts, 2013 (2013.985)
Recorded provenance: Acquired by Duncan Clarke in Lagos, Nigeria, 2011; Duncan Clarke, London, 2011–13

Aṣọ òkè ("cloth from above") refers to narrow-band textiles and garments produced in present-day Nigeria, once exclusively made by male weavers. These range from simple monochromatic cloths to elaborate multicolored creations that may include silk fibers, supplementary-weft patterns, and *ẹlẹya* (openwork). As the translation implies, *aṣọ òkè* hold deep significance among Yoruba-speaking communities, who associate the cloth with elevated status and ancestral history. Their connection to venerated forebears is reinforced during masquerades, particularly *egúngún* performances in honor of departed family. *Egúngún* performers manifest visits from ancestral spirits to their descendants, to confer blessings or punishments and to reinforce familial bonds. Their costumes involve layers upon layers of imported mill-woven cloths, usually worn atop a foundation of locally woven *aṣọ òkè*. These elaborate textile ensembles give shape to and augment the movements of the ancestors, while also concealing and containing their supernatural power. Beyond performance, *aṣọ òkè* also feature in daily dress and celebratory attire, and they are among the most desired gifts marking significant life events.

This *aṣọ òkè* is formed from eleven bands woven from handspun cotton yarns, each three and three-quarter inches wide. Its framed design is unusual, and cloths with this layout form a distinctive corpus. Minimally patterned edges form a border that surrounds the elaborate openwork patterning of the central field. Five handpicked variations of *ẹlẹya* patterns, created by the addition of supplementary multi-ply weft yarns that

WEST AFRICAN COASTAL FORESTS

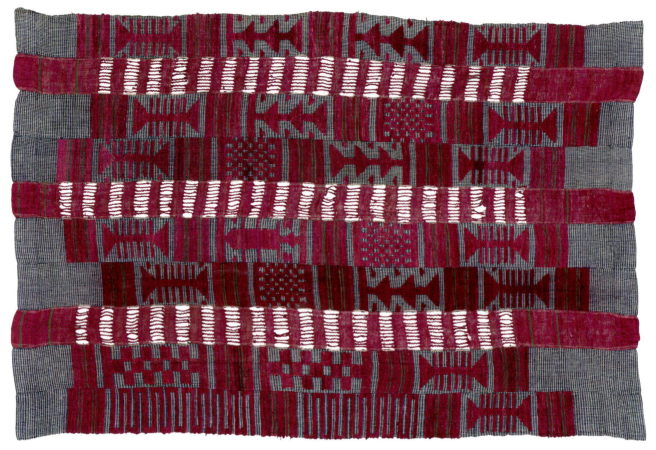

Fig. 21. *Aṣọ òkè ìró* (woman's wrapper). Yoruba artist. Nigeria, 19th century. Cotton, silk, dye, 41 × 73 in. (104.1 × 185.4 cm). Purchase, Mrs. Howard J. Barnet Gift, 2012 (2012.335)

were laid in between two or more picks of the thinner weft, distinguish the wrapper's design. These patterns include the ribbed equilateral triangles with openwork edges spaced along the upper and lower bands and the openwork "dots" that create a continuous inner border. Additionally, in the central field, a vertical stripe of openwork bisects the field into two groups of fourteen *ẹlẹya* columns. The fifth variation is found in three columns of openwork at the warp ends of each band. These were created by shifting groups of three warps over each other and inserting the thick weft to create a simple gauze pattern. While this example celebrates the understated beauty of white, related examples may be enhanced by the addition of beige-colored wild *sányán* silk yarns derived from the nest covers of *Anaphe infracta* moths and processed locally.

Refined *ẹlẹya* textiles have been popular in Lagos since the mid-nineteenth century. Brightly colored and costly combinations of cotton and *àlààrì* silk (see fig. 21) were used for women's overskirts. In contrast, white *aṣọ*

Detail of no. 20

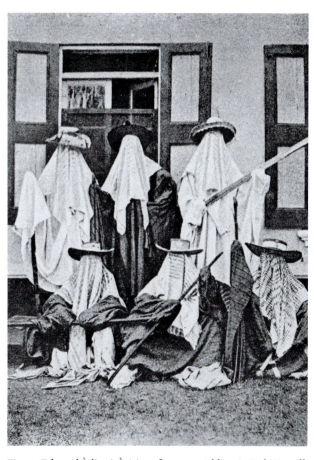

Fig. 22. Ethereal Àdàmú Òrìṣà performers wielding òpámbàtà staffs and wearing broad-brimmed hats over their openwork aṣọ òkè head coverings, Lagos, Nigeria, ca. 1910

òkè with extensive openwork appear in additional contexts. Early photographs show women wearing them tucked around the waist as overskirts or suspending them for use as sunshades. They also appear prominently during festivals of dance and oratory known as Àdàmú Òrìṣà or Ẹyọ Plays. Held primarily on Lagos Island, these masquerades have their roots in nineteenth-century funerary rites that commemorated the city's founding Awori Yoruba lineages. They are commissioned by the ọba of Lagos, typically in honor of a recently deceased member of the royal family. The weeklong events culminate in a striking procession of hundreds of men garbed in all-white costumes consisting of an agbádá (see no. 22), a pair of billowing trousers, a broad-brimmed cap, and an openwork aṣọ òkè known as an ìbojú (fig. 22). Worn draped over the head, an ìbojú constitutes a veil through whose perforations a performer may peer. The emphasis on white signifies the purity and sanctity of the ancestors, imparting to the wearer an aura of peace.

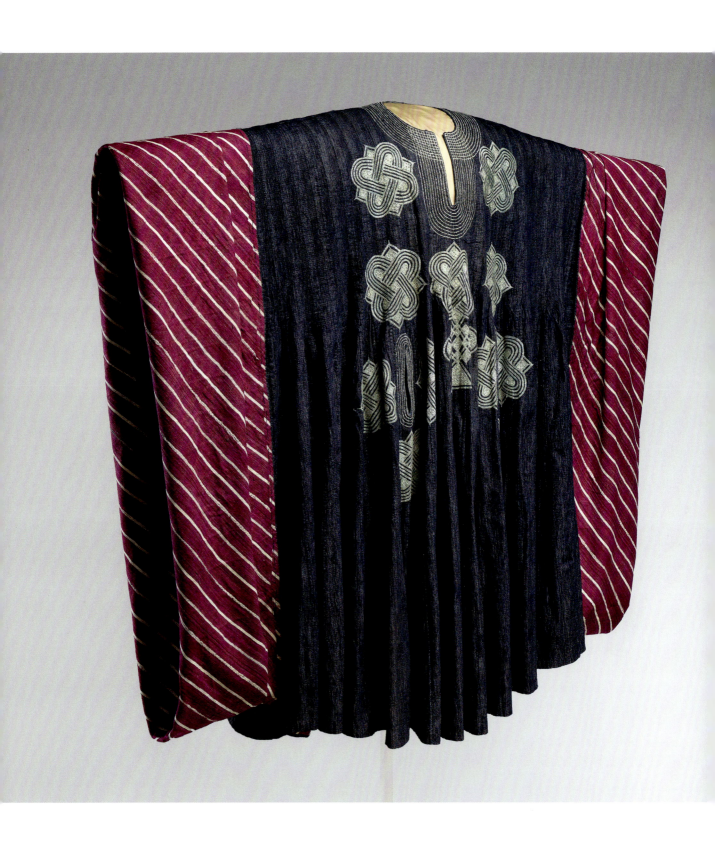

21

Ẹtù dámò àlàárì dàǹdógó (man's ceremonial robe)

Ijebu-Yoruba artist
Ilesha region, Nigeria, ca. 1929
Cotton, silk, dye, 4 ft. 6½ in. × 12 ft. 10 in. (138.4 × 391.2 cm)
Purchase, Roda and Gilbert Graham Gift, 1988 (1988.86.1)
Recorded provenance: Chief Solaja, Ilishan, Nigeria, ca. 1929–ca. 1988; Abayomi Akinsanya, Chicago, by 1988

Expansive *dàǹdógó* are the most sumptuous garments worn by high-ranking Yoruba men on special occasions. The term *dàǹdógó* derives from the Hausa word *dogo*, meaning to get larger. These meticulously handwoven, tailored, and embroidered robes physically extend the presence of the wearer and emphasize his movements. This particular *dàǹdógó* was assembled from a genre of local handspun and handwoven cloth known as *ẹtù*, a reference to the refined black-and-white plumage of the guinea fowl. Like those speckled birds, *ẹtù* cloth features indistinct white stripes shimmering against a dark background, in this case yarns that have been so deeply dyed with indigo that they appear black. A fabric closely tied to authority, *ẹtù* is considered a prerequisite for becoming an *ọba*, or king, in Yoruba communities. Only a master dyer could produce the necessary dark and level shade of indigo—a skill that would be known to all who encountered this garment. To create the subtle striped pattern, the weaver introduced two thin white yarns for every three thick indigo yarns, using a warp-face plain-weave structure. Although the two adjacent white yarns should appear as a solid line, they nestle into the fluffier handspun indigo threads and become intermittently obscured, thus appearing as light flecks dancing on a midnight ground. Over time, the white yarns may pick up a faint blue hue from the surrounding indigo fibers. In this example, the unburnished fabric effectively absorbs the brightest sunlight, and the contrast between the near-black and white has been masterfully activated by the artist-weaver.

More than two hundred yards of bands two and one-quarter inches wide were needed to create this luxurious fabric. The body of the robe was constructed from twenty-seven bands draped vertically over the shoulder line. Along the upper torso, these bands are carefully overlapped by one-half to three-quarters of an inch, except for the center band, which is shown at its full width. Descending onto the lower torso, the overlaps slowly decrease in width until the bands are separated enough to allow for more bands of overlapping fabric to be added

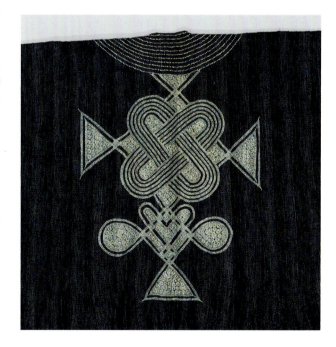

between them. These additional bands also gradually separate as they move toward the hem. What begins as a 36-inch width across the shoulders terminates in a hem circumference of 266 inches.

The garment's flowing sleeves are equally extravagant. To form them, two sets of narrow bands were oriented horizontally at the open sides of the robe. Each sleeve required forty bands of fabric and measures approximately fifty by forty-two inches. The combined wingspan would have far exceeded the reach of its wearer, requiring him to artfully fold and balance the excess fabric over his upper arms. In this state, the vibrant facing of striped magenta silk and white cotton that lines the sleeves of the garment is revealed. This same fabric was again used to face the entire lower circumference of the garment. Historically, cloth that incorporated large amounts of magenta silk imported into northern Nigeria through trans-Saharan trade networks was called *àlàárì*. Today the term may describe any predominantly red or pink cloth.

Silk is further employed on the interlace motifs embroidered on the front and back of this *dàńdógó*. The white color and sheen of this fiber suggests that it was also imported spun silk. These visual references to costly trade in precious fibers would have further underscored the status of the wearer.

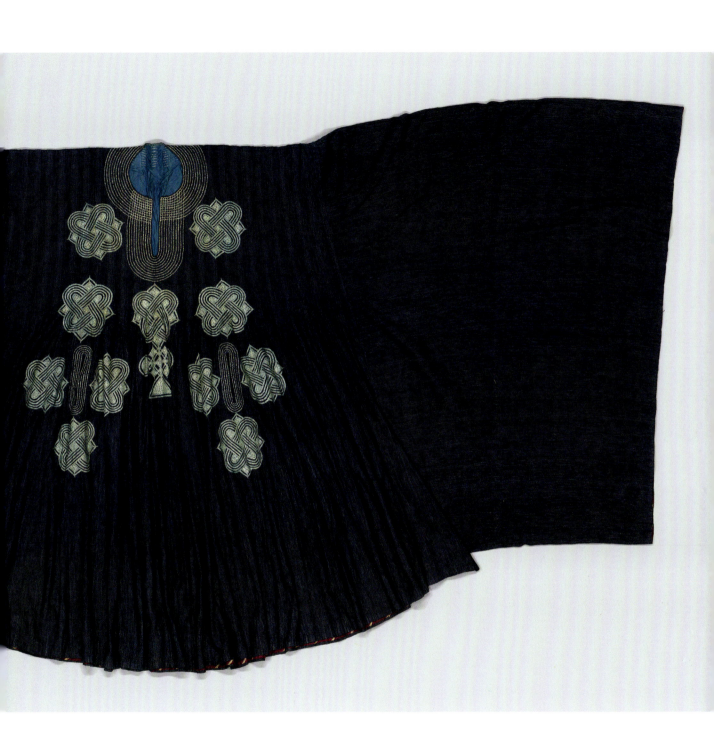

22

Agbádá (man's ceremonial robe)

Hausa, Nupe, and/or Yoruba artist(s)
Nigeria, mid-20th century
Cotton, silk, dye, 48 × 93 in. (121.9 × 236.2 cm)
Gift of Duro Olowu, 2014 (2014.751.1)
Recorded provenance: Martin Olowu Akinsuroju, Ode-Aye,
Ondo State, Nigeria, by 2002; Festus Kayode Olowu, Lagos, 2002–12; Duro Olowu, London, 2012–14

Created from locally woven *aṣọ òkè* textiles and richly embroidered with silk floss, this imposing *agbádá* was a wearable statement of the political and religious authority of His Royal Majesty Ọba Martin Olowu Akinsuroju, who served as the *lapoki*, or king, of Ode-Aye in the Ondo State of Nigeria for fifty years until his passing in 2002. Similar in appearance to the voluminous *dàńdógó* (see no. 21), *agbádá* are one piece of an ensemble worn during family and community events. These valued creations frequently became heirlooms—fashion designer Duro Olowu was gifted this robe and the accompanying slippers by his father, Festus Kayode Olowu, who had inherited them from his father, Akinsuroju. The generational continuity of these custom-made robes underscores not only their economic value, but also the familial connections fortified through their wearing and display.

Within Yoruba communities, handwoven *aṣọ òkè* (see no. 20) continue to enjoy wide popularity, and demand for bespoke garments has remained strong among a middle class that was formed during the mid-twentieth century. Weavers played a part in this wider adoption of *aṣọ òkè* by readily embracing mill-spun cotton yarns, synthetic yarns such as rayon and Lurex, and innovative weaving patterns to suit their growing, fashionable clientele. Garments tailored from handwoven cloth serve as "visible symbols of prosperity, status and pride in ethnic heritage," as Judith Perani and Norma H. Wolff have argued.

This vibrant, striped *agbádá* incorporates the triad of Yoruba basic colors: *funfun* (white or light colors), *dudu* (black or cold colors), and *pupa* (red or warm tones). Handspun and mill-spun yarns have been grouped to form three repeating wide stripes, which appear as gray, blue, and red. Close examination reveals textural details created by the contrast between the fluffier handspun indigo yarns and the thinner mill-spun red and white threads. Variations in the thickness of the black, blue, and white warps create the subtle but effective dimensionality in the full- and half-tones constructed through the contrasting colors of warp and weft.

The garment is further elaborated with rich silk embroidery undertaken by an artisan who drew upon diverse references to integrate and transform widely circulating motifs. Among the various designs, he included two monumental spirals extending down the back and the proper right chest. Known among the Yoruba as *Ìyá Ilọrin* (mother of Ilorin), these motifs reference the town of Ilorin in western Nigeria, which has been a prominent center for narrow-band cloth production since the second half of the nineteenth century.

In contrast to the less dense, ethereal quality of the embroidery employed in the spirals, the large pocket

104 WEST AFRICAN COASTAL FORESTS

(woven from a distinct yet harmonious striped *aṣọ òkè* fabric) has been heavily embroidered with a shiny bronze-colored silk, giving it a metallic sheen. The embossed quality of this embroidery is echoed in the thick metal-wrapped threads that were used on the complementary velvet slippers (fig. 23), extending the aesthetic of luxury across the ensemble. Among the complex geometric and interlace motifs on the pocket are a pair of vertical tapering forms. These are known as *aska biyu* (two blades) and serve as a visual reference to *dhu al-faqar*, the double-pronged sword of the Prophet Muhammad and his son-in-law ʿAli. While this potent symbol of Islamic heritage is widely employed by Muslim communities in northern Africa, the Middle East, and central and southern Asia, some artisans in western Africa have creatively replicated and expanded the motif to five-, eight-, and even ten-blade versions. Within the elements embroidered across the pocket, the artist varied his stitch type, length, and density to create subtle infinity-knot patterning, a design element echoed in the motifs featured along the lower right corner of the pocket.

Fig. 23. Ceremonial slippers. Yoruba artist. Nigeria, mid-20th century. Leather, silk, metal, dye, 11 × 3 in. (7.6 × 27.9 cm). Gift of Duro Olowu, 2014 (2014.751.2a, b)

WEST AFRICAN COASTAL FORESTS

106 WEST AFRICAN COASTAL FORESTS

WEST AFRICAN COASTAL FORESTS 107

Elégẹ̀gẹ̀ pupa (woman's prestige wrapper with red band)

Obamadesara (Yoruba, d. 1956)
Owo, Nigeria, early 20th century
Cotton, silk, dye, 34 × 65 in. (86.4 × 165.1 cm)
Gift of Samuel and Gabrielle Lurie, in celebration of the Museum's 150th Anniversary, 2018 (2018.925.5)
Recorded provenance: Douglas Dawson Gallery, Chicago, by 2002;
Samuel and Gabrielle Lurie, New York, 2002–18

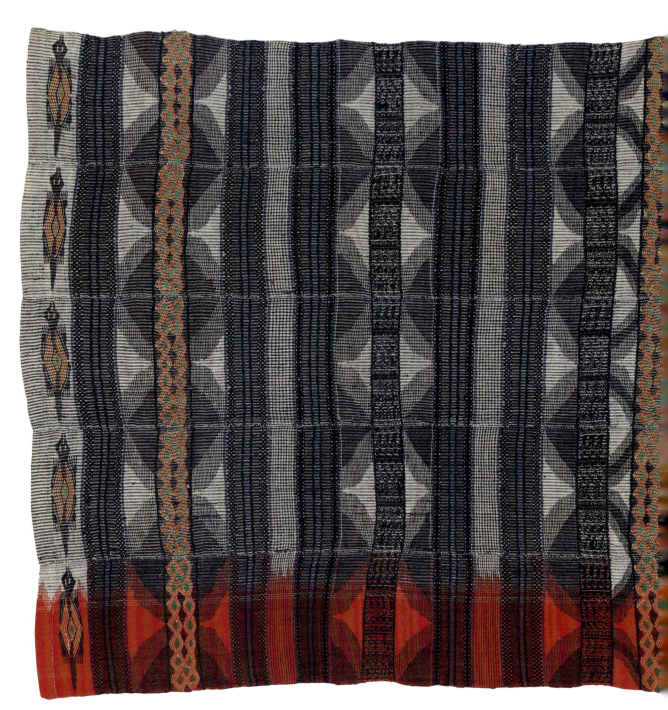

Obamadesara's life history is a rare account from which textile scholars and enthusiasts can trace an innovative moment in early twentieth-century Nigerian weaving. Born into a royal Owo household in the mid-nineteenth century, he temporarily altered the Owo weaving industry through his introduction of the horizontal treadle loom, tapestry weave, and male textile production. His natal town of Owo in southwestern Nigeria has been an important weaving center for many centuries. Historically and in the present day in Owo, women have dominated the industry. Their valued creations, produced on a vertical loom, have mediated religious and ceremonial rites. This association with spiritual experience extends beyond the textiles themselves to include the processes and materials employed in their creation. Indeed, Robin Poynor notes that in this town "the very act of weaving on the

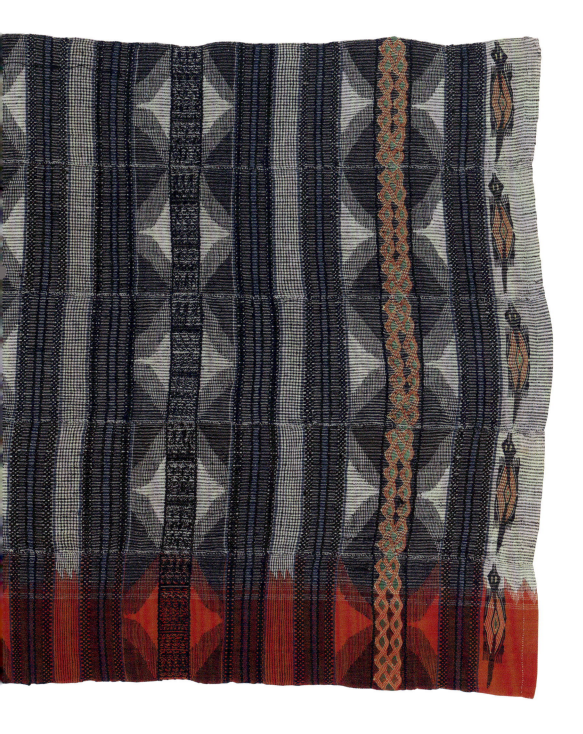

vertical loom often approaches ritual, with special demands and proscriptions placed upon the weaver."

Obamadesara began learning to weave in his teenage years at the nearby town of Emure, which was dominated by male weavers. He further developed his craft between 1920 and 1930, during a period of exile in Benin imposed on him by British authorities for inciting civil unrest against their colonial administration. Upon his return to Owo he produced a small corpus of textiles for female and male patrons, elégègè among them. This garment is worn by women from royal Owo households, wrapped around the waist as an overskirt. While Obamadesara produced monochromatic variations of the wrapper in black (deep indigo) and white, this elégègè pupa is distinguished by a single, red-dominant band along the lower border. The inclusion of this panel allows the composition to incorporate all three of the Yoruba triad of colors: funfun (white), dudu (black), and pupa (red).

Both talent and training are on display in the weaving of this textile. It is constructed from five bands that are six and one-half inches in width. Four of these employ handspun cotton warp yarns, which alternate four white yarns with two indigo-dyed yarns. The fifth band adds mill-spun and -dyed red cotton yarns. Obamadesara composed the complex design of this wrapper by exploiting the different thicknesses of indigo and white yarns and employing them in the warp and weft directions in what is primarily a plain-weave structure. The minimal yellow and green additions may be imported silk, placed as accents to the bands containing lizard and interlace motifs.

The warp sett allows for a balanced plain weave, as evidenced by the checkered pattern. The sett is significant here for two reasons. First, it allowed the artist to create the multicolored tapestry-woven lizards and the interlaced bands using eccentric wefts with minimal out-of-plane distortion. Second, it permitted the development of three contrasting grayscale tones that create imagery that can be read either as nested diamond-in-circle motifs or as hourglass patterns. The wrapper also includes continuous supplementary-weft bands of thick indigo-dyed yarns containing patterns that are just beyond legibility. The finely detailed woven forms on this elégègè are equally finished on both sides, resulting in two equivalent faces—a remarkable feature further attesting to the virtuosic skill of this early twentieth-century weaver.

Obamadesara was active through the second quarter of the twentieth century. According to his daughter, his weavings were so complex that he was unable to pass on his innovations to any apprentice. As a result, his techniques and designs are no longer produced in Owo. Those he created during his lifetime have mostly remained cherished heirlooms worn during important family and community events such as funerals.

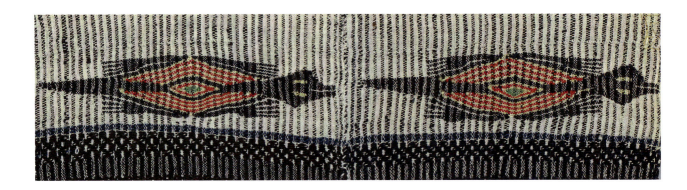

24

Wrapper

Ndoki-Igbo artist
Akwete, Nigeria, early 1990s
Cotton, dye, 41¾ × 76½ in. (106.1 × 194.3 cm)
Gift of Robert and Anita LaGamma, 1998 (1998.389.2)
Recorded provenance: Acquired by Robert LaGamma from the women's weaving cooperative in Akwete, Nigeria, early 1990s; Robert LaGamma, Reston, VA, early 1990s–1998

Akwete, in southeastern Nigeria, has been a preeminent center of textile weaving for many centuries. It rose to prominence in the mid-nineteenth century when residents of the town developed a close relationship with Ijo traders from the Niger Delta who exchanged valuable palm oil, known as "red gold," for local Ndoki cloth. The boom in demand for these goods caused weaving in Akwete to grow from a part-time activity to a full-time industry in which all the town's women participated as weavers (and some as traders) to produce thousands of cloths for a sophisticated clientele. This transformation was accompanied by changes in materials, designs, and cloth dimensions, spurred by Ijo aesthetic preferences.

Ijo patrons had voracious appetites for textiles. Those they acquired from Europe and India were wider than those originally woven on Ndoki looms. The Ijo preferred these wider textiles, which were ideal to wear as wrappers. Consequently, the width of the Akwete women's upright-frame loom was increased to accommodate a greater weft dimension. Ijo consumers also favored intricately patterned cloths. In response, weavers in Akwete introduced sophisticated bi- or multicolored warp and weft sequencing and began to use pattern sticks to facilitate the creation of complex geometric and figurative motifs with supplementary-weft structures, in imitation of favored South Asian designs.

Contemporary Akwete textiles—created at what has become a more organized women's cooperative—continue to be handwoven with a continuous warp of fine mill-spun cotton on this deceptively simple yet endlessly adaptable single-heddle loom. This example features bright orange warps that regularly appear between every five black warps. These orange warps perform two functions. First, they join the textile's even-numbered warps to participate in the odd-even rhythm of the striped plain-weave foundation. Second, they bind the continuous supplementary wefts that create the multicolored vertical border stripes and the discontinuous wefts that create the geometric field patterns. When supplementary

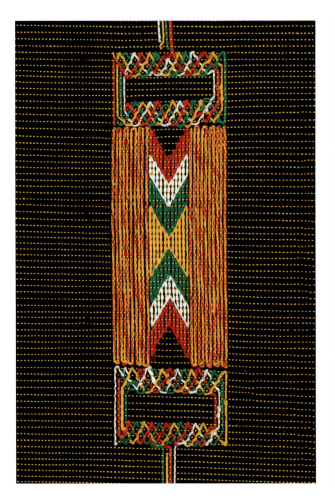

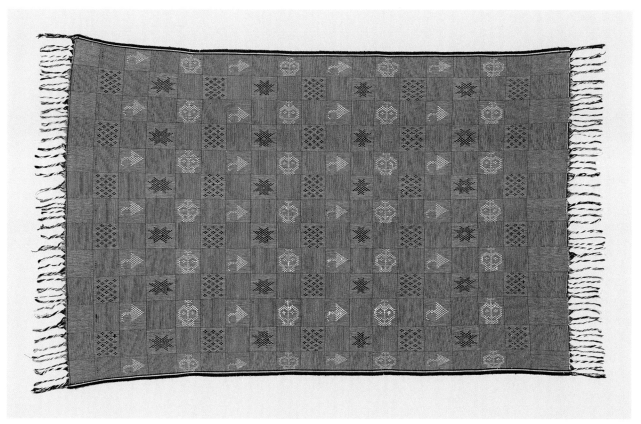

Fig. 24. Wrapper. Ndoki-Igbo artist. Akwete, Nigeria, early 1990s. Cotton, Lurex, dye, 50 × 85½ in. (127 × 217.2 cm). Gift of Robert and Anita LaGamma, 2002 (2002.619)

pattern wefts needed to be inserted, the orange warps alone were raised by a pattern stick to bind the supplementary wefts to the cloth in all the necessary locations across the weave. The one-two rhythm of the plain weave then repeats until another group of pattern wefts is inserted. The cut ends of these discontinuous wefts are clearly visible on the face of the cloth, while the plain-weave structure alone is visible on the back. Pickup pattern wefts can move in almost any direction—side to side, up, and diagonally—because they are not constrained by the foundation weave.

A related grayscale Ndoki wrapper (fig. 24), also acquired in Akwete in the 1990s, presents a more complex structure that is equally legible on both sides of the cloth. More than one pattern or heddle stick was needed to create the double-sided checkerboard of black and white squares as well as the small geometric and representational motifs that repeat in straight alignment across the weft. These motifs are formed by short skips in the plain-weave structure that result in weft floats on one face of the cloth and warp floats on the other. The entire cloth radiates a subtle sparkle through the incorporation of Lurex threads.

The diversity of designs employed by Akwete weavers is a source of great pride, with many boasting of their abilities to compose more than one hundred distinct patterns. Today, as in the past, the Ijo remain the primary patrons of these refined weavings, and their continued interest spurs design ingenuity among their Ndoki makers. Because of these cloths' association with trade, they have assumed symbolic meaning as representations of wealth and prestige. Accordingly, such textiles are often worn as ceremonial attire to broadcast the status of the wearer.

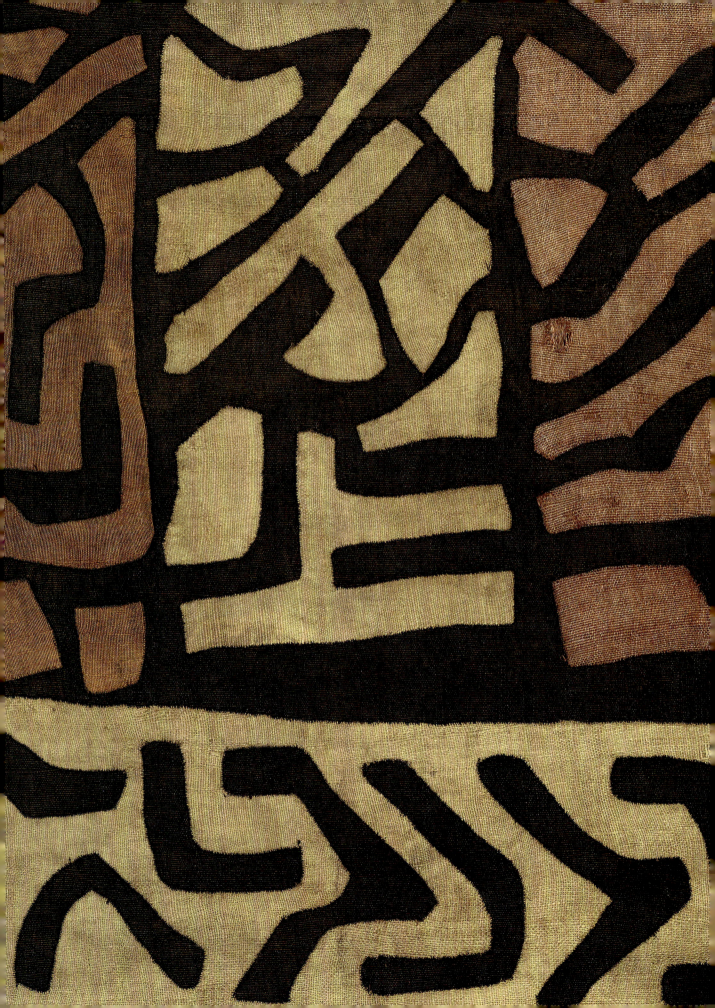

CENTRAL AFRICA

25
Ndop (royal display cloth)

Grassfields artists
Northwestern highlands, Cameroon, early–mid-20th century
Cotton, wool, dye, 8 ft. 1 in. × 27 ft. (246.4 × 823 cm)
Gift of Eve Glasberg and Amyas Naegele, 2013 (2013.1140.15)
Recorded provenance: Arouna Ndam, Foumban, Cameroon, by 2010; Amyas Naegele, New York, 2010–13

Epic *ndop* textiles speak to deep histories of migration, cultural contact, and exchange that have defined the stratified northwestern Cameroonian Grassfields chiefdoms and their neighbors. As cotton does not flourish in this area, these handwoven stitch-resist-dyed indigo fabrics were initially imported from the Benue River region, where they were produced by Hausa-speaking Abakwariga artisans who had migrated from present-day Niger and northern Nigeria by the fifteenth century. Such exotic goods were eagerly sought by the *fons* (kings) of the various Grassfields polities, for whom their use and display underscored royal control over regional trade networks. By the early twentieth century, many chiefdoms began developing their own *ndop* ateliers, and the

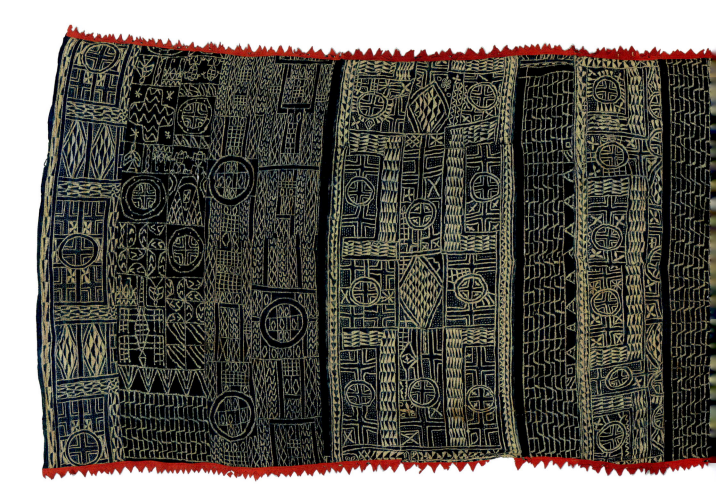

northern provinces began investing in cotton production on a commercial scale. King Ibrahim Njoya of Bamum (r. 1895–1924) was a leading figure in this shift. He established a weaving and dyeing center in his palace at Foumban by inviting Abakwariga artisans to relocate there and by encouraging the women of his court to participate as cotton spinners. While Njoya's textile venture was abandoned by the 1920s, other chiefdoms have continued to sponsor *ndop* production through the creation of royal workshops and the patronage of independent weaving and dyeing centers located primarily in the northern, cotton-growing areas.

Cameroonian *ndop* required a long-distance manufacturing process. The raw cotton was processed and spun by men and women living in the north. The cloth was subsequently woven by men on a double-heddle loom in workshops in the Benue River region, then sent to sites in the western chiefdoms for surface patterning. Typically, men drew the designs, and women tightly stitched these outlines with raffia fibers. The prepared cloths were then sent back north to be dyed in the indigo pits of Garoua. Once dyed, they were returned to the south, where women undertook the painstaking process of unpicking the stitching used to hold the pattern in reserve.

The ambitious decorative program of this twenty-seven-foot display cloth was created from eighteen individual *ndop* sections of different dimensions, all of which retain their original seams along the weft selvages. The number of narrow bands per section ranges from two to twenty-two. Some sections appear fresh, while others show signs of age and use. The sections are invariably joined by machine stitching. Whether the selection and

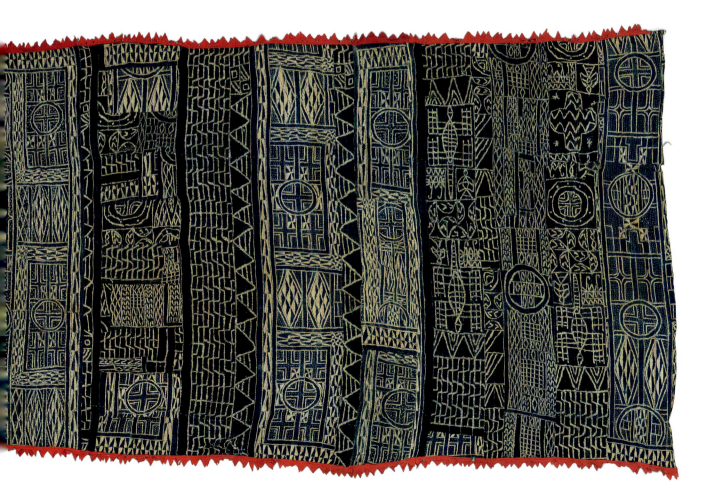

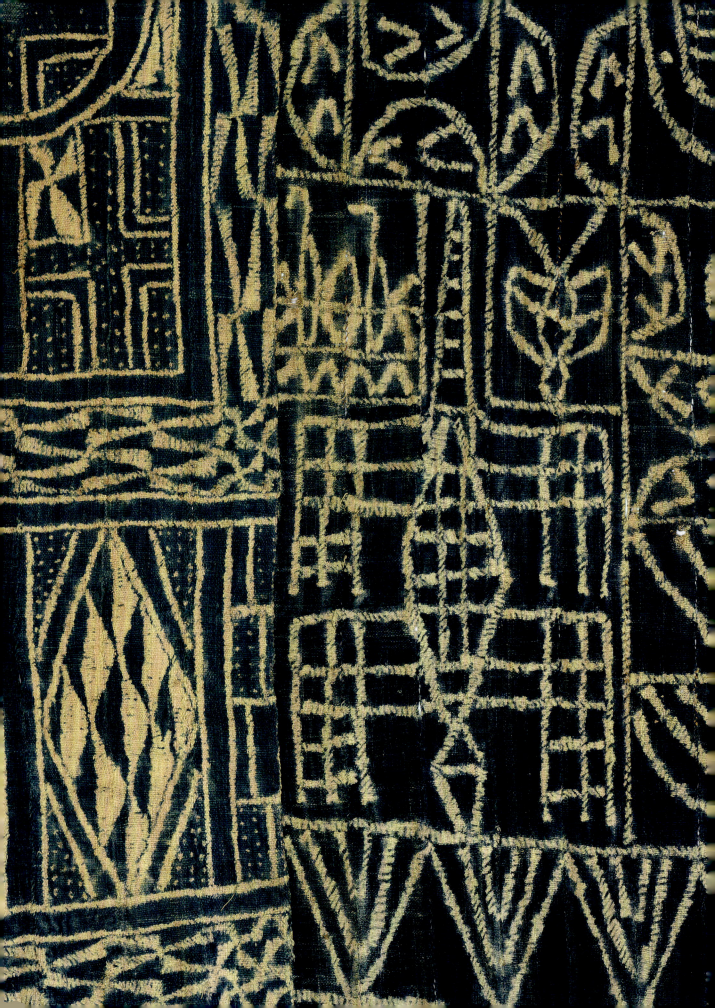

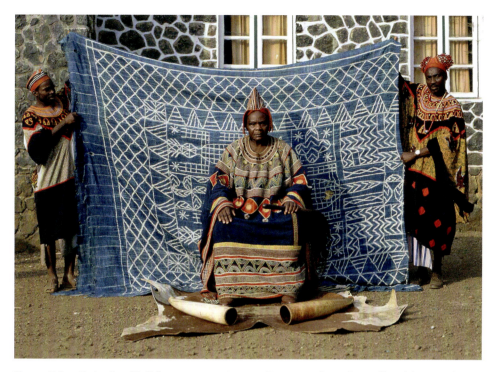

Fig. 25. Galega II, the *fon* of Bali from 1940 to 1985, seated in state in front of one of his elaborate *ndop* display cloths, which is held by two Bali nobles, northwestern highlands, Cameroon, 1981

grouping of these sections held meaning has not been recorded, yet the arrangement of the sections features a dynamic interplay of forms. While interpretations of the individual motifs vary greatly, many are associated with the authority of the royal courts. For example, the four geometric crocodiles depicted on this display cloth are known as powerful creatures for their ability to take life—an idea also extended to the *fon*, who is understood as simultaneously powerful and dangerous. The entire composition is unified by a bright-red zigzag trim made from imported wool cloth.

The ownership and use of these works reinforced the wealth and authority of the *fons*, as they alone commanded the necessary resources to commission such labor-intensive creations. Monumental cloths like this example could be hung as dramatic architectural backdrops for royal ceremonies (fig. 25), including the funerals for Grassfields elites, investiture rites, and public performances like the *lela*, at which different factions within the Bali Nyonga chiefdom reaffirm their loyalty to the *fon*. Indeed, this cloth retains two horizontal rows of stitch marks that indicate it was once secured to a support. Royal cloths have also been exchanged as gifts between *fons*, reinforcing relationships across the Grassfields chiefdoms. *Ndop* can also be cut into smaller pieces, which would then be sewn into prestige gowns or gifted to members of the community as rewards for special services, perhaps to be incorporated into dramatic display pieces like this example.

26

Prestige gown

Grassfields artists
Northwestern highlands, Cameroon,
early–mid-20th century
Cotton, wool, dye, H. 45 in. (114.3 cm),
W. across sleeves 88 in. (223.5 cm)
Purchase, Dr. and Mrs. Sidney Clyman
Gift and Rogers Fund, 1987 (1987.163)
Recorded provenance: Michael Oliver,
New York, by 1987

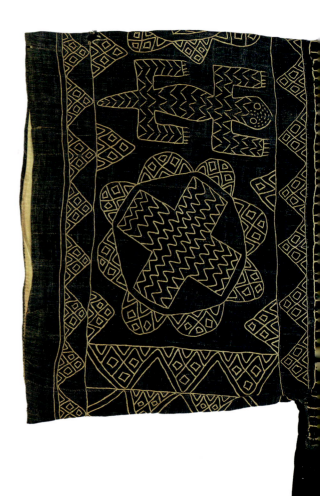

Richly embellished gowns are widely embraced by the varied aristocratic chiefdoms living in the highlands of western Cameroon. Their shape and some of their technical and decorative details link these elite garments to Fulani, Hausa, and Yoruba robes (see nos. 18, 21, 22). Grassfields oral histories, recorded by art historian Moira Harris, recount how such voluminous garments were introduced to the highlands in the early nineteenth century when Chamba bowmen rode down from the upper Benue River region in present-day Nigeria, raiding and settling among Bali communities. Struck by the power of these northern invaders, elites within the various Grassfields chiefdoms emulated the flowing cotton garments they wore. By the late nineteenth century prestige gowns were a well-established fashion adopted by the courts of Bali, Fontem, Kom, and Bafut. Variations in the format of this garment enforced social hierarchies—full-length, long-sleeve gowns like this example were exclusively worn by *fon*s (kings). In contrast, local chiefs and other Grassfields elites donned either a short, sleeveless version or a knee-length tunic with short sleeves.

The creation of this cotton gown required a collaborative effort among expert spinners, dyers, weavers, tailors, and embroiderers. The foundation fabric is a traditional warp-face, narrow-band cloth. Sixteen bands two and one-half inches wide are oriented vertically to

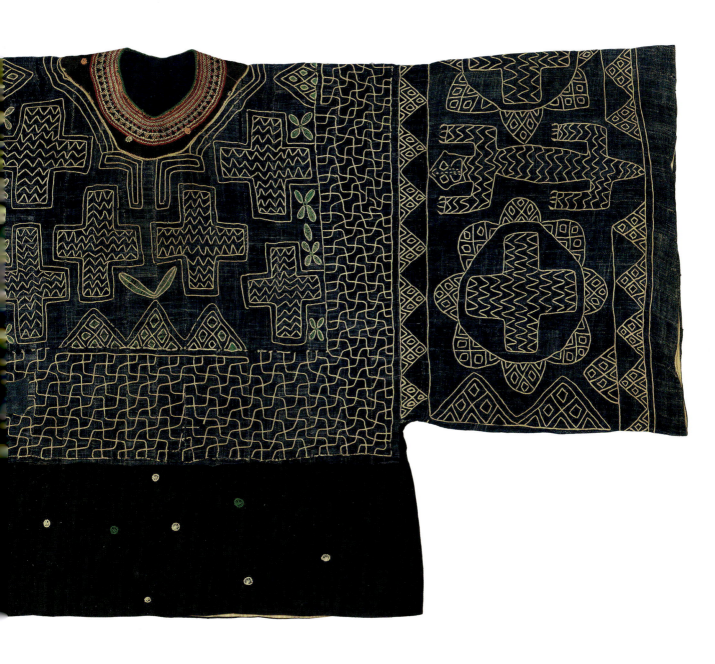

CENTRAL AFRICA 121

form the body, while the sleeves are each composed of thirty horizontally oriented bands of two and one-eighth inches width. This layout follows the construction formats of handwoven boubou and *riga*. The gown is visibly worn and has been repaired with fabric that is stitched into the neck opening and replaces the lower skirt. As is also customary in Nigerian robes, the inside edges of the lower sleeves and the lower skirt are faced with a contrasting fabric—in this instance, an ecru mill-manufactured cotton. The fact that this gown was cared for over many years and restored with imported fabric underscores its value as a family heirloom.

Here the garment's similarities to *riga* end and the tastes of Cameroonian Grassfields communities take over. There is no pocket, and the *riga*'s V-shaped neck opening has been replaced by a round one. The lower skirt has been emphasized by a foundation fabric of rich, dark mill-manufactured cotton with a satin-weave structure. The tightly woven surface is smooth and retains some of its original sheen. The same dark cotton fabric was used to embellish the neckline, where it was inserted into a trimmed and seamed opening, roughly following the framing embroidery on the handwoven cloth, and then stitched into place. The alternation of dark and light fabrics creates distinct zones within the silhouette, which similarly appear in some of the earliest examples of these gowns.

The large-scale embroidered patterns covering the body and sleeves are similar to the imagery included on Cameroonian *ndop* display cloth (see no. 25). Featured here are large crocodiles and crosses, both protective symbols amplifying the power of the wearer. Smaller motifs, including triangles, leaves, and intersecting wavy lines, may relate to agriculture and the settling of the land. As opposed to resist-dyed cloths like *ndop*, this robe's embroidery allowed for greater color variation—intricate, V-shaped bands of green, red, yellow, and cream-colored embroidery in running stitches around the neck recall, in miniature, the geometric designs applied to the body of the garment. Small piqué-stitch circles float around the neck and on the lower skirt, lending a note of whimsy to the formal patterns of the body and sleeves. The combined impact of the lengths of expensive handwoven, indigo-dyed cotton and lavish embroidery would have communicated the wealth and prestige of the *fon* who wore this gown.

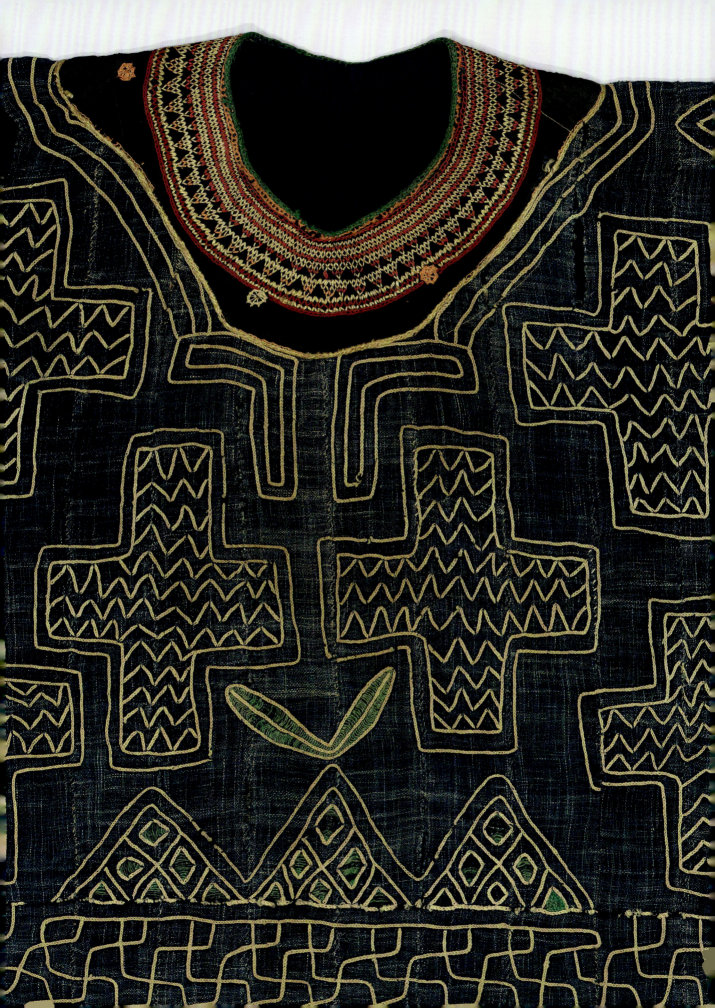

27

Chief's *nogi* (breechcloth)

Mangbetu artist
Uele River region, Democratic Republic of the Congo, first half of 20th century
Bark cloth (*Ficus natalensis* or *Ficus platyphylla*), dye, 75 × 78¾ in. (190 × 200 cm)
Purchase, The Richman Family Foundation Gift, in honor of Alisa LaGamma, 2012 (2012.334)
Recorded provenance: Acquired by the Dominican Missionary Sisters of Notre Dame de Namur in the
Democratic Republic of the Congo, by 1959; Pierre Loos, Galerie Ambre Congo, Brussels, by 2010;
Andres Moraga, Berkeley, CA, 2010–12

Pleated between the legs and flared out around the torso, sturdy bark-cloth *nogi* are secured at the waist with a belt to create a voluminous garment for a man (fig. 26). To wear the textile, the individual positions the wider end along his back and the narrower end at his front, folding the fabric with the middle between his legs. Once the cloth is cinched and secured around the waist, the excess material at the front and back can be fanned out to form a wide ruff around the torso. When European scholars and explorers visited the northeast Congo in the early twentieth century, they reported that such sophisticated bark-cloth garments were widely worn throughout the region. Among the Mangbetu and neighboring communities, artfully shaped and painted examples visually affirmed the wearer's wealth and influence. Male members of the Mangbetu court displayed their elevated status by consistently wearing new wrappers whose edges extended stiffly above their belts. In contrast, those of lesser social standing wore older *nogi* with surfaces softened from regular use.

While such personal items are often handcrafted by the wearer, more elaborate examples are created by specialists. The regular commission of new bark-cloth garments is not a trivial expense. In Central Africa, the raw material for these is harvested from different species of ficus trees by cutting and removing long sections of bark, often a meter or more in height, from around the tree trunk. Exemplifying the connection from raw material to finished product, both the ficus trees and the cloth obtained from them are referred to as *roko* throughout the region. The hard outer bark is removed first, then the inner fibers, called bast, are subjected to multiple stages of drying, folding, wetting, and beating with a specially carved hardwood mallet. This multiday process of creating a cloth of consistent thickness with a lightly textured, undamaged surface requires considerable skill and training. Mangbetu artisans were considered especially talented, and neighboring Zande communities eagerly acquired their bark-cloth creations as luxury imports in the late nineteenth and early twentieth centuries.

Bark cloth is widely embraced across the Niger-Congo region, where the technology for creating it may

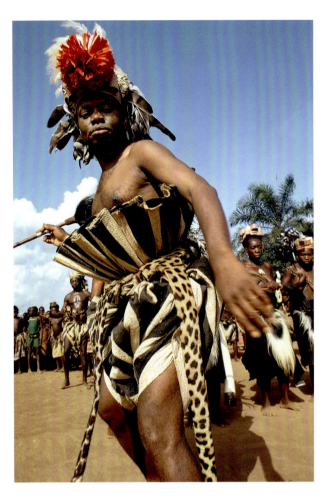

Fig. 26. Chief Teingu wearing a dance ensemble that includes a deep-brown and cream-colored multipanel *nogi*, Mongomasi village, Democratic Republic of the Congo, 1970

date back more than six thousand years. A distinguishing feature of bark cloth is the great width it can reach during production. As the vertically oriented bast fibers are macerated by the beater, they spread apart horizontally, making the cloth thinner and more flexible. The dimension of the original bast section greatly increases across the width, while the length increases minimally. In one recorded example, a bark panel that began at 108 inches by 18 inches expanded to a still-stiff cloth that measured 126 inches by 88 inches.

This *nogi* is composed of five bark-cloth panels cut to form rectangles and trapezoids. Joined by raffia-fiber whipstitching, they create a wide fan shape. The symmetrical composition consists of a central black-dyed panel framed by ornamented and natural-toned sections. The stamped circle and sunburst motifs on the ornamented panels further enhance the garment's prestigious character and visually proclaim the time and effort expended on this finery.

While many communities elsewhere in Central Africa have valued design formats based on organic movement, Mangbetu aesthetics place a strong emphasis on balance and symmetry. This extends not only to the composition of royal bark-cloth garments like this *nogi*, but also to the arrangement of performances and public ceremonies. Early researchers documented the careful organization involved in Mangbetu court procedures with identically posed officials grouped in equidistant pairs around a central event. The symmetrical format and embellishment of clothing underlines these broader aesthetic and social ideals.

28

Prestige panel

Dengese artist(s)
Sankuru River region, Democratic Republic of the Congo, early–mid-20th century
Raffia palm fiber, dye, 22 × 26 in. (55.9 × 66 cm)
Gift of William B. Goldstein, 1999 (1999.522.8)
Recorded provenance: Mary H. Kahlenberg, Tai Gallery, Santa Fe, NM, by 1995;
William B. Goldstein, Wilton, CT, 1995–99

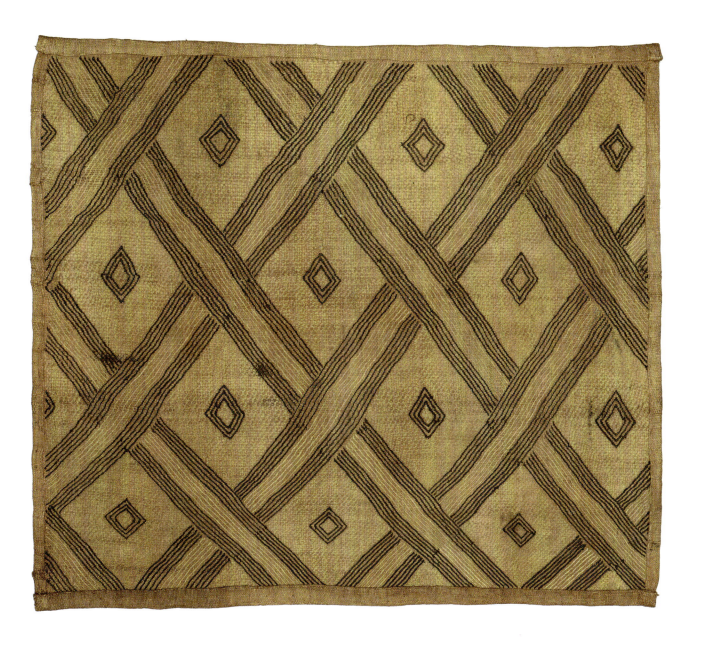

Coarsely woven and embroidered Dengese panels are among a vast body of Central African textiles created from the leaf fibers of raffia palms. These trees flourish throughout the verdant forest-savanna of equatorial Africa, from the Atlantic coast to the Great Lakes region. As early as 3000 BCE, artisans living in present-day Cameroon began harvesting raffia palm leaves and transforming their stiff fibers into cloth. By the fifteenth century, specialists in the Nkisi Valley in the Kingdom of Kongo had refined raffia-weaving, -dyeing, and -embroidering techniques to create a lavish array of textiles that could be worn and displayed as status symbols. Unembellished cloths were also used as an important currency within regional trade networks. In parallel, Dengese, Mbun, Pende, and (later) Kuba weavers and embroiderers developed their own specialized practices that drew from local sources of inspiration and from techniques employed on raffia cloths exchanged across the region.

Although fibers can be harvested from all species of raffia, those of the *Raphia textilis* and *Raphia gentiliana* may have been preferred because they produce the longest strands. The harvesting and transformation of raffia fibers into woven panels has primarily been a male occupation. Young boys procure the leaves by climbing the palms and cutting off a closed leaf shoot once it has gained a certain height. A knife is used to remove the midrib and strip away the thin outer tissue from the individual leaflets. The remaining inner fibers are then left in the sun to dry. The dried leaflets, which are of limited length, are hand-sectioned and may be combed into the thin strands required for weaving. An experienced male weaver then sets up the warp by tying small bundles of the processed fibers onto two horizontal bars. Additional tools and accessories are added to create a single-heddle loom. Collectively, these items assist the weaver in creating tension on the warps, keeping the strands untangled while dividing them into odd and even sets, opening the alternating sheds, and packing the wefts along the warps during the weaving process. Individual raffia strands are added in each weft shed. When the panel is cut from the loom bars, all four sides bristle with a stiff fringe. Because the raffia strands are not joined to create longer lengths, the dimensions of a woven panel are limited by the length of the processed fibers. However, these panels can be joined to others to create cloths of any desired dimension.

The completed plain-weave panels are then turned over to a female relative for further processing. The unfinished edges of this Dengese example were folded to the

front and stitched in place. The area under these protected perimeter seams reveals that the panel was originally dyed a rich brown-pink, although the exposed fibers have faded to a warm beige. The textile was embroidered with fibers that were more finely divided than those employed for its weaving. The artist alternated her use of black-dyed and naturally warm-yellow fibers to execute a diagonal interlace pattern in stem stitches. The open sections in the lattice were further embroidered with yellow cut-pile punctuated with a small black diamond. Similar interlacing was carved onto wooden figures of male *itoci* dignitaries and etched onto the body as bold cicatrices. While regular, rhythmic patterning, as well as the spare use of cut-pile embroidery, are hallmarks of Dengese arts, rare preserved examples of similarly patterned raffia cloths from the seventeenth and eighteenth centuries suggest that many patterns are of some antiquity and continue to be interpreted and valued across the region (see fig. 27).

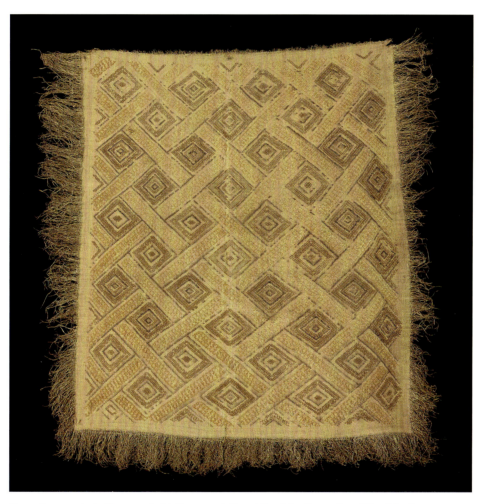

Fig. 27. Luxury cloth. Kongo artist(s). Democratic Republic of the Congo, Republic of the Congo, or Angola, 17th–18th century (inventoried 1709). Raffia palm fiber, dye, 39 1/8 × 35 7/8 in. (99.5 × 91 cm) excluding fringe. Museo delle Civiltà, Rome (5472)

CENTRAL AFRICA 129

29

Double prestige panel

Kuba artists
Sankuru River region, Democratic Republic of the Congo, late 19th–mid-20th century
Raffia palm fiber, dye, 20 × 45¾ in. (50.8 × 116.2 cm)
Gift of William B. Goldstein, 1999 (1999.522.15)
Recorded provenance: Mary H. Kahlenberg, Tai Gallery, Santa Fe, NM, by 1996;
William B. Goldstein, Wilton, CT, 1996–99

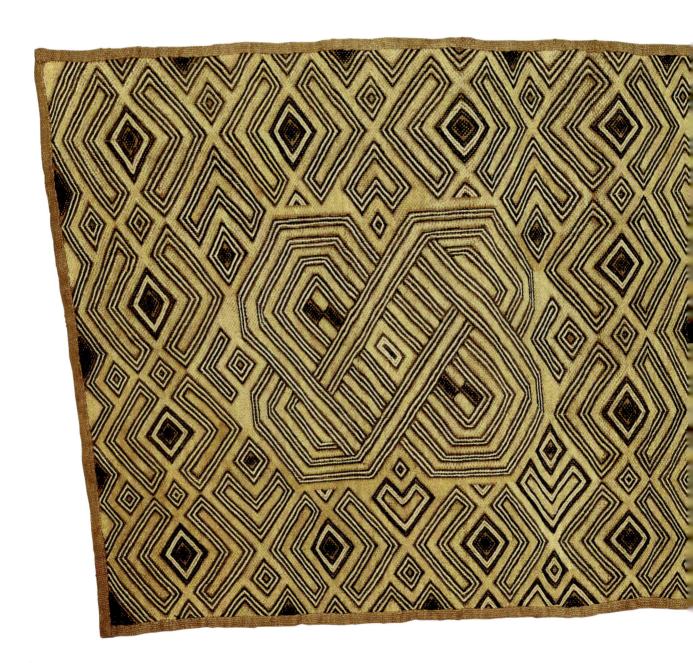

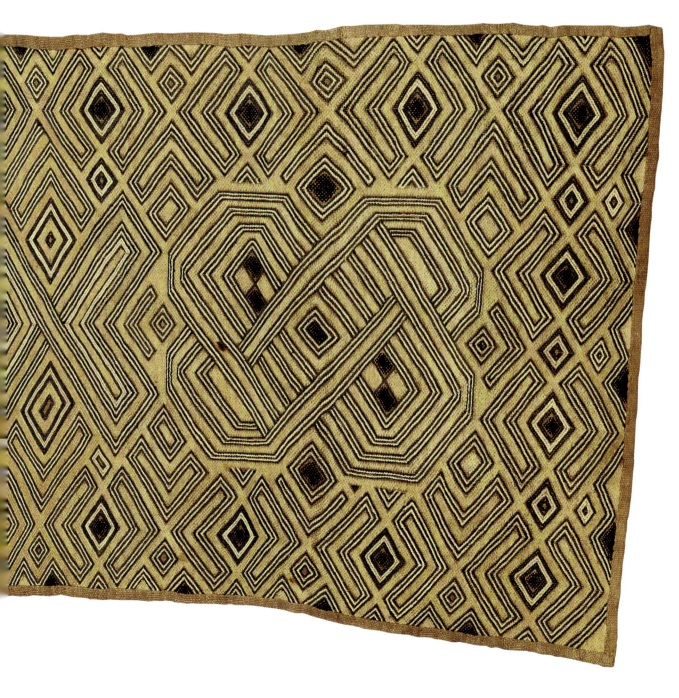

CENTRAL AFRICA 131

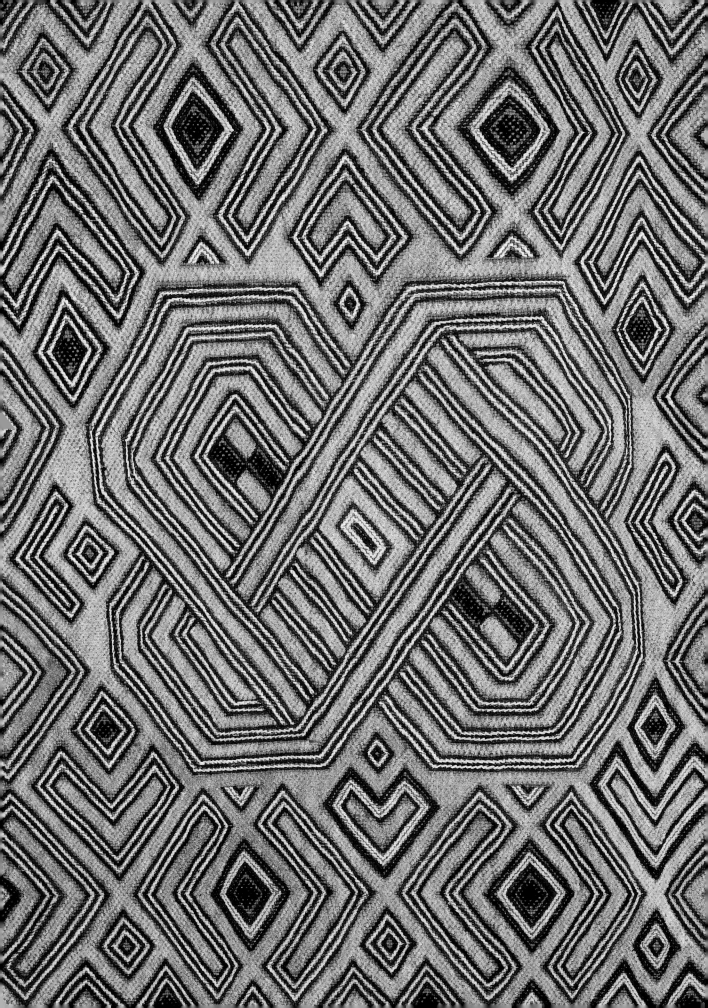

Within the Kuba kingdom, textiles served as forms of visual and material wealth that nearly all members of the community sought to produce, trade, and accumulate. So embedded were raffia weavings in Kuba culture that they factored into oral histories of the founding of the kingdom. First published by Belgian anthropologist Jan Vansina, these narratives include retellings of the travels of aMbul aNgoong, the son of an enslaved woman, who visited various lands in Central Africa, likely as a trader, to gather the wisdom and power necessary to rule. Central to his newly acquired knowledge were embroidery techniques, particular styles of courtly dress, and raffia-weaving methods. With these skills and others, aMbul aNgoong united the various chiefdoms of the Kasai River region, establishing his capital at Nsheng among the Bushong clan. As *nyim* (king), he identified so closely with woven and embroidered cloth that he adopted the term for raffia palm, *shyaam*, as one of his regnal titles, styling himself Shyaam aMbul aNgoong (r. ca. 1625–40).

Subsequent rulers embraced raffia textiles as emblems of political rank and social status within the highly stratified court that developed. The *nyim* based in Nsheng, as well as subordinate chiefs elsewhere in the kingdom, amassed great quantities of plain and decorated cloth within their treasuries. Undecorated woven raffia panels (*mbala*) circulated as currency. Lavishly embroidered cloths like the present example were displayed at public ceremonies as signals of familial wealth, taste, and authority. Clans put great effort into creating and acquiring textiles for use during an individual's lifetime and in their death. Indeed, the Kuba believe that the deceased must be shrouded in bark cloth and raffia finery to enter the land of the dead and be immediately identified as Kuba. In the three- to nine-month period of mourning that follows a death, female relations remain in their homes and devote themselves to sewing and embroidering in order to replenish the family's depleted textile stores.

The flaring rectangular shape of this finely embroidered double panel was created by joining two plain-weave *mbala*. At their join, the trimmed edges of each panel were folded and stitched to each other and to the back of the textile, creating a central seam that is visible from behind. Once the two pieces were joined, the unfinished perimeter edges were trimmed so they could be seamed after patterning. Within that border, the surface of the cloth was completely covered with cut-pile and stem-stitch embroidery to create a rich, velvety surface of geometric patterns.

The mazelike designs were organized according to a fractured symmetry. Each panel is dominated by a central interlace motif known as *imbol*, or the royal knot. Employed across Kuba visual media, the meaning of this ubiquitous symbol varies greatly—it can be highly esoteric in nature or can more concretely reference lineage and social status. Encircling the double panel are nested diamonds, held between wide V shapes. These patterns are further used as a vertical column that runs just left of the center of the textile. Within this ordered composition, a large, twisted X abruptly breaks the design. This tension between balance and repetition, on the one hand, and rhythm and variation, on the other, is a key principle of Kuba aesthetics. Over many centuries, infinitely expanding networks of interlace patterns have been variously applied to ceramics, ivories, architecture, carved wooden artifacts, and the human body.

30

Mapel (man's ceremonial skirt)

Kuba artists
Democratic Republic of the Congo, mid–late 19th century
Raffia palm fiber, cotton, dye, 2 ft. 5 in. × 12 ft. 4 in. (73.7 × 375.9 cm)
Gift of William B. Goldstein, 1999 (1999.522.3)
Recorded provenance: Acquired in Central Africa, early 20th century; Minnesota Museum of American Art, St. Paul, by 1973–97; Butterfield & Butterfield, San Francisco, 1997; William B. Goldstein, Wilton, CT, 1997–99

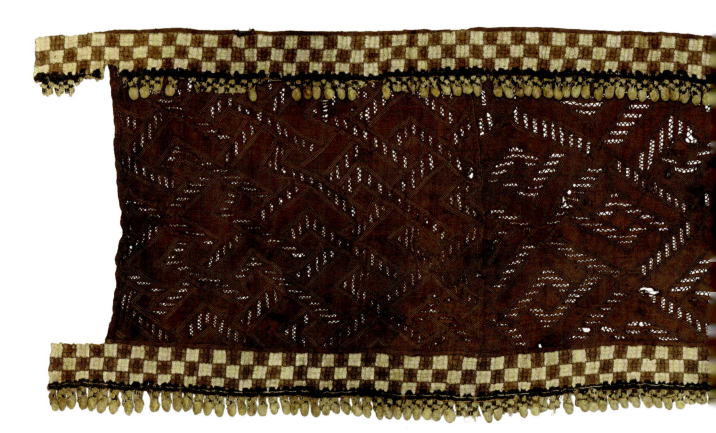

This richly detailed seven-panel cloth is a large fragment of a man's ceremonial skirt, examples of which could extend to over thirty feet in length. These monumental textiles were wrapped, gathered, and pleated around the torso to create extravagant layers of handwoven and embroidered raffia that spoke to the wearer's access to and control over the labor and raw materials needed to create such a prized garment. Worn at momentous events, including the investiture rites of kings and chiefs and the funeral ceremonies of important dignitaries, *mapel* had a scale and visual drama that punctuated the movements of court officials during public performances.

Such bold, sumptuous fashions became increasingly popular during the second half of the nineteenth century, when the Kuba court was enriched through their monopoly over the ivory and slave trades in their confederation. This economic and political authority allowed the Kuba to retain control of their borders, resist colonial intervention, and restrict access to European commercial goods. Under these conditions, local artistic production flourished. While all members of the kingdom, from the general population to the elite, were expected to learn a craft, specialists created the most prized works. The affluence and grandeur of the court attracted these highly skilled

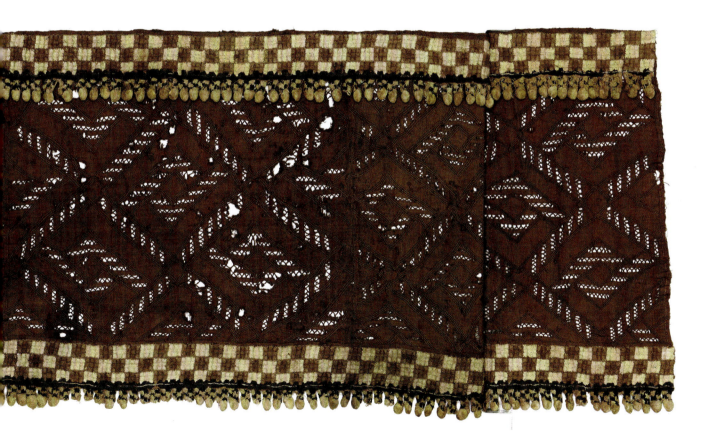

CENTRAL AFRICA 135

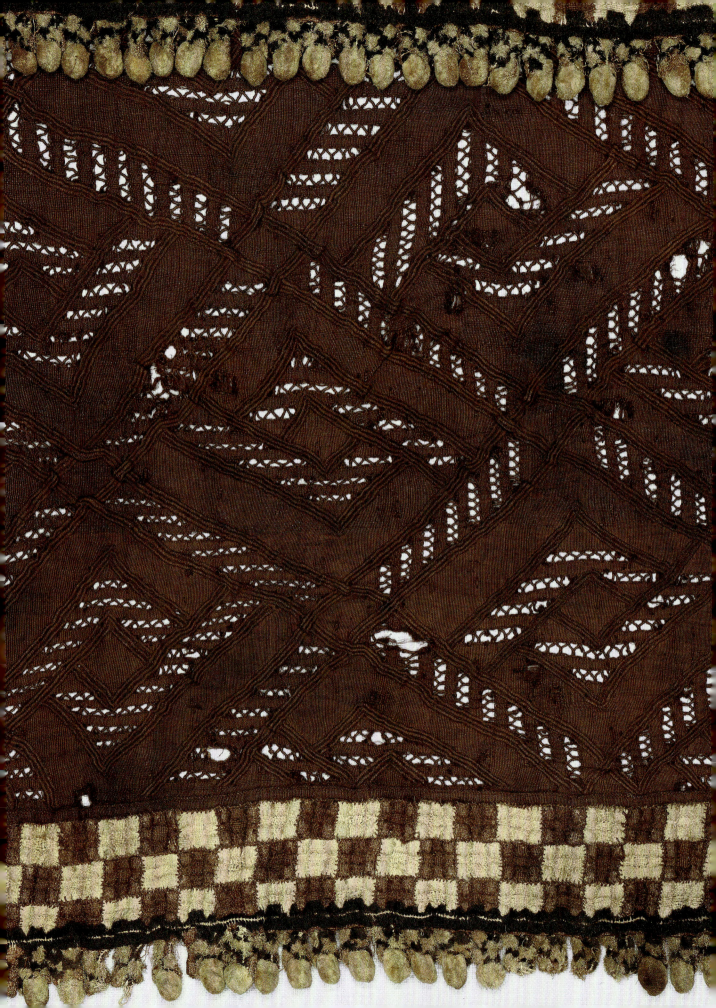

weavers, sculptors, and metalsmiths to the Kuba capital at Nsheng, where many worked exclusively for the *nyim* (king). His splendor was further magnified by the royal tribute system, which ushered wealth into the capital in the form of prestige goods from allied Kuba clans. This courtly opulence complemented the development of complex social structures. Every art form and specialty were honored with a title and officially represented at ruling councils.

While all members of Kuba society may don raffia clothing for celebratory and solemn occasions, wearing sumptuous *mapel* has been the exclusive prerogative of male titleholders. All elements of these lavish garments were woven, assembled, and embroidered by male specialists, except for openwork and cut-pile techniques, which were undertaken by female artisans. *Mapel* are composed of a consistently patterned main field that is enclosed, at top and bottom, by one or more elaborate composite borders. The left side of this skirt appears to be unfinished, as related examples are typically completed with a narrow border on that edge. On the right edge, remains of stitching indicate missing panels. This *mapel*'s ambitious cut-and-embroidered field pattern features variations of interlocking L shapes enclosed in a diamond lattice. The checkerboard border is created from hundreds of small squares of red-dyed and natural-toned woven

raffia that were individually cut, folded, and seamed together. What at first appears to be embroidered pile cloth is, in fact, woven cloth with thick bundles of finely divided raffia fibers stitched atop it—the bundles and the underlying cloth were cut into sections and capped with large pom-poms. The technique used to create a pilelike surface is similar to that used to create the decorative edging on Mbun skirts (see no. 33), highlighting how Kuba artisans drew inspiration from (and inspired) the styles and techniques of creations produced within and without the kingdom.

Mapel have a definite orientation when worn. The upper border and fringe band is attached to the main skirt panel with its finished surface facing toward the body. When the skirt is pleated and wrapped around the torso, one or more belts are employed to secure the garment below the upper border. This creates a wide lower circumference that allows the free movement of the hips and legs. The overall weight of the combined layers of the lengthy skirt and accompanying belts—which are densely covered with beads, cowrie shells, and other attachments—is considerable. Even so, the range of motion offered by the positioning of the skirt enabled performers to complete high leaps and other acrobatics at court ceremonies while wearing such weighty finery.

31

Ncák (ceremonial skirt)

Kuba artists
Kasai River region, Democratic Republic of the Congo, early–mid-20th century
Raffia palm fiber, dye, 2 ft. 2 in. × 13 ft. 11 in. (66 × 424.2 cm)
Rogers Fund, 2004 (2004.254)
Recorded provenance: Austin Newton, Princeton, NJ, by 2004; Andres Moraga, Berkeley, CA, 2004

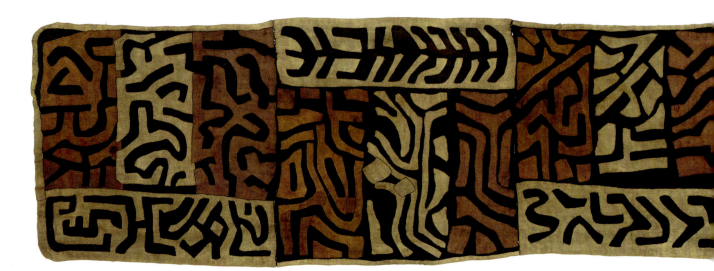

The design formats and tailoring techniques employed in the creation of *ncák* remained relatively consistent from the nineteenth through at least the late twentieth century. These skirts are recognizable by their lengthy proportions and narrow seamed perimeter, which is formed by folding forward and sewing down the fabric's edges. That this ceremonial garment embodies these characteristics yet produces a wildly different visual effect from a typical early twentieth-century *ncák* (fig. 28) is a testament to Kuba women's imaginative compositional freedom.

The production of these elaborate raffia skirts is a collaborative venture that instantiates relationships among clan members. Production begins by preparing raffia fibers that men weave into *mbala* (plain-weave cloths). The female head of a clan typically organizes the creation of these garments. Once she acquires the necessary units of *mbala*, she enlists the skilled labor of her female relatives and organizes their work, which begins with them pounding the stiff cloth to soften it. She may also outline the embroidery patterns before assigning specific panels to the others, and, once the embroidery is

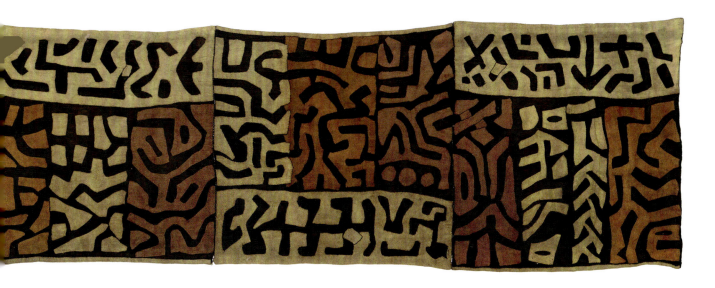

complete, she is responsible for assembling and finishing the garment. Resulting from this cooperative effort, the completed *ncák* is not owned by an individual, but rather is considered clan property.

This six-panel *ncák* is exceptional for the assertiveness of its overall design, the exploitation of the dark fabric as it shifts from figure to ground, the method of joining the panels, and the innovative juxtaposition of border and field. Privileging the square format of the primary *mbala* unit, the six panels were each shaped, layered, seamed, and finished before they were joined together. All are similarly composed of three vertically aligned rectangular units that occupy two-thirds of each square, and one horizontal rectangular unit that fills the remaining space. Alternating panels were rotated 180 degrees so the placement of the horizontal unit switches between the top and bottom of the garment, disrupting the typical format of consistently aligned panels. Color variations among the motifs reinforce their shifting orientation. In five of the panels, the vertical rectangles are created using appliqué, a technique in which shaped pieces of cloth are sewn onto a foundation fabric. The

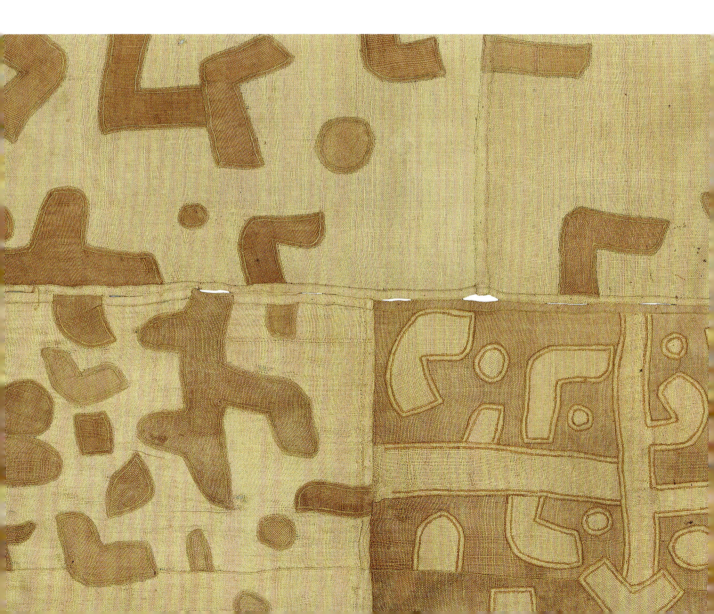

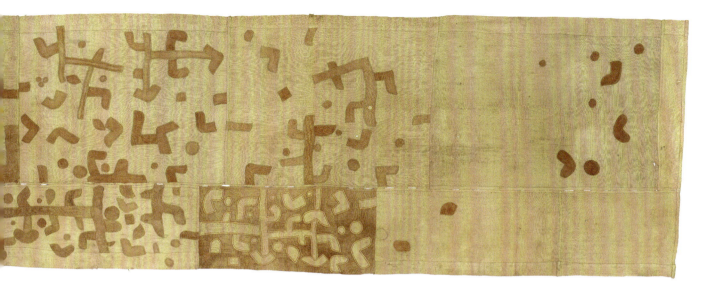

Fig. 28. *Ncák* (ceremonial skirt). Kuba artists. Sankuru River region, Democratic Republic of the Congo, first half of 20th century. Raffia palm fiber, dye, 2 ft. 9½ in. × 16 ft. 1 in. (85.1 × 490.2 cm). Bequest of John B. Elliott, 1998 (1999.47.78)

Fig. 29. Detail of the *ncák* in fig. 28

horizontal motifs and the entire leftmost panel are patterned using reverse appliqué, whereby cloths are layered together and then pieces of one or more layers are cut away to reveal the cloth beneath. The rounded corners of the leftmost panel indicate that it is the outermost "show panel," visible when the wrapper is spiraled around the body.

The geometric organization of this vibrantly colored and layered garment contrasts with the constellations of branching shapes in the relatively quieter seven-panel *ncák* in figure 28. Each panel is similarly divided into two sections—a roughly square section and a narrow rectangle. However, in this instance, all the rectangles are aligned along the garment's lower edge, creating a border-like band. The intricate patterning features whimsical, floating appliqués in simple comma and V shapes as well as more complex configurations that in some iterations resemble a Kuba throwing knife. The light-brown hues of the dyed-fabric appliqués create a lively interplay with the natural gold tones of the raffia ground. While most of the appliqués were added before the individual panels were assembled and joined together, some were evidently added after assembly, as they cross or completely hide seams (fig. 29). Its ambitious design unfolds from right to left—the panel with the fewest decorative elements would have been obscured when wrapped under the three or four layers of the skirt as worn. As the pattern progresses, the motifs build to a lively crescendo in the final panel, which was finished by pleating the perimeter to create rounded edges.

CENTRAL AFRICA 141

32

Woman's overskirt

Bushong-Kuba artists
Democratic Republic of the Congo, 18th–late 19th century
Raffia palm fiber, 15 × 52 in. (38.1 × 132.1 cm)
Purchase, Maureen and Harold Zarember, Drs. James J. and Gladys W. Strain, Seiler Foundation and
Carol and Jerome Kenney Gifts, and funds from various donors, 2004 (2004.252)
Recorded provenance: Austin Newton, Princeton, NJ, by 2004; Andres Moraga, Berkeley, CA, 2004

This rare early example of a densely embroidered Kuba overskirt is among the most prestigious creations associated with Kuba women's expertise and consumption. Although contemporary versions have greater dimensions, such overskirts continue to be worn by elite women during public celebrations, where they are layered over ample, often equally embellished, underskirts (see no. 31, fig. 30). They may also be displayed and then buried as part of funerary rites for the venerated dead. This example is composed of seven tightly woven panels. Two large panels create the foundation for the center field and five narrow ones constitute the border. The undecorated portion of one narrow end is a standard characteristic of overskirts, and the damage they often sustain is the result of their being tightly anchored or tucked into the wrapper and belt assembly. Contemporary overskirts continue to follow the standard organizational format seen here.

Weaving is a primarily male occupation throughout Central Africa, and most Kuba men learn to weave cloth for family consumption. The skill displayed in the weaving of these panels, however, demonstrates that they were produced by a professional weaver. The finely divided raffia fibers were expertly prepared and woven with almost equal warp and weft counts. The flexibility of the fabric and the slightly fuzzy surface of the overskirt's underside is evidence that the foundation cloths were pounded in mortars. While men always weave the foundation fabrics, both men and women pound raffia cloth in mortars to soften it. Once the garment's base cloths were prepared, women would have undertaken all aspects of its design and construction. Whether produced by an individual or by multiple clan members, this cloth evinces an assembly and needlework patterning of high quality that suggest it was the work of a well-trained artisan or group of artisans. The entire surface of the center field has been elaborated with rib-textured, interlocking T shapes built from thousands of tiny stem stitches that each pass under a single thread of the foundation fabric. This rhythmic, uniform patterning may have relied on a charcoal underdrawing sketched by the female head of the clan in advance of the embroidery. It may also have benefited from a counted thread system to organize the stitches. The borders were embroidered using the same stem stitch, this time to create a repeat series of stacked full and split diamonds. In the center field and border designs, the changing angle of the stitches further emphasizes the intricacy of the patterning and creates subtle differences in how

the light reflects on the surface. Indeed, while the entire composition relies on the golden tones of natural raffia, the contrast between the lighter, shimmering sections and the darker, matte tones depends on the orientation of the stitches.

To complete the garment, the unfinished perimeter edges of each of the seven panels were double folded to the face and stitched in place, after which they were joined to form the full overskirt. A complex knotted border was added on the outer perimeter as a final sumptuous detail. Although parts of the worn face have taken on a gray tone, glimpses of the warm ocher of the natural raffia can still be seen. The subtle play of light within the monochromatic palette, as well as the uniform repeating motifs of the field and borders, is closely associated with the design sensibilities of the Bushong, the ruling clan into which the *nyim* (king) of the various Kuba chiefdoms is born.

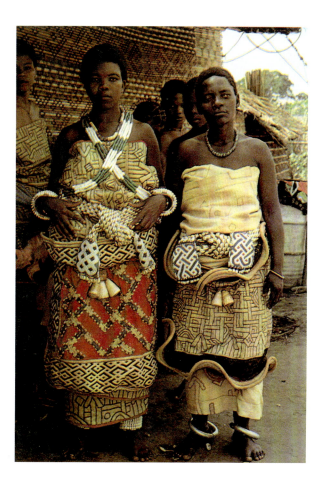

Fig. 30. At left, the wife of Nyim Kot a-Mbweeky III (r. 1969–present) wears an overskirt around her *ncák* (red cloth has replaced the former pile panels). At right, a wife of the preceding *nyim* Mbop aMabiinc maKyeen (r. 1939–69) wears a flounce-edged overskirt decorated with a pile border and linear embroidery. Democratic Republic of the Congo, ca. 1976

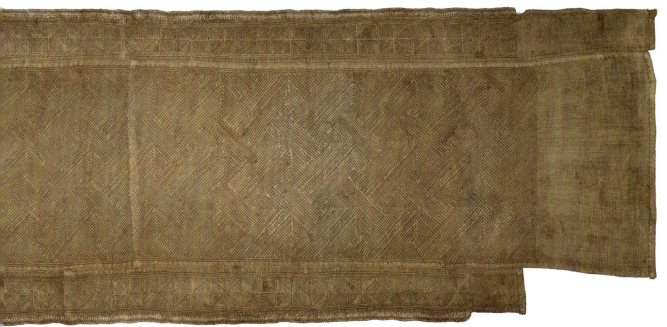

CENTRAL AFRICA 143

33

Woman's ceremonial skirt

Mbun artist(s)
Southern Kasai River region, Democratic Republic of the Congo, late 19th–early 20th century
Raffia palm fiber, dye, 27 × 40½ in. (68.6 × 102.9 cm)
The Bryce Holcombe Collection of African Decorative Art, Bequest of Bryce Holcombe, 1984 (1986.478.46)
Recorded provenance: Bryce P. Holcombe, New York, by 1984

This finely woven and embroidered woman's skirt is one of a modest corpus of richly patterned raffia garments attributed to Mbun weavers living in western Central Africa. Little has been published on the histories of these textiles or those who wove and embroidered them. The most detailed information about the Mbun comes from oral narratives from neighboring Kuba, Kongo, and Pende populations, recorded by Belgian anthropologist Jan Vansina in the mid-twentieth century. According to those accounts, the Mbun migrated from the Kwango River region on the border with Angola to their present location, south of the lower Kasai River, sometime between the fifteenth and seventeenth centuries. There, they integrated into extensive trade networks connecting many Central African communities, within which raffia textiles served as important units of currency, wealth, and prestige. The centrality of the Mbun within this region is attested by Kuba histories crediting them as the source of Kuba political structures, urban planning, and some embroidering techniques—although it appears that little of these diverse systems has been maintained among today's decentralized Mbun communities.

Textiles preserved in museum collections thus offer valuable insights into the history and creativity of this influential Central African society. This Mbun skirt, like similar works from this corpus, is composed of seven pieces of raffia cloth. A large central panel of woven raffia is visually divided into two halves by a narrow embroidered rectangle bounded by short, cut-fiber pom-poms and filled with variations of nested diamonds. A smaller rectangular panel is seamed to the left and right of the central panel. The three joined pieces are flanked by two

panels at top and at bottom. These borders are filled with embroidered variations of diamond and zigzag patterns and edged along their upper and lower perimeter with additional cut-pile fringe.

The layering of subtle surface embellishments on Mbun garments is exceptional among raffia textiles produced in this region. The carefully combed raffia fibers used for the foundation fabric and for the tufted fringe are of the finest quality. Subtle stripes of darker and lighter fibers are woven into all three central panels, a masterful effect similarly employed on other Mbun skirts. The panels are further patterned by means of skipped interlacing to create subtle geometric surface patterning. The two end panels feature a regular diamond-lattice pattern, while the central rectangle is articulated with zigzag stripes running parallel to the long axis of the cloth. A sophisticated contrast is created between the matte finish of the foundation structure and the shinier quality of the skipped interlace patterns. Further embellishment is created by dark-brown-dyed and natural-colored raffia embroidery fibers tightly twisted into smooth and shiny cords that rise above the woven foundation. This same embroidery yarn was knotted into tiny balls to create the raised diamond patterns in the embroidered center band. The embroidered and woven patterns, as well as the use of knots and pom-poms, relate to patterning strategies employed by Kongo and Pende craftsmen in the seventeenth and eighteenth centuries, suggesting the movement of goods, techniques, and even artisans between these neighboring communities.

The fine craftsmanship and layered embellishments of such garments have made them into a form of tangible

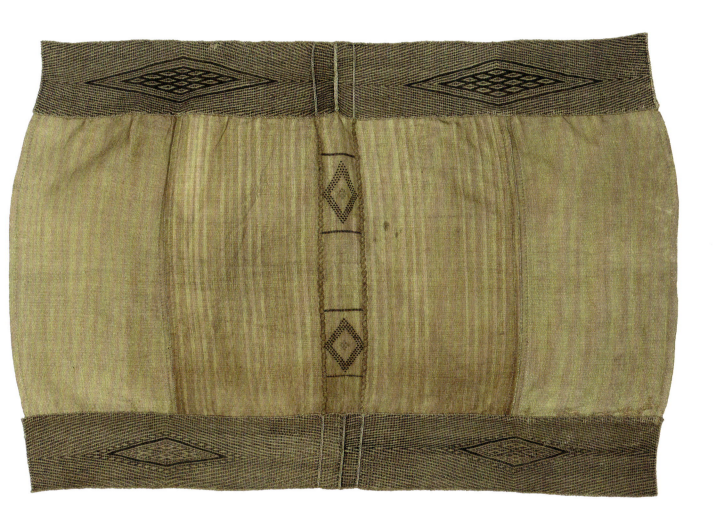

wealth that speaks to the time and skill lavished on them by specialized weavers, dyers, and embroiderers. The uses of these elaborate textiles within Mbun communities are not recorded, but their small scale may indicate that some were intended to shroud venerated dead. On the other hand, the format, weaving quality, and labor-intensive embellishment strongly suggest that many were created to be worn by elite women, perhaps as a top layer over a series of skirts wrapped and secured around the waist, similar to Kuba women's overskirts (see no. 32).

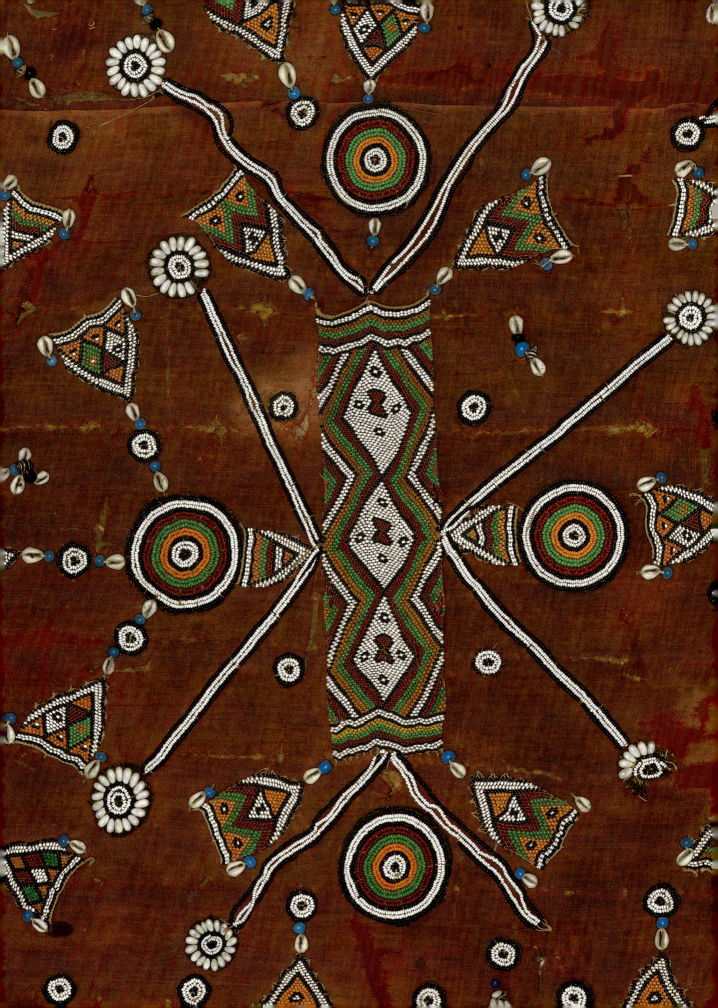

34

Te saqwit (tent divider)

Beja artists
Eastern Sudan, mid-20th century
Cotton, leather, beads, cowrie shell, doum palm leaf (*Hyphaene* species, possibly *thebaica*), dye,
5 ft. at tallest point × 14 ft. 3½ in. across widest points (152.4 × 435.6 cm)
Gift of Jerome Vogel and Susan Vogel, in memory of Shirley Gordon Nichols, 1996 (1996.455)
Recorded provenance: Jerome and Susan Vogel, New York, by 1996

The Beja are a seminomadic pastoral population who, as early as 4000 BCE, have migrated within the Eastern Desert that stretches along the present-day nations of Egypt, Sudan, and Eritrea. Communities of up to two hundred Beja households travel together, and the most defining feature of their camps are familial tents known as *badaigaw* (in Beja) or *bait al-burush* (in Arabic) (fig. 31). These residences are constructed from wooden poles planted in the ground. Bent and secured to one another, they form a domed armature that supports an outer covering of plaited doum palm mats (*burush*; singular *birsh*).

These lightweight structures are disassembled and transported across vast distances on camelback. The creation, assembly, and management of *badaigaw* are overseen exclusively by women, who work in small groups to erect and dismantle their tents under the supervision of an elder female "engineer."

Within the *badaigaw*, space is divided into two main sections: a front section with a lower ceiling height, intended for women's daytime activities, and a more intimate space situated under the tent's dome. This back section is fitted with a raised platform for sleep and

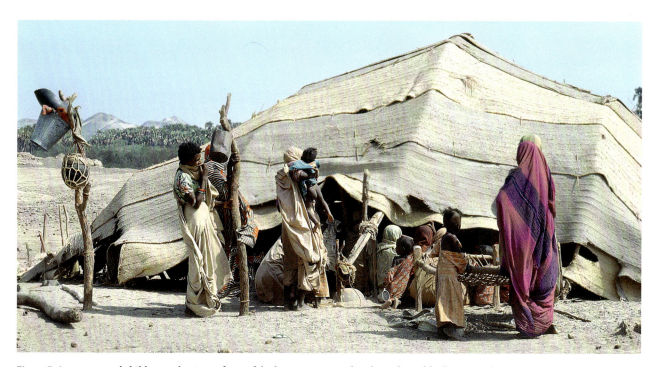

Fig. 31. Beja women and children gathering in front of the low entrance to their large domed *badaigaw*, Sudan, 2005

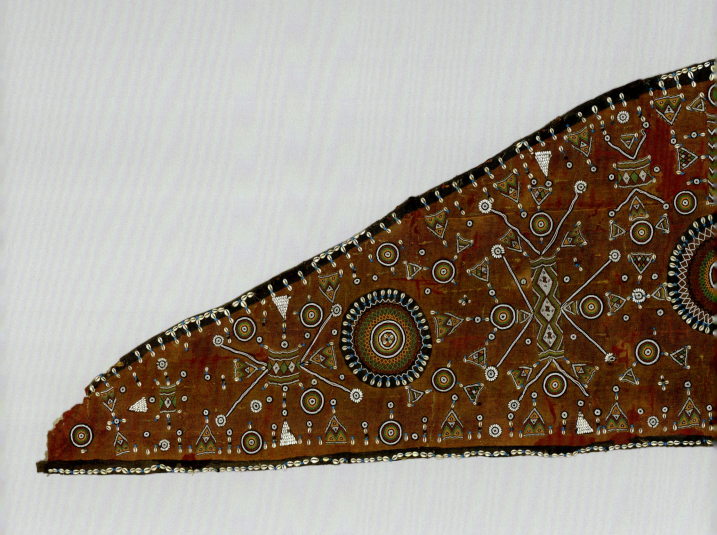

storage. In the rainy season, it may also be used for daytime activities. The division between communal and private spaces is marked by a large structure (*te saqwit*) suspended from the rafters. Hung facing the low entrance and elaborated with imported beads and shells, it is the most prominent and likely the most expensive interior element of the dwelling.

A woman's female relatives produce a *te saqwit* at the time of her betrothal. Layers of dissimilar materials are loosely but securely bound together during fabrication. The foundation is formed from the same doum palm mats that cover the exterior of the *badaigaw*. Here a large single mat, plaited in a two-by-two twill pattern, forms the elongated triangle. Its perimeter was reinforced with plaited palm bands averaging three and one-half inches in width. The lower corners were further reinforced with additional sections of narrow bands. All these pieces were secured to each other and to the larger structure by interweaving and stitching together the plaited bands. One side of the mat was covered with two different colors of mill-woven, plain-weave cotton fabric—an ecru layer overlaid with a red one. The tent divider perimeter was finished by enclosing it in strips of gray-black cotton folded around the edge, then stitching the many layers together.

The tent divider's red face served as the canvas upon which Beja women stitched a dynamic composition of glass beads and shells. Designs depicting crescent and full

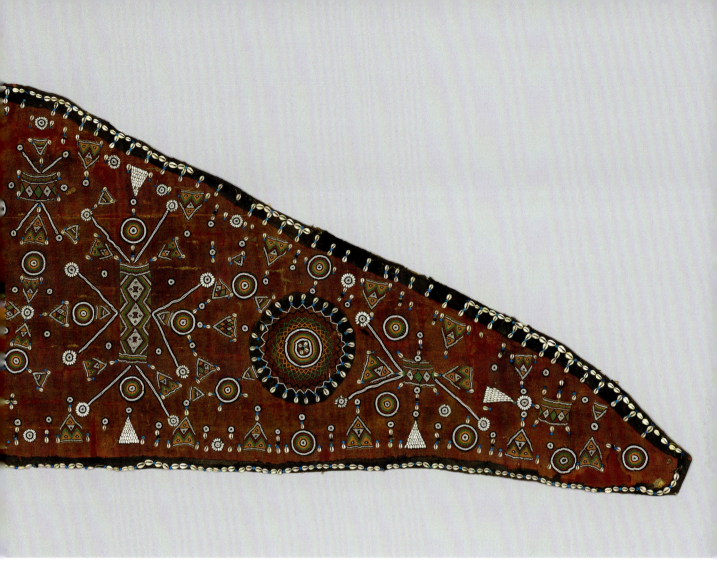

moons allude to marriage and fertility. The dense constellation of imagery also features beaded emblems that that likely include livestock brands, which are considered potent protective symbols within this pastoralist society. Elaborating the access point to the vulnerable and intimate interior space dedicated to sleeping, such amuletic compositions are understood to contribute to the occupants' physical and spiritual protection.

Beja tents are subject to dimensional distortion and wear, as they are regularly erected and dismantled. Thus, individual parts are routinely replaced. The survival of a monumental tent divider is rare, and this twentieth-century *te saqwit* is the only recorded example held in a museum. Scholars Susan and Jerome Vogel came upon it in an Omdurman market, where the valuable beads and shells were being harvested, presumably to be reused in another creation. Following the lead of Beja nomads, the new owners rolled and folded this object into a manageable shape for its penultimate peregrination to their loft in New York.

35

Jibba (tunic)

Mahdist artist(s)
Sudan, late 19th–early 20th century
Cotton, wool, dye, 56 × 41¼ in. across sleeves (142.2 × 104.8 cm)
Bequest of John B. Elliott, 1997 (1999.47.112)
Recorded provenance: John B. Elliott, Princeton, NJ, by 1997; John B. Elliott Estate, 1997–99

This restrained cotton tunic was likely worn by an elite resistance fighter for the Mahdist theocratic state launched in 1881 in the Nilotic Sudan by Muhammad Ahmad ibn ʿAbd Allah. The Mahdist movement developed during an incredibly turbulent period in the history of northeastern Africa. Conquered by Ottoman-Egyptian forces in 1820, citizens throughout the region of present-day Sudan were increasingly subjected to forced labor, heavy taxation, and poor administrative oversight as Egypt and its dominions fell under British control in the late nineteenth century. In response to the growing unrest, Muhammad Ahmad initially devoted himself to prayer and joined the Sammaniyya Sufi order, one of many mystical brotherhoods that promoted a more personal relationship with God. As his reputation grew, he gradually distanced himself from his Sufi brethren and challenged the authority of the British-Egyptian government. Claiming divine authority, he took the title Muhammad Ahmad al-Mahdi, or "the rightly guided," and encouraged his followers to divest themselves of worldly goods, seek *ihsan* (excellence), and resist colonialism. These tunics, which became the most recognizable symbols of the Mahdist movement, reflect that religious fervor by referencing the tattered and patched garments of Sufi ascetics.

While the embrace of such garments was founded on ideas of piety and equality, the desire to differentiate commanders from their troops ultimately led to visual stratification. Officers wore tunics with more elaborate embroidery and brighter patches. Their distinctive appliqués were often sourced from the uniforms of dead enemy soldiers, emphasizing the movement's military prowess and austere thrift.

Women, both free and captive, were responsible for sourcing fabric for these garments, which they also tailored and finished. The wool and cotton fabrics employed in this *jibba* appear to have been commercially manufactured, and they were new or little used when the tunic was created. The garment sections were flat cut—a method whereby the desired silhouette of a tailored garment is deconstructed into flat shapes and arranged on a length of cloth in a manner that produces minimal waste. It was made more adaptable through clever tailoring that created a garment with an identical front and back, a feature of all such tunics examined to date. The symmetrical arrangement of the rectangular black, brown, tan, and blue appliqués highlights the flared contours of the garment, which were created with four gussets around the skirt. Elongated horizontal appliqués under the arm

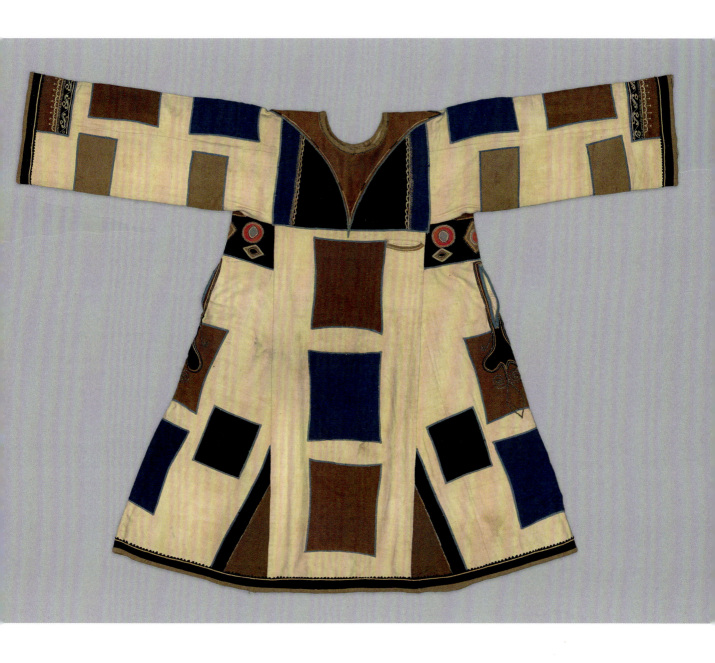

gussets add visual interest along with reinforcement. A wide, concave diamond surrounds the neck opening, drawing attention to the head. The side pockets, yoke, sleeve edges, and underarm patches have been richly embellished with eye-motif appliqués and delicate embroidery. Those additions served to distinguish and protect leaders on the battlefield.

Unprepared for the broad appeal and fervent devotion of the *ansar al-mahdi* (followers of the Mahdi), which included a powerful division of Hadendowa-Beja fighters, British-Egyptian forces quickly succumbed to them on the battlefield. In the four years before Muhammad Ahmad died of typhus in 1885, he led his followers to reclaim nearly all the territory formerly occupied by the Egyptians. His successor, ʿAbd Allah ibn Muhammad, continued this mission, liberating the remainder of Sudan from foreign rule by 1898. However, an overwhelming British military invasion on September 2 of that year led to the loss of over ten thousand Mahdi soldiers at the Battle of Omdurman, the capital of the Mahdist state. Many tunics now held in Western museum collections were taken as spoils of war following that decisive British victory.

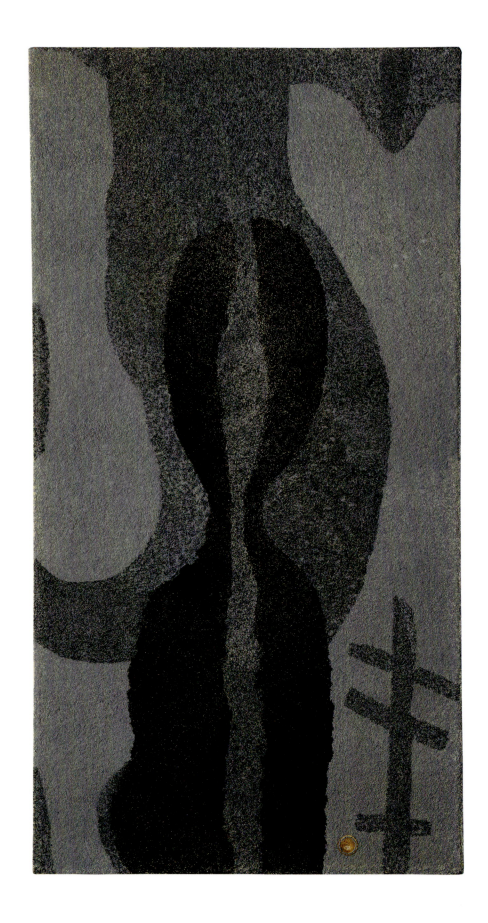

36

Ants & Ceramicists 4

Elias Sime (Ethiopian, born 1968)
Addis Ababa, Ethiopia, 2009–11
Cotton, metal, synthetic fiber, paint, dye, 60 × 33 in. (152.4 × 83.8 cm)
Gift of Ellen Stern, in loving memory of Jerome Stern, 2022 (2022.466)
Recorded provenance: Elias Sime, Addis Ababa, Ethiopia, 2011–15;
James Cohan Gallery, New York, 2015; Ellen L. Stern, New York, 2015–22

Each material I collect has its own story. It has its own language. . . . I think about the first person who thought or dreamed of it and all the people who transformed that dream into a material. I also think about the various people who used and reused the material before it landed in my hands.

—Elias Sime

Created for an immersive installation entitled *Ants & Ceramicists*, this textile panel is one of fifteen large-scale embroideries minutely hand-stitched by Elias Sime to present layered, textured surfaces that convey the movement of hordes of swarming ants with disturbing effectiveness. Along with these wall hangings, the exhibition included woven floor pieces and ceramics the artist commissioned from a community of traditional potters in the Ethiopian capital of Addis Ababa. The installation drew a connection between the ecological service of lowly ants who maintain soil viability and the work of impoverished Ethiopian potters (*shekla seri*) who transform earthen materials into functional forms. For generations these specialists have lived in artisanal communities near rivers, where they can easily source the necessary clay for their creations. In the present day, that land is owned by others who view *shekla seri* as inconvenient pests. Moreover, in recent decades, their livelihood has been threatened by the mass production of cooking and serving vessels. Despite their humble circumstances, ants and ceramicists have endured for centuries, adapting to their harsh environments and developing complex social structures within their respective communities.

Simultaneously captivating and disconcerting, these embroideries highlight Sime's masterful ability to depict fluid form. The majority of his needlework does not re-create individual ant bodies—instead he approaches imagery in an impressionistic manner. Tiny, pointillistic stitches create the effect of entangled masses of insects writhing and flowing across the surface of the panel. Physical clues on the back, around the perimeter, and in the mounting reveal that the unprimed canvas was coated with a thin layer of gray paint. The embroidery was executed prior to securing it to the support. At lower right, where an artist's signature might appear, Sime has stitched on a flattened and punched bottle cap, its interior facing out. One of the most ubiquitous kinds of litter, the bottle cap is here transformed into a shiny avatar. The years of work and physical demands of layering tens of millions of stitches into thoughtfully detailed shapes required Sime to take frequent breaks to ease the strain on his eyes. After he completed his *Ants & Ceramicists* series, he turned from embroidery to mixed-media assemblage.

Sime's practice is defined by salvaged materials that he transforms into visual meditations on the human condition. His more recent *Tightrope* series is composed of works that tessellate and interweave electronic waste into highly detailed, visually rich meditations on the intersection of nature and technology, handicraft and mass production, and the local and global circulation of goods and ideas. Sime's appetite for experimenting with a wide range of materials has paralleled his desire to enrich his art through formal education and the study of vernacular craft practices. He studied graphic art at Addis Ababa

EAST AFRICA 155

University's Alle School of Fine Arts and Design between 1986 and 1990 and works closely with ceramicists and art specialists in the city (such as those from whom he commissioned the vessels for *Ants & Ceramicists*). He has also traveled widely inside and outside Ethiopia to document traditional artistic practices and collect materials. Drawing upon these diverse sources of inspiration, Sime's work challenges viewers to reflect upon the environmental impacts of, and meanings attached to, handmade and mass-produced materials.

37

Kanga (commemorative wrapper)

Designed by Tanzanian(?) artist
Probably Tanzania, 1974
Cotton, dye, 45 3/8 × 58 1/8 in. (115.3 × 147.6 cm)
Gift of Barbara and Gregory Reynolds, 1985 (1985.375.47)
Recorded provenance: Barbara and Gregory Reynolds, Vermont, by 1985

EAST AFRICA 157

Workshop- or factory-produced in great quantities for worldwide consumption, vividly patterned *kanga* fabrics are sold in open-air markets as uncut pairs that can be divided and seamed on the cut ends to create a matching set. These garments are typically worn by women, who wrap one around the waist and the other around the upper torso. *Kanga* may also serve as tablecloths, bed coverings, baby slings, and banners; men may wear them tied over one shoulder; and individuals may transform them into bespoke garments, to list but a few of their diverse functions. The designs of contemporary versions are defined by three primary elements: the *pindo*, or "border," the *mji*, or "city" (referring to the central design), and the *jina*, or "name" (a phrase typically printed on the bottom center of the design).

While *kanga* are wildly popular throughout Kenya and Tanzania, these cloths are marketed across much of eastern, Central, and southern Africa. Their broad appeal connects them to the long history of commercial networks linking port cities across the Indian Ocean since at least the first century CE, in which textiles, particularly those made of cotton, have served as important commodities. That interconnected history can be seen in the design format and individual motifs of some *kanga* (see fig. 32). This uncut indigo-dyed example is related to South Asian saris through the format of its continuous horizontal borders across the uncut lengths. The paisley (*boteh*) motifs and the diamond-and-star patterns reinforce this association, given their long history of use in Indian textile practice. Similarly patterned archaeological fragments have been excavated from Red Sea ports.

By the nineteenth century, merchants had capitalized on the marketability of richly patterned, washable, durable cotton and flooded coastal centers with *kanga* fabrics that were adapted to local color and design preferences. Along the Swahili Coast, formerly enslaved women

and their descendants adopted these garments as a means of asserting their new status as free individuals.

Before the mass production of slogan-bearing T-shirts for propaganda purposes, eastern and Central African politicians, activists, and other leaders of the late 1950s recognized the communicative value of featuring taglines on garments. Many local design and production centers for *kanga* emerged in the late colonial and independence eras between the 1950s and 1980s, especially in Tanzania. The country's first president, Julius Nyerere, promoted a strong national identity that cut across ethnic, linguistic, and religious divides. He further invested in Tanzanian independence through the concepts of

ujamaa (socialism) and *kujitegemea* (self-reliance). Nyerere expanded education and healthcare systems and nationalized many industries, including textile production, dividing it across two centers: Urafiki Textile Company and Karibu Textile Mills.

This *kanga* is a product of Tanzania's post-independence history, marking the tenth anniversary of the formation of the contemporary nation through the merging of the Zanzibar archipelago with mainland Tanganyika. This union followed the violent 1964 Zanzibar Revolution (*mapinduzi*), which Nyerere used as an opportunity to insert himself into Zanzibari politics. He ultimately backed the victorious Afro-Shirazi Party (ASP), granting them semiautonomous status under the banner of his own political party, the Tanganyika African National Union (TANU). This *kanga* was likely created to celebrate the authority of the ASP within Zanzibar—one band of the border is formed from the repeated party acronym, and the center field includes a prominent depiction of the party headquarters. Tanzania's socialist history is alluded to in the *jina*, which states "usiamue peke yako shauriana na wenzako" (don't decide by yourself, consult with your colleagues), referencing shared community values. Such overt displays of political propaganda were likely produced for use as banners and gifts at ASP celebratory events.

Fig. 32. *Kanga* (commemorative wrapper). Unidentified designer. 1960–75. Cotton, dye, 3 ft. 9½ in. × 10 ft. 10 in. (115.6 × 330.2 cm). Gift of Arthur Englander, 1975 (1975.228.4)

38

Les herbes folles du vieux logis

Joël Andrianomearisoa (Malagasy, born 1977)
Paris and Antananarivo, Madagascar, 2022
Cotton, natural and synthetic fibers, dye, 8 ft. 6½ in. × 5 ft. 11 in. (260 cm × 180 cm)
Gift of Hasnaine Yavarhoussen, 2024 (2024.415.1)
Recorded provenance: Studio Joël Andrianomearisoa, Paris and Antananarivo, Madagascar, 2022–23;
Hasnaine Yavarhoussen, Antananarivo, 2023–24

They are paintings—because it's a manipulation of texture, and it's a manipulation of color.

—Joël Andrianomearisoa

Inspired by words and attendant memories drawn from the dark night's transition to day, Joël Andrianomearisoa's multimedia installations fuse the cerebral to the sensual. Examining states of belonging in an uncertain world, he mines the deep and storied history of textile arts in Madagascar and across the globe. This creation is one of thirty monumental "textile paintings" in a series that also includes roughly twenty oil pastel drawings. The developmental process for these larger works occurred over eight months during which the artist experimented with language, created preparatory drawings, and sourced various fibers and textiles from shops and markets around the world, which he finally arranged and layered into highly affective compositions. Roughly translating to "the wild grasses of the old lodging," the title for this series is drawn from the writing of Malagasy poet Maurice Ramarozaka (1931–2010). Inspired by Ramarozaka's melancholic reminiscences of Madagascar's fertile landscape, Andrianomearisoa's series visually invokes similar themes and serves as a nostalgic tribute to the island's natural beauty. Through careful manipulations of texture and color, Andrianomearisoa produces a surface that ripples and shifts like grasses in the wind.

The work requires the viewer's physical movement to fully activate its dynamic, tactile surface. Shifting perspectives expose, sparingly at first, glints of gold and light, then—suddenly—shimmering stripes of color running across the upper half. Viewed straight on, this dimensional landscape is suffused with a somber, organic mood. Its peaks and valleys suggest the riven bark of ancient lowland forests or the furrowed fields of tilled earth. Long, narrow strips of woven fabric, mostly cut on the bias, are divided in half and sewn down their centers parallel to the height of the canvas. These strips are not everywhere continuous; they break, overlap, and restart, adding sharp, jagged edges to the work's surface. The deep-black fabrics that fill the lower half and right side of the canvas ground the creation by absorbing light. The rich natural tones simultaneously recall the colors of stones, earth, and sky as well as the stripes that enrich traditional *lamba* textiles (see no. 39). Approximately two dozen factory-woven fabrics appear here, and their differing structures and finishes enable the bias cut to either limit or promote fraying. The black fabrics are not easily raveled, suggesting endurance and adding to their visual weight. The colored strips easily fray—and indeed, have been encouraged to do so—with the most loosely woven of these now featuring uplifted tangled strands, some quite attenuated, further evoking the grasses of the undulating savannas in the center of Madagascar's verdant landscape.

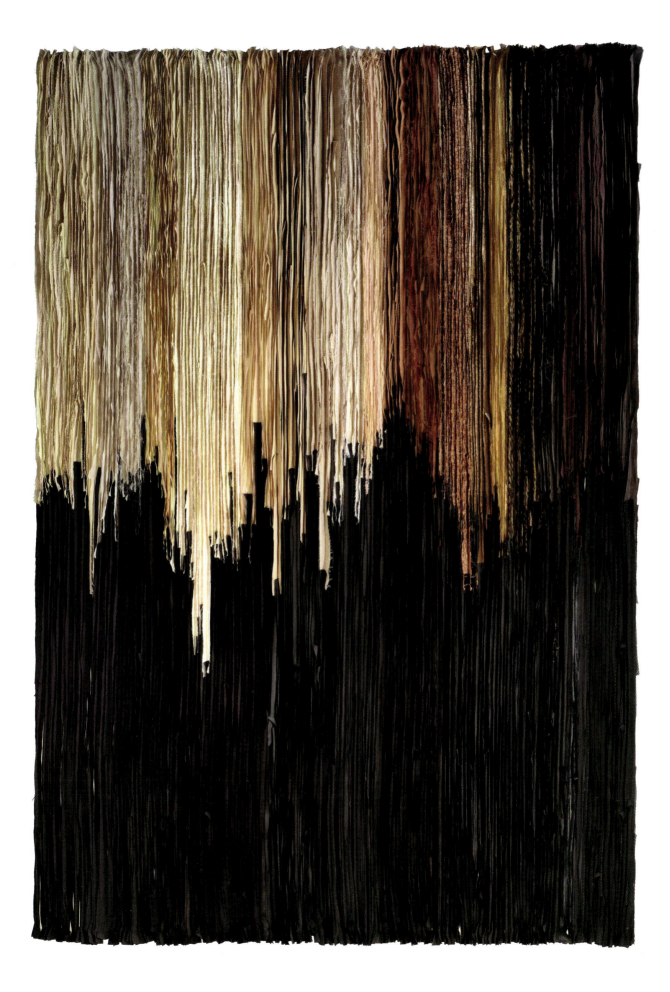

Andrianomearisoa describes himself and his work as grounded in multiple geographies. Toward that goal, he has transformed the world into his studio by involving global artisans in the elaboration of his installations. Raised in Antananarivo, Andrianomearisoa began engaging in diverse artistic circles in the early 1990s, drawing inspiration from musicians, fashion designers, and textile artists. He later moved to Paris, where he graduated from the École Spéciale d'Architecture in 2003. Beginning with fragile paper creations, his practice embraces a mixed-media approach ranging from sculpture and craft to installation and textiles. He has exhibited his creations at leading global institutions, including the Studio Museum in Harlem and the Centre Pompidou, and in 2019 he became the first artist to represent Madagascar at the Venice Biennale. Consciously global in his approach, Andrianomearisoa moves between Paris and Antananarivo, where he cofounded Hakanto Contemporary, a nonprofit independent space for artists, with Hasnaine Yavarhoussen.

39

Lamba akotifahana (mantle with supplementary-weft designs)

Merina artist
Central highlands, Madagascar, mid–late 19th century
Silk, dye, 65¾ × 92⅛ in. (167 × 234 cm)
Purchase, Irene Lewisohn and Alice L. Crowley Bequests, 1992 (1992.44)
Recorded provenance: Mohr Textile Arts, New York, by 1992

Artisans in Madagascar have exploited the island's rich natural resources to create an array of fabrics since at least the tenth century. The fibers they harvested included dwarf banana, raffia, cotton, and the silk of wild *Borocera* moths. Dyes were sourced from *Indigofera* leaves and *nato* and logwood trees, among other flora. As foreign trade intensified in the early modern period, their descendants were introduced to textiles imported from southern and eastern Asia, Europe, and the Arabian Peninsula. Within this thriving artistic environment, female weavers experimented with new media, woven structures, decorative techniques, and styles. By the mid-nineteenth century, the highly skilled female weavers of noble Merina clans had embraced what came to be called "akoty" silk yarns and textiles, imported from the west coast of the Indian subcontinent. This new medium provided the impetus for the production of vibrantly striped *Bombyx mori* silk mantles (*lamba*) embellished with *akotifahana* (discontinuous supplementary-weft) motifs.

The *lamba akotifahana* retains a traditional mantle format, which alternates wide solid-colored stripes with groups of very narrow multicolored stripes. Considerable visual interest is added to this layout by populating the wider bands with intricate geometric and vegetal motifs. Brightly colored *akotifahana* designs break with the restrained low-chroma color scheme employed on traditional mantles; these textiles are transformed by an exuberant palette of yarns with saturated hues, likely inspired by and borrowed from those used in imported textiles.

Ongoing research by art historian Sarah Fee highlights the local and international appetite for vibrant *akotifahana*. Up to the last quarter of the nineteenth century, these textiles were popular among wealthy Malagasy consumers, who wore them wrapped around their shoulders as part of ceremonial attire or gifted them to foreign dignitaries. By 1885, however, Western-style dress became popular among local populations. At the same time, *akotifahana* and similar-style textiles were increasingly commissioned by Europeans. Weavers responded to this shift

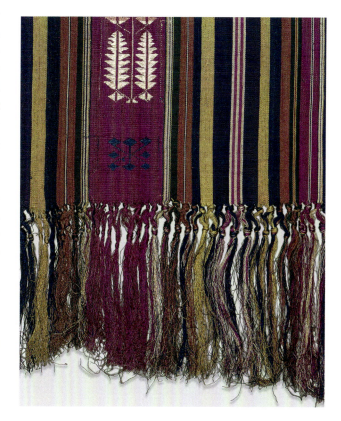

EAST AFRICA 163

by creating cloths in smaller dimensions to accommodate their use as tablecloths and shawls. The French colonial government also promoted *akotifahana* weaving through training programs in Madagascar and displays at colonial fairs throughout Europe, the United States, and Africa. In this period, the cloths' consumption within Malagasy communities diversified to include any individual who could afford one. Weavers further modified their creations to reduce costs for this broader clientele by simplifying the forms and the variety of motifs they produced and by spacing them farther apart.

This example of a *lamba akotifahana* epitomizes a fashion trend of the mid- to late nineteenth century, when highly prized magenta silk floss was imported to Madagascar via Oman. It is created from three panels individually woven on a fixed-heddle Malagasy ground loom and seamed along their selvages. The strong twist of the mantle's thin reeled warp is visible in its fringe, which has been knotted twice, the second knot offset from the first. Like other *lamba akotifahana* from this period, it features an array of motifs. Approximately twenty distinct patterns are generously spaced and randomly repeated throughout the surface's seven wide magenta and navy stripes. Some of the motifs rely on vertical or rotational symmetry, adding to the *lamba*'s visual complexity.

The limited placement of *akotifahana* motifs underscores that in the nineteenth century they were viewed as *haingo*, or decorative embellishments, rather than symbols communicating the rank of the wearer. Color, technique, and fiber have played a much larger role than have motifs in defining the meanings and uses of a given *lamba*. While those woven from imported silk emphasized the wearer's access to global trade networks, those made from local *Borocera* silk, which resists decay, were and continue to be associated with the ancestors and the creator spirit. As such, *Borocera* silk is the preferred fiber used for red versions, known as *lambamena*, that are used to shroud the venerated dead for burial.

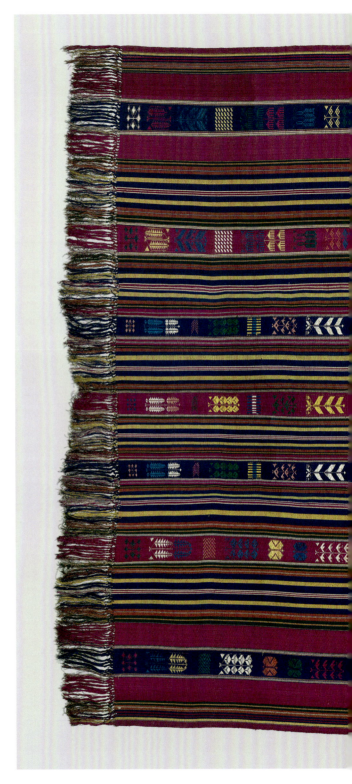

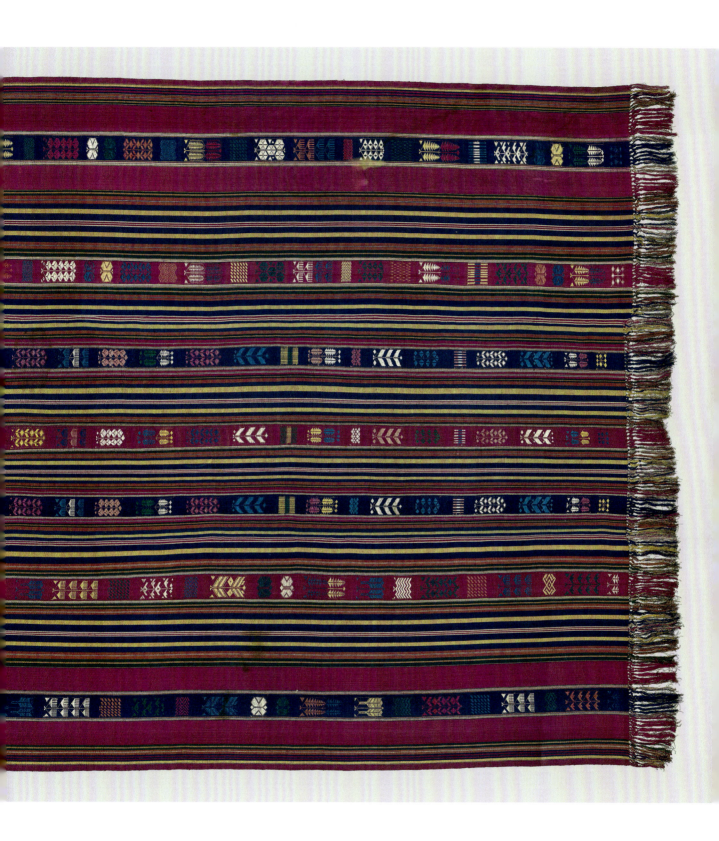

EAST AFRICA

40

Lamba Mpanjaka Marevaka (King's Bright Mantle)

Martin Rakotoarimanana (Malagasy, born 1963)
Antananarivo, Madagascar, 1998–99
Silk, dye, 9 ft. × 5 ft. 10⅛ in. (274.3 × 178.1 cm)
Purchase, Rogers Fund and William B. Goldstein Gift, 1999 (1999.102)
Recorded provenance: Simon Peers, Lamba SARL, Antananarivo, 1998–99

Weaving has been the principal activity of our family for generations and generations.

—Martin Rakotoarimanana

This dazzling display piece belongs to a small corpus of contemporary works designed by Merina fiber artist Martin Rakotoarimanana. Woven by Rakotoarimanana and by artisans working with him at the Lamba SARL workshop between the 1990s and the early 2000s, these creations eloquently reimagine nineteenth-century *lamba akotifahana* (see no. 39). Those textiles, embellished with supplementary-weft designs, were once worn by members of the Merina aristocracy over their ceremonial attire, enrobing the body in an au courant statement. They were also gifted to Merina elites and foreign dignitaries. While production of these lavish mantles continued in various forms through the twentieth century, the tradition had largely stagnated by the 1970s. Established by Simon Peers in Antananarivo in 1994, Lamba SARL revitalized the designs, styles, and techniques of this historic Malagasy fashion.

Prior to meeting Peers, Rakotoarimanana and his family of weavers used the same discontinuous supplementary-weft structure as the renowned nineteenth-century *lamba* in their silk cloths patterned with large floral and bird motifs. Relying on photographs he took of *akotifahana* held in the Queen's Palace Museum at Antananarivo and at the British Museum, Peers introduced the weavers to the historic designs. The timing was prescient, as the Queen's Palace Museum was largely destroyed by fire in 1995. The reinvigorated contemporary weavers of Lamba SARL invest their time in handwoven textile production for both regional and global trade, creating *akotifahana* masterpieces as well as luxury fabrics for a high-end interior design market. They endeavor to continue a centuries-old, once female-led, tradition of handweaving luxury fabrics despite the unfavorable economics of producing bespoke products.

This masterpiece, with supplementary-warp and -weft patterning, is composed of five panels woven on a modified contemporary shaft loom. Rakotoarimanana begins his design process by choosing motifs sourced by Peers from historical *lamba*. He transcribes these into point-paper diagrams for the weavers to follow as they select the pattern warps needed to create them. Weaving these motifs requires an extra heddle set, which is placed in front of the weaver. As artist Hortense Cecilia Harinjaka demonstrates (fig. 33), the appropriate heddles are hand-gathered to selectively raise the binding warps for each row of the pattern, following the paper diagram, which is suspended at eye level. A different paper design may be hung for each motif, but the artists have memorized many patterns and often do not need guides to create them. The foundation structure, controlled by the

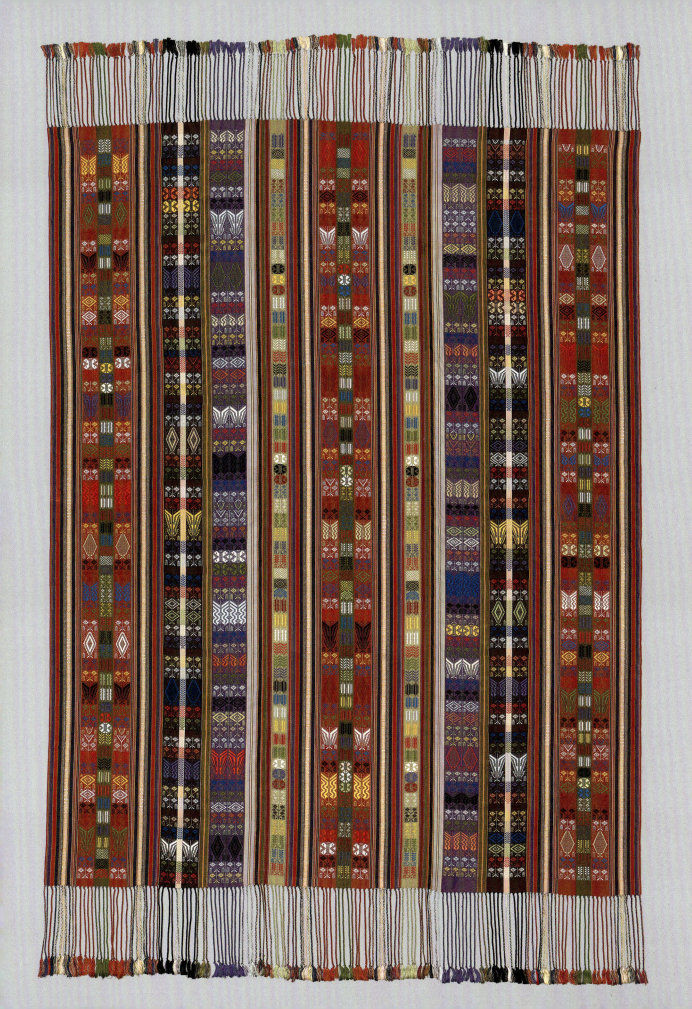

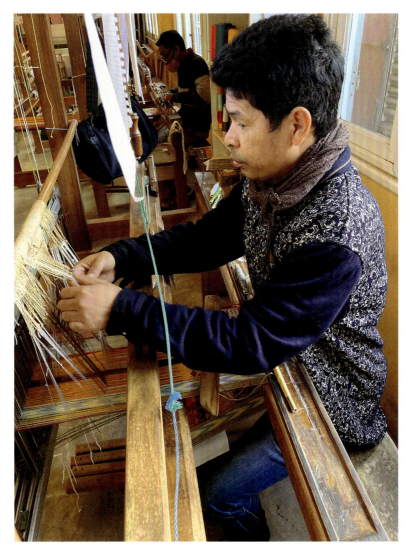

Fig. 33. Merina master weaver Hortense Cecilia Harinjaka working at a locally manufactured countermarch treadle loom fitted with an extra heddle set, Antananarivo, Madagascar, 2021

shaft-loom treadles, is woven between passes of the pattern. Once the finished panels of this example were removed from the loom and assembled by seaming them along the weft selvages, the unwoven warps were gathered and plaited into a long, tidy fringe.

The works made by the members of the Lamba SARL workshop are often intended for display and named in accordance with the awe-inspiring visual impact of the colors and patterns dominating their compositions. This example, titled *Lamba Mpanjaka Marevaka* (King's Bright Mantle), employs hundreds of precisely executed geometric and vegetal motifs that are tightly stacked atop one another across the vibrant purple, red, yellow, and blue striped ground. Typical of the contemporary revivals of Lamba SARL, this masterpiece evokes the splendor and opulence of the nineteenth-century Merina court.

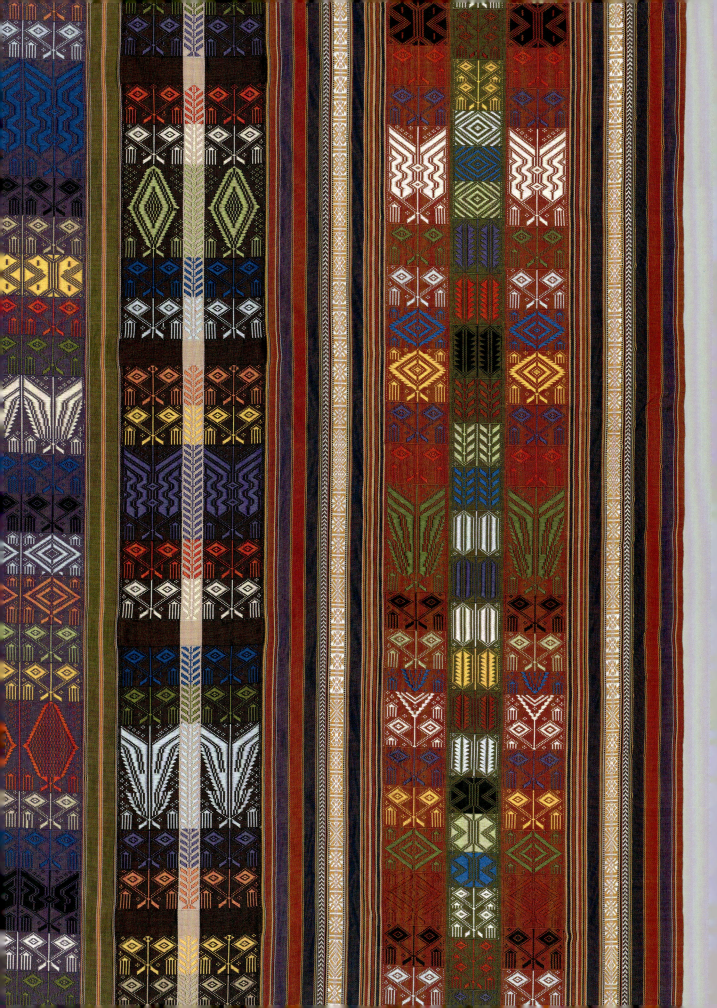

SOURCES

* Asterisks indicate sources for direct quotations in text.

Introduction

Aronson, Lisa. "Akwete Weaving: A Study of Change in Response to the Palm Oil Trade in the Nineteenth Century." PhD diss., Indiana University Bloomington, 1982.

Barber, E. J. W. *Prehistoric Textiles: The Development of Cloth in the Neolithic and Bronze Ages with Special Reference to the Aegean.* Princeton: Princeton University Press, 1991.

* Benjamin, Jody. "Historicizing Fashion in Western Africa: Global Linkages, Regional Markets, and Local Tastes, 1400–1850." In *Creating African Fashion Histories: Politics, Museums, and Sartorial Practices*, edited by JoAnn McGregor, Heather Akou, and Nicola Stylianou, 41–66. Bloomington: Indiana University Press, 2022. Quotation: pp. 42–43.

Burnham, Dorothy K. *Warp and Weft: A Textile Terminology.* Toronto: Royal Ontario Museum, 1980.

Clarke, Duncan. "Aso Oke: The Evolving Tradition of Hand-Woven Textile Design among the Yoruba of South-Western Nigeria." PhD diss., University of London, 1998.

Darish, Patricia J. "Dressing for the Next Life: Raffia Textile Production and Use among the Kuba of Zaire." In *Cloth and Human Experience*, edited by Annette B. Weiner and Jane Schneider, 117–40. Washington, DC: Smithsonian Institution Press, 1989.

Desrosiers, Sophie. "Appendix L: Note sur le damas et sur le «voile» de soie d'Essouk-Tadmekka." In *Essouk-Tadmekka: An Early Islamic Trans-Saharan Market Town*, edited by Sam Nixon, 393–99. Leiden: Brill, 2017.

* Fair, Laura. "Remaking Fashion in the Paris of the Indian Ocean: Dress, Performance, and the Cultural Construction of a Cosmopolitan Zanzibari Identity." In *Fashioning Africa: Power and the Politics of Dress*, edited by Jean Allman, 13–30. Bloomington: Indiana University Press, 2004. Quotation: p. 18.

Fee, Sarah. "Chasing Silk: A Search for Meaning and Memory in Madagascar's Illustrious Textiles." *ROM Magazine* (Fall 2013): 28–33.

Gardi, Bernhard, and Michelle Gilbert. "*Arkilla*, *Kaasa*, and *Nsaa*: The Many Influences of Wool Textiles from the Niger Bend in West Africa." *Textile Museum Journal* 48 (2021): 24–53.

Gilbert, Michelle. "Names, Cloth and Identity: A Case from West Africa." In *Media and Identity in Africa*, edited by Kimani Njogu and John Middleton, 226–44. Bloomington: Indiana University Press, 2009.

Guy, John. *Woven Cargoes: Indian Textiles in the East.* London: Thames and Hudson, 1998.

Helm, Elijah. "The Cultivation of Cotton in West Africa." *Journal of the Royal African Society* 2, no. 5 (October 1902): 1–10.

Kraamer, Malika. "Ghanaian Interweaving in the Nineteenth Century: A New Perspective on Ewe and Asante Textile History." *African Arts* 39, no 4 (Winter 2006): 36–53, 93–95.

Kweku Nimo, Ken. *Africa in Fashion: Luxury, Craft and Textile Heritage.* London: Laurence King, 2022.

Labelle, Marie-Louise. *Beads of Life: Eastern and Southern African Beadwork from Canadian Collections.* Gatineau, Quebec, and Ottawa: Canadian Museum of Civilization and University of Ottawa Press, 2005.

Lamunière, Michelle. *You Look Beautiful Like That: The Portrait Photographs of Seydou Keïta and Malick Sidibé.* Exh. cat. Cambridge, MA: Harvard University Art Museums, 2001.

Magnavita, Sonja. "The Oldest Textiles from Sub-Saharan West Africa: Woolen Facts from Kissi, Burkina Faso." *Journal of African Archaeology* 6, no. 2 (2008): 243–57.

McGregor, JoAnn, Heather Akou, and Nicola Stylianou. *Creating African Fashion Histories: Politics, Museums, and Sartorial Practices.* Bloomington: Indiana University Press, 2022.

Nettleton, Anitra. "Women, Bead*work* and Bodies: The Making and Marking of Migrant Liminality in South Africa, 1850–1950." In "The Making and Changing of Migrant Workers' Worlds (1800–2014)." Special issue, *African Studies* 73, no. 3 (December 2014): 341–64.

Phipps, Elena. *Looking at Textiles: A Guide to Technical Terms.* Los Angeles: J. Paul Getty Museum, 2012.

Ringuedé, Annie. "West African Indigo Textiles under Influences: The Fouta-Djallon Wrapper and the Mauritanian *Melhafa*." In *Crosscurrents: Land, Labor, and the Port; Textile Society of America 15th Biennial Symposium Proceedings*, 384–95. DigitalCommons@University of Nebraska Lincoln, 2016. https://digitalcommons.unl.edu/cgi/viewcontent.cgi?article=1996&context=tsaconf.

* Rovine, Victoria L. *African Fashion, Global Style: Histories, Innovations, and Ideas You Can Wear.* Bloomington: Indiana University Press, 2015. Quotation: p. 6.

Ryan, MacKenzie Moon. "The Global Reach of a Fashionable Commodity: A Manufacturing and Design History of *Kanga* Textiles." PhD diss., University of Florida, 2013.

Schulz, Vera-Simone. "Crossroads of Cloth: Textile Arts and Aesthetics in and beyond the Medieval Islamic World." *Perspective: Actualité en l'histoire de l'art* 1 (2016): 93–108.

Seiler-Baldinger, Annemarie. *Textiles: A Classification of Techniques.* Washington, DC: Smithsonian Institution Press, 1994.

Thomas, Wendy. "The Role of Woven and Embroidered Textiles of the BaKuba: Visual and Historical Dimensions." Master's thesis, York University, 1983.

Vansina, Jan. "Raffia Cloth in West Central Africa, 1500–1800." In *Textiles: Production, Trade and Demand*, edited by Maureen Fennell Mazzaoui, 263–81. Aldershot, UK: Ashgate, 1998.

Wharton, Conway T. *The Leopard Hunts Alone.* New York: Fleming H. Revell, 1927.

No. 1

* *Abdoulaye Konaté.* Milan: Primo Marella Gallery, 2022. "Absorbing" quotation: p. 34.

* Konaté, Abdoulaye. Interview by Elaine Sullivan. July 20, 2022. Epigraph quotation translated by Elaine Sullivan.

Konaté, Abdoulaye. Interview by Jenny Peruski. New York, January 17, 2024.

No. 2

Bloom, Jonathan M,. and Sheila S. Blair, eds. *The Grove Encyclopedia of Islamic Art and Architecture.* Oxford: Oxford University Press, 2009.

Dupuis-Yakouba, Auguste. *Industries et Principales Professions des Habitants de la région de Tombouctou.* Paris: Émile Larose, Libraire-Éditeur, 1921.

Gardi, Bernhard. *Le boubou – c'est chic: Les boubous du Mali et d'autres pays de l'Afrique de l'Ouest.* Exh. cat. 2nd ed. Museum der Kulturen Basel. Basel: Christoph Merian, 2002.

* Prussin, Labelle. *African Nomadic Architecture: Space, Place, and Gender.* Washington, DC: Smithsonian Institution Press and National Museum of African Art, 1995. Quotation: p. 85.

Prussin, Labelle. *Hatumere: Islamic Design in West Africa.* Berkeley: University of California Press, 1986.

Ross, Eric. *Sufi City: Urban Design and Archetypes in Touba.* Rochester: University of Rochester Press, 2006.

No. 3

Brett-Smith, Sarah C. *The Silence of the Women: Bamana Mud Cloths.* Milan: 5 Continents, 2014.

Imperato, Pascal James. *African Mud Cloth: The Bogolanfini Art Tradition of Gneli Traoré of Mali.* Exh. cat. Tenafly, NJ: African Art Museum of the SMA Fathers. New York: Kilima House Publishers, 2006.

Rovine, Victoria L. *Bogolan: Shaping Culture through Cloth in Contemporary Mali.* Washington, DC: Smithsonian Institution Press, 2001.

Nos. 4, 5

Bloom, Jonathan M., and Sheila S. Blair, eds. *The Grove Encyclopedia of Islamic Art and Architecture.* Oxford: Oxford University Press, 2009.

Boser-Sarivaxévanis, Renée. *Les tissus de l'Afrique Occidentale: Méthode de classification et catalogue raisonné des étoffes tissées de l'Afrique de l'Ouest établis à partir de données techniques et historiques.* Vol. 1, *Sénégal, Gambie, Mali, Haute-Volta, Niger, Guinée portugaise, Guinée, Sierra Leone, Libéria, Côte d'Ivoire, Ghana.* Basel: Pharos-Verlag Hansrudolf Schwabe, 1972.

Imperato, Pascal James. "Wool Blankets of the Peul of Mali." *African Arts* 6, no. 3 (Spring 1973): 40–47, 84.

Gardi, Bernhard, ed. *Woven Beauty: The Art of West African Textiles.* Exh. cat. Museum der Kulturen Basel. Basel: Christoph Merian, 2009.

Gardi, Bernhard, and Michelle Gilbert. "*Arkilla*, *Kaasa*, and *Nsaa*: The Many Influences of Wool Textiles from the Niger Bend in West Africa." *Textile Museum Journal* 48 (2021): 24–53.

No. 6

Bouttiaux, Anne-Marie, John Mack, Frieda Sorber, and Anne Van Cutsem-Vanderstraete. *African Costumes and Textiles: From the Berbers to the Zulus.* Milan: 5 Continents, 2008.

Bovin, Mette. "Nomadic Performance—Peculiar Culture? 'Exotic' Ethnic Performances of Wodaabe Nomads of Niger." In *Recasting Ritual: Performance, Media, Identity*, edited by Felicia Hughes-Freeland and Mary M. Crain, 93–112. London: Routledge, 1998.

* Bovin, Mette. *Nomads Who Cultivate Beauty: Wodaabe Dances and Visual Arts in Niger.* Uppsala: Nordiska Afrikainstitutet, 2001. Quotation: p. 16.

Bovin, Mette. "Stories in between Anthropology and Theatre." *Journal of Theatre Anthropology* 2 (2022): 236–45.

No. 7

Buggenhagen, Beth. "Are Births Just 'Women's Business'? Gift Exchange, Value, and Global Volatility in Muslim Senegal." *American Ethnologist* 38, no. 4 (2011): 714–32.

Clarke, Duncan, Vanessa Drake Moraga, and Sarah Fee. *African Textiles.* New York: Abbeville, 2022.

Pfeil, Gretchen Elisabeth. "*Sarax* and *Sutura*: Alms and the Value of Discretion in Dakar, Senegal." PhD diss., University of Chicago, 2020.

No. 8

Balfour-Paul, Jenny. *Indigo.* London: Archetype, 2006. Originally published in 1998 by British Museum Press.

Benjamin, Jody. "Historicizing Fashion in Western Africa: Global Linkages, Regional Markets, and Local Tastes, 1400–1850." In *Creating African Fashion Histories: Politics, Museums, and Sartorial Practices*, edited by JoAnn McGregor, Heather Akou, and Nicola Stylianou, 41–66. Bloomington: Indiana University Press, 2022.

Bolland, Rita. "Clothing from Burial Caves in Mali, 11th–18th Century." In *History, Design, and Craft in West African Strip-Woven Cloth*, 53–81. Washington, DC: National Museum of African Art, Smithsonian Institution, 1992.

Bolland, Rita. *Tellem Textiles: Archaeological Finds from Burial Caves in Mali's Bandiagara Cliff.* Translated by Patricia Wardle. Amsterdam: Tropenmuseum / Royal Tropical Institute, 1991.

Cardon, Dominique. *Natural Dyes: Sources, Tradition, Technology and Science.* London: Archetype, 2007.

Fenton, Rebecca. "Cloth as Conduit: Aesthetics, Dress, and Commerce in Mande Diasporas." PhD diss., Indiana University Bloomington, 2018.

Paoletti, Giulia, and Yaëlle Biro. "Photographic Portraiture in West Africa: Notes from 'In and Out of the Studio.'" *Metropolitan Museum Journal* 51 (2016): 182–99.

No. 9

Easmon, M. C. F. *Sierra Leone Country Cloths.* London: Waterlow and Sons, 1924.

Edwards, Joanna P. "The Sociological Significance and Uses of Mende Country Cloth." In *History, Design, and Craft in West African Strip-Woven Cloth*, 133–68. Washington, DC: National Museum of African Art, Smithsonian Institution, 1992.

Edwards, Joanna P. "Weaving Styles and Techniques of Mende Country Cloth: Its Sociological and Economic Significance." PhD diss., Indiana University Bloomington, 1986.

Helm, Elijah. "The Cultivation of Cotton in West Africa." *Journal of the Royal African Society* 2, no. 5 (October 1902): 1–10.

Kriger, Colleen E. "Mapping the History of Cotton Textile Production in Precolonial West Africa." *African Economic History* 33 (2005): 87–116.

Lamb, Venice, and Alastair Lamb. *Sierra Leone Weaving.* Hertingfordbury, UK: Roxford Books, 1984.

No. 10

Clarke, Duncan, Vanessa Drake Moraga, and Sarah Fee. *African Textiles.* New York: Abbeville, 2022.

Edwards, Joanna P. "The Sociological Significance and Uses of Mende Country Cloth." In *History, Design, and Craft in West African Strip-Woven Cloth*, 133–68. Washington, DC: National Museum of African Art, Smithsonian Institution, 1992.

Edwards, Joanna P. "Weaving Styles and Techniques of Mende Country Cloth: Its Sociological and Economic Significance." PhD diss., Indiana University Bloomington, 1986.

Gardi, Bernhard, and Michelle Gilbert. "*Arkilla*, *Kaasa*, and *Nsaa*: The Many Influences of Wool Textiles from the Niger Bend in West Africa." *Textile Museum Journal* 48 (2021): 24–53.

Lamb, Venice, and Alastair Lamb. *Sierra Leone Weaving.* Hertingfordbury, UK: Roxford Books, 1984.

No. 11

Ferrarini, Lorenzo. "The Shirts of the Donso Hunters: Materiality and Power between Concealment and Visual Display." *African Studies Review* 62, no. 1 (March 2019): 76–98.

McNaughton, Patrick. "The Shirts That Mande Hunters Wear." *African Arts* 15, no. 3 (May 1982): 54–58, 91.

Prussin, Labelle. *Hatumere: Islamic Design in West Africa.* Berkeley: University of California Press, 1986.

No. 12

Balfour-Paul, Jenny. *Indigo.* London: Archetype, 2006. Originally published in 1998 by British Museum Press.

Cardon, Dominique. *Natural Dyes: Sources, Tradition, Technology and Science.* Translated by Caroline Higgitt. London: Archetype, 2007.

Douny, Laurence. "From Pits to Pots: Indigo Dyeing Traditions of the Maranse of Burkina Faso." *Technology's Stories* 7, no. 2 (June 2019). https://www.technologystories.org/from-pits-to-pots.

Hill-Thomas, Genevieve. "Faso dan fani: Marka Textiles in Burkina Faso." PhD diss., Indiana University Bloomington, 2012.

Roy, Christopher. *Art of the Upper Volta Rivers.* Translated by Françoise Chaffin. Meudon, France: Alain et Françoise Chaffin, 1987.

No. 13

Adams, Monni, and T. Rose Holdcraft. "Dida Woven Raffia Cloth from Côte d'Ivoire." In "West African Textiles." Special issue, *African Arts* 25, no. 3 (July 1992): 42–51, 100–101.

Koblan Avoni, Axel. "L'expression du génie Dida: Le pagne de raphia." *Fraternité Matin*, October 20–21, 1990, 24–25.

No. 14

* Clarke, Duncan. "The Cloth from Bondoukou: Textiles of the Ghana/Côte d'Ivoire Border." *Hali: Carpet, Textile and Islamic Art* 157 (Autumn 2008): 98–104. Quotation: p. 100.

Clarke, Duncan, Vanessa Drake Moraga, and Sarah Fee. *African Textiles.* New York: Abbeville, 2022.

Ross, Doran H., ed. *Wrapped in Pride: Ghanaian Kente and African American Identity.* Exh. cat. Los Angeles: UCLA Fowler Museum of Cultural History, 1998.

No. 15

Clarke, Duncan. "The Cloth from Bondoukou: Textiles of the Ghana/Côte d'Ivoire Border." *Hali: Carpet, Textile and Islamic Art* 157 (Autumn 2008): 98–104.

Clarke, Duncan, Vanessa Drake Moraga, and Sarah Fee. *African Textiles.* New York: Abbeville, 2022.

Vogel, Susan. *Baule: African Art, Western Eyes.* Exh. cat. Washington, DC: National Museum of African Art, Smithsonian Institution. New Haven: Yale University Press, 1997.

Vogel, Susan. Email message to Jenny Peruski, April 3, 2024.

No. 16

* Busia, Abena P. A. "Maternal Legacies: A Weave of Stories." In *Wrapped in Pride: Ghanaian Kente and African American Identity*, edited by Doran H. Ross, 60–63. Exh. cat. Los Angeles: UCLA Fowler Museum of Cultural History, 1998. Quotation: p. 61.

Cole, Herbert, and Doran H. Ross. *The Arts of Ghana*. Exh. cat. Los Angeles: Museum of Cultural History, University of California, 1977.

Ross, Doran H., ed. *Wrapped in Pride: Ghanaian Kente and African American Identity*. Exh. cat. Los Angeles: UCLA Fowler Museum of Cultural History, 1998.

No. 17

Clarke, Duncan, Vanessa Drake Moraga, and Sarah Fee. *African Textiles*. New York: Abbeville, 2022.

Cole, Herbert, and Doran Ross. *The Arts of Ghana*. Exh. cat. Los Angeles: Museum of Cultural History, University of California, 1977.

Dennis, Ahiagble Bob. *The Pride of Ewe Kente*. Accra: Sub-Saharan Publishers, 2004.

Ross, Doran H., ed. *Wrapped in Pride: Ghanaian Kente and African American Identity*. Exh. cat. Los Angeles: UCLA Fowler Museum of Cultural History, 1998.

Nos. 18, 19

Douny, Laurence. "Silk-Embroidered Garments as Transformative Processes: Laying, Inscribing and Displaying Hausa Material Identities." In "Materializing Identities." Special issue, *Journal of Material Culture* 16, no. 4 (December 2011): 401–15.

Gardi, Bernhard. *Le boubou – c'est chic: Les boubous du Mali et d'autres pays de l'Afrique de l'Ouest*. Exh. cat. 2nd ed. Museum der Kulturen Basel. Basel: Christoph Merian, 2002.

Heathcote, David. "Hausa Embroidered Dress." *African Arts* 5, no. 2 (Winter 1972): 12–19, 82, 84.

Heathcote, David. "A Hausa Embroiderer of Katsina." *Nigerian Field* 37, no. 3 (1972): 123–31.

Heathcote, David. "Some Hausa Lizard Designs." *Embroidery* 23, no. 4 (1972): 114–16.

Heathcote, David. "A *shabka mai yanka* from Zaria." *Embroidery* 27, no. 2 (Summer 1976): 40–41.

Kriger, Colleen E. *Cloth in West African History*. Lanham, MD: AltaMira Press, 2006.

Olatunji Hussain, Busari (TJ). Conversation with Jenny Peruski. Lagos, Nigeria, October 31, 2024.

Perani, Judith. "The Cloth Connection: Patrons and Producers of Hausa and Nupe Prestige Strip-Weave." In *History, Design, and Craft in West African Strip-Woven Cloth*, 95–112. Washington, DC: National Museum of African Art, Smithsonian Institution, 1992.

Nos. 20-23

Abiodun, Rowland, Ulli Beier, and John Pemberton III. *Cloth Only Wears to Shreds: Yoruba Textiles and Photographs from the Beier Collection*. Exh. cat. Amherst, MA: Mead Art Museum, Amherst College, 2004.

Agogoro Eyo. Lagos: Eyo Festival / Lagos State Government, 2009.

Akinwumi, Tunde. "Woven Shawls of Obamadesara: An Account of the Development and Loss of a Weaving Artistry." In *Diversity of Creativity in Nigeria: A Critical Selection from the Proceedings of the 1st International Conference on the Diversity of Creativity in Nigeria*, edited by Bolaji Campbell, 153–65. Ile-Ife, Nigeria: Department of Fine Arts, Obafemi Awolowo University, 1993.

Clarke, Duncan. "Aso Oke: The Evolving Tradition of Hand-Woven Textile Design among the Yoruba of South-Western Nigeria." PhD diss., University of London, 1998.

Clarke, Duncan, Vanessa Drake Moraga, and Sarah Fee. *African Textiles*. New York: Abbeville, 2022.

Davies-Okundaye, Nike. Conversation with Jenny Peruski. Lagos, Nigeria, November 2, 2024.

Gardi, Bernhard. *Le boubou – c'est chic: Les boubous du Mali et d'autres pays de l'Afrique de l'Ouest*. Exh. cat. 2nd ed. Museum der Kulturen Basel. Basel: Christoph Merian, 2002.

Gillow, John. *African Textiles*. San Francisco: Chronicle Books, 2003.

* Perani, Judith, and Norma H. Wolff. *Cloth, Dress and Art Patronage in Africa*. Oxford: Berg, 1999. Quotation: p. 171.

* Poynor, Robin. "Traditional Textiles in Owo, Nigeria." *African Arts* 14, no. 1 (November 1980): 47–51, 88. Quotation: p. 47.

Quadri, Oluwasegun O., and Eseagwu Oyenike. "Cultural-Tourism Advocacy through Eyo (Adamu) Festival and Costume: An Artistic Exploration of Opambata and Its Linear Inflection." *International Journal of Innovative Research and Development* 2, no. 2 (February 2013): 735–50.

No. 24

Aronson, Lisa. "Akwete Weaving: A Study of Change in Response to the Palm Oil Trade in the Nineteenth Century." PhD diss., Indiana University Bloomington, 1982.

Aronson, Lisa. "Patronage and Akwete Weaving." *African Arts* 13, no. 3 (May 1980): 62–66, 91.

Nos. 25, 26

Adamu, Mahdi. "The Spread of the Hausa Culture in West Africa, 1700–1900." *Savanna: A Journal of the Environmental and Social Sciences* 5, no. 1 (June 1976): 3–13.

Akinwumi, Olayemi. "The Abakwariga and the Economic Transformation of the Jukun, Kingdom of Wukari, ca. 1650-1900." *Nordic Journal of African Studies* 7, no. 1 (1998): 93–102.

Geary, Christraud M. "Art and Political Process in the Kingdoms of Bali-Nyonga and Bamum (Cameroon Grassfields)." *Canadian Journal of African Studies / Revue canadienne des études africaines* 22, no. 1 (1988): 11–41.

Gebauer, Paul. "Art of Cameroon." *African Arts* 4, no. 2 (Winter 1971): 24–35, 80.

Harris, Moira Flanagan. "The Royal Cloth of Cameroon." PhD diss., University of Minnesota, 1985.

Joseph, Marietta B. "West African Indigo Cloth." *African Arts* 11, no. 2 (January 1978): 34–37, 95.

Lamb, Venice, and Alastair Lamb. *Au Cameroun: Weaving-tissage.* Hertingfordbury, UK: Roxford Books, 1981.

No. 27

A. D. F. T. "Bark-Cloth Making in Buganda." *Uganda Journal* 1, no. 1 (January 1934): 17–21.

Ehret, Christopher. *The Civilizations of Africa: A History to 1800.* Charlottesville: University of Virginia Press, 2002.

Oakland, Amy. "Zande Bark Cloth." In *Berg Encyclopedia of World Dress and Fashion*, vol. 1, *Africa*, edited by Joanne B. Eicher and Doran H. Ross. Oxford: Berg Publishers, 2010. http://dx.doi.org/10.2752/BEWDF/EDch1412.

Schildkrout, Enid. "The Spectacle of Africa through the Lens of Herbert Lang: Belgian Congo Photographs 1909–1915." In "Historical Photographs of Africa." Special issue, *African Arts* 24, no. 4 (October 1991): 70–85, 100.

Schildkrout, Enid, and Curtis A. Keim. *African Reflections: Art from Northeastern Zaire.* Exh. cat. New York: American Museum of National History. Seattle: University of Washington Press, 1990.

Nos. 28–33

Benedetto, Robert, ed. *Presbyterian Reformers in Central Africa: A Documentary Account of the American Presbyterian Congo Mission and the Human Rights Struggle in the Congo, 1890–1918.* Translated by Winifred K. Vass. Leiden: Brill, 1996.

Binkley, David A., and Patricia J. Darish. "'Enlightened but in Darkness': Interpretations of Kuba Art and Culture at the Turn of the Twentieth Century." In *The Scramble for Art in Central Africa*, edited by Enid Schildkrout and Curtis A. Keim, 37–62. Cambridge: Cambridge University Press, 1998.

Blier, Suzanne Preston. *The Royal Arts of Africa: The Majesty of Form.* New York: Harry N. Abrams, 1998.

Brincard, Marie-Thérèse, ed. *Kuba Textiles: Geometry in Form, Space, and Time.* Exh. cat. Purchase, NY: Neuberger Museum of Art, 2015.

Darish, Patricia J. "Dressing for the Next Life: Raffia Textile Production and Use among the Kuba of Zaire." In *Cloth and Human Experience*, edited by Annette B. Weiner and Jane Schneider, 117–40. Washington, DC: Smithsonian Institution Press, 1989.

Darish, Patricia J. "Dressing for Success: Ritual Occasion and Ceremonial Raffia Dress among the Kuba of South-Central Zaire." In *Art and Initiation in Zaire*, edited by Christopher D. Roy, 179–91. Vol. 3 of *Iowa Studies in African Art: The Stanley Conferences at the University of Iowa.* Iowa City: University of Iowa, 1990.

Ling Roth, Henry. *Studies in Primitive Looms.* 3rd ed. Halifax, UK: Bankfield Museum, 1950. First published 1916–18 in *Journal of the Royal Anthropological Institute of Great Britain and Ireland.*

Moraga, Vanessa Drake. *Weaving Abstraction: Kuba Textiles and the Woven Art of Central Africa.* Exh. cat. Washington, DC: The Textile Museum, 2011.

Picton, John, and John Mack. *African Textiles: Looms, Weaving and Design.* London: British Museum Publications, 1979.

Sieber, Roy. *African Textiles and Decorative Arts.* Exh. cat. New York: Museum of Modern Art, 1972.

Torday, E. *On the Trail of the Bushongo: An Account of a Remarkable and Hitherto Unknown African People, Their Origin, Art, High Social and Political Organization and Culture, Derived from the Author's Personal Experience amongst Them.* Philadelphia: J. B. Lippincott Company, 1925.

Torday, E., and T. A. Joyce. *Notes ethnographiques sur les peuples communément appelés Bakuba, ainsi que sur les peuplades apparentées. - Les Bushongo.* Series 4, vol. 2 of *Annales du Musée du Congo Belge.* Brussels: Le Ministère des Colonies, February 1911.

Vansina, Jan. *Being Colonized: The Kuba Experience in Rural Congo, 1880–1960.* Madison: University of Wisconsin Press, 2010.

Vansina, Jan. *The Children of Woot: A History of the Kuba Peoples.* Madison: University of Wisconsin Press, 1978.

Vansina, Jan. *Kingdoms of the Savanna.* Madison: University of Wisconsin Press, 1966.

No. 34

Abdel-Magid, Anwar. "History of the Nomadic Architecture of the Hadendowa in Northeast Sudan." In *The Archaeology of Mobility: Old World and New World Nomadism*, edited by Hans Barnard and Willeke Wendrich, 441–64. Los Angeles: Cotsen Institute of Archaeology Press, 2008.

Ausenda, Giorgio. "Leisurely Nomads: The Hadendowa (Beja) of the Gash Delta and Their Transition to Sedentary Village Life." PhD diss., Columbia University, 1987.

Barnard, Hans, and Kim Duistermaat, eds. *The History of the Peoples of the Eastern Desert.* Los Angeles: Cotsen Institute of Archaeology Press, 2012.

Fadlalla, Amal Hassan. *Embodying Honor: Fertility, Foreignness, and Regeneration in Eastern Sudan.* Madison: University of Wisconsin Press, 2007.

No. 35

Kramer, Robert. "Holy City on the Nile: Omdurman, 1885–1898." PhD diss., Northwestern University, 1991.

Nicoll, Fergus. "Interview with Imam Ahmad al-Mahdi, Grandson of the Mahdi." Making African Connections Digital Archive. Recorded March 14, 2020. https://makingafrican connections.org/s/archive/item/2111.

Nicoll, Fergus, and Osman Nusairi. "The Jibba: Clothing for Sufi and Soldier." Making African Connections Digital Archive. https://makingafricanconnections.org/s/archive/item/1999.

Nusairi, Osman. "The Role of Women in the Mahdist Period." Making African Connections Digital Archive. Recorded January 7, 2020. https://makingafricanconnections.org/s/archive/item/2030.

Searcy, Kim. *The Formation of the Sudanese Mahdist State: Ceremony and Symbols of Authority, 1882–1898*. Leiden: Brill, 2011.

Vogelsang-Eastwood, Gillian. "Embroidery from Sudan." In *Encyclopedia of Embroidery from the Arab World*, 294–312. London: Bloomsbury, 2016.

No. 36

* Adler, Tracy L., ed. *Elias Sime: Tightrope*. Exh. cat. Clinton, NY: Ruth and Elmer Wellin Museum of Art. New York: DelMonico Books, 2019. Quotation: p. 175.

Fenstermaker, Will. "'I Had to Fight to Show What I Could Do': How Elias Sime Emerged as One of Africa's Leading Contemporary Artists." *Artnet News*, March 24, 2020. https://news.artnet.com/art-world/elias-sime-interview-1807065.

Lorenz, Carol Ann. Review of *Elias Sime: Tightrope*, curated by Tracy L. Adler, Ruth and Elmer Wellin Museum of Art, Hamilton College, Clinton, NY. *African Arts* 53, no. 4 (2020): 86–89.

Sime, Elias. "Elias Sime." Interview by Zack Hatfield. *Artforum*, September 3, 2019. https://www.artforum.com/columns/elias-sime-on-living-and-working-with-technology-244449.

No. 37

Bjerk, Paul. *Building a Peaceful Nation: Julius Nyerere and the Establishment of Sovereignty in Tanzania, 1960–1964*. Rochester: University of Rochester Press, 2015.

Brennan, James R. "Blood Enemies: Exploitation and Urban Citizenship in the Nationalist Political Thought of Tanzania, 1958–75." *Journal of African History* 47, no. 3 (2006): 389–413.

Fair, Laura. "Dressing Up: Clothing, Class and Gender in Post-Abolition Zanzibar." *Journal of African History* 39, no. 1 (1998): 63–94.

Fair, Laura. "Remaking Fashion in the Paris of the Indian Ocean: Dress, Performance, and the Cultural Construction of a Cosmopolitan Zanzibari Identity." In *Fashioning Africa: Power and the Politics of Dress*, edited by Jean Allman, 13–30. Bloomington: Indiana University Press, 2004.

No. 38

* Andrianomearisoa, Joël. Interview by Alisa LaGamma. Antananarivo, Madagascar, May 3, 2023.

Andrianomearisoa, Joël. Interview by Jenny Peruski. New York, April 10, 2024.

Andrianomearisoa, Joël, and Alya Sebti. "Artist Talk with with Joël Andrianomearisoa and Curator Alya Sebti." Ifa Gallery Berlin, July 11, 2024. Video, 43 min., 13 sec. https://www.youtube.com/watch?v=uoTTfLB6Lvg.

"In the Studio with Joël Andrianomearisoa." Almine Rech, YouTube, posted February 9, 2024. 2 min., 34 sec. https://www.youtube.com/watch?v=6koyXyGF0EA.

Nos. 39, 40

Fee, Sarah. "Chasing Silk: A Search for Meaning and Memory in Madagascar's Illustrious Textiles." *ROM Magazine* (Fall 2013): 28–33.

Fee, Sarah. "Historic Handweaving in Highland Madagascar: New Insights from a Vernacular Text Attributed to a Royal Diviner-Healer, c. 1870." *Textile History* 43, no. 1 (2012): 61–82.

Fee, Sarah. "New Acquisition: Lamba Marevaka: Cloth of Dazzling Colour." *ROM Magazine* (Summer 2021): 12–13.

Fee, Sarah. "The Shape of Fashion: The Historic Silk Brocades (akotifahana) of Highland Madagascar." *African Arts* 46, no. 3 (Autumn 2013): 26–39.

Fee, Sarah, and Bako Rasoarifetra. "Recipes from the Past: Highland Textile Dyes in 19th Century Merina Sources, with a Translation of Passages from the 'Ombiasy's Manuscript.'" *Études océan Indien* 42–43 (2009): 1–25.

Green, Rebecca L. "Addressing and Redressing the Ancestors: Weaving, the Ancestors, and Reburials in Highland Madagascar." PhD diss., Indiana University Bloomington, 1996.

Kreamer, Christine Mullen, and Sarah Fee, eds. *Objects as Envoys: Cloth, Imagery, and Diplomacy in Madagascar*. Exh. cat. Washington, DC: National Museum of African Art, Smithsonian Institution. Seattle: University of Washington Press, 2002.

Kusimba, Chapurukha M., J. Claire Odland, and Bennet Bronson, eds. *Unwrapping the Textile Traditions of Madagascar*. Exh. cat. Los Angeles: Field Museum and UCLA Fowler Museum of Cultural History, 2004.

Peers, Simon. Email messages to Christine Giuntini, April–October 2024.

* Rakotoarimanana, Martin. Interview by Alisa LaGamma. May 5, 2023. Epigraph quotation translated by Jenny Peruski.

Reif, Rita. "On an Adventure of Exotic Colors and Age-Old Art." *New York Times*, September 16, 2001. https://www.nytimes.com/2001/09/16/arts/art-architecture-on-an-adventure-of-exotic-colors-and-age-old-art.html.

FURTHER READING

Aronson, Lisa. "Patronage and Akwete Weaving." *African Arts* 13, no. 3 (May 1980): 62–66, 91.

Barnard, Hans, and Kim Duistermaat, eds. *The History of the Peoples of the Eastern Desert.* Los Angeles: Cotsen Institute of Archaeology Press, 2012.

Benjamin, Jody. "Historicizing Fashion in Western Africa: Global Linkages, Regional Markets, and Local Tastes, 1400–1850." In *Creating African Fashion Histories: Politics, Museums, and Sartorial Practices*, edited by JoAnn McGregor, Heather Akou, and Nicola Stylianou, 41–66. Bloomington: Indiana University Press, 2022.

Brett-Smith, Sarah C. *The Silence of the Women: Bamana Mud Cloths.* Milan: 5 Continents, 2014.

Brincard, Marie-Thérèse, ed. *Kuba Textiles: Geometry in Form, Space, and Time.* Exh. cat. Purchase, NY: Neuberger Museum of Art, 2015.

Clarke, Duncan, Vanessa Drake Moraga, and Sarah Fee. *African Textiles.* New York: Abbeville, 2022.

Emery, Irene. *The Primary Structures of Fabrics: An Illustrated Classification.* New York: Watson-Guptill Publications/ Whitney Library of Design. Washington, DC: The Textile Museum, 1995.

Gardi, Bernhard. *Le boubou – c'est chic: Les boubous du Mali et d'autres pays de l'Afrique de l'Ouest.* Exh. cat. 2nd ed. Museum der Kulturen Basel. Basel: Christoph Merian, 2002.

Gardi, Bernhard, ed. *Woven Beauty: The Art of West African Textiles.* Exh. cat. Museum der Kulturen Basel. Basel: Christoph Merian, 2009.

Gardi, Bernhard, and Michelle Gilbert. "*Arkilla, Kaasa,* and *Nsaa*: The Many Influences of Wool Textiles from the Niger Bend in West Africa." *Textile Museum Journal* 48 (2021): 24–53.

Heathcote, David. "A Hausa Embroiderer of Katsina." *Nigerian Field* 37, no. 3 (1972): 123–31.

History, Design, and Craft in West African Strip-Woven Cloth. Washington, DC: National Museum of African Art, Smithsonian Institution, 1992.

Kraamer, Malika. "Ghanaian Interweaving in the Nineteenth Century: A New Perspective on Ewe and Asante Textile History." *African Arts* 39, no 4 (Winter 2006): 36–53, 93–95.

Kriger, Colleen E. *Cloth in West African History.* Lanham, MD: AltaMira Press, 2006.

Kusimba, Chapurukha M., J. Claire Odland, and Bennet Bronson, eds. *Unwrapping the Textile Traditions of Madagascar.* Exh. cat. Los Angeles: Field Museum and UCLA Fowler Museum of Cultural History, 2004.

LaGamma, Alisa, and Christine Giuntini. *The Essential Art of African Textiles: Design Without End.* Exh. cat. New York: The Metropolitan Museum of Art, 2008.

Machado, Pedro. "Cloths of a New Fashion: Indian Ocean Networks of Exchange and Cloth Zones of Contact in Africa and India in the Eighteenth and Nineteenth Centuries." In *How India Clothed the World: The World of South Asian Textiles, 1500–1800*, edited by Giorgio Riello and Tirthankar Roy, 53–84. Leiden: Brill, 2009.

Nwafor, Okechukwu. *Aso Ebi: Dress, Fashion, Visual Culture, and Urban Cosmopolitanism in West Africa.* Ann Arbor: University of Michigan Press, 2021.

Perani, Judith, and Norma H. Wolff. *Cloth, Dress and Art Patronage in Africa.* Oxford: Berg, 1999.

Prussin, Labelle. *Hatumere: Islamic Design in West Africa.* Berkeley: University of California Press, 1986.

Ross, Doran H., ed. *Wrapped in Pride: Ghanaian Kente and African American Identity.* Exh. cat. Los Angeles: UCLA Fowler Museum of Cultural History, 1998.

Rovine, Victoria L. *African Fashion, Global Style: Histories, Innovations, and Ideas You Can Wear.* Bloomington: Indiana University Press, 2015.

Schaedler, Karl-Ferdinand. *Weaving in Africa: South of the Sahara.* Munich: Panterra, 1987.

Schildkrout, Enid, and Curtis A. Keim. *African Reflections: Art from Northeastern Zaire.* Exh. cat. New York: American Museum of National History. Seattle: University of Washington Press, 1990.

Vansina, Jan. *The Children of Woot: A History of the Kuba Peoples.* Madison: University of Wisconsin Press, 1978.

Vogelsang-Eastwood, Gillian, and Willem Vogelsang. *Encyclopedia of Embroidery from Sub-Saharan Africa.* London: Bloomsbury Visual Arts, 2023.

GLOSSARY

appliqué A surface pattern created by adding shaped pieces of cloth to a support fabric.

continuous weft A weft that is incorporated into the structure of a cloth across the entirety of its warp.

cut-pile embroidery A Central African patterning technique whereby strands of raffia are embroidered into a plain-weave cloth following its over-one-under-one structure, cut with a knifepoint, and rubbed to form a raised surface known as pile.

discontinuous weft A weft that is incorporated into the structure of a cloth within a specific area rather than across the entirety of its warp.

embroidery A form of surface decoration using yarns or fibers that are usually passed from one face of a fabric to the other by means of a needle.

face The surface of a fabric; each fabric has two faces.

float structure A woven structure whereby the regular interlacing of warps and wefts can be varied by skipping one or more interlacing or by adding supplementary continuous or discontinuous warps and wefts to the foundation fabric.

gusset A shaped piece of fabric added to garments to relieve or reduce areas of stress during use.

heddle set On a loom, a set of tools (heddles) that holds a set of warps so they can be selected in unison during weaving. May also be referred to as a "shaft."

infinity knot An interlace motif in which curved lines form a shape with no beginning or end.

interlace motif A surface pattern in which curved lines appear to pass over and under each other.

loom A tool or apparatus that facilitates the weaving of two or more sets of yarns into cloth.

mercerized yarns Cotton yarns that have been treated with chemical solutions to alter the molecular structure of the fibers, making them stronger, smoother, shinier, and easier to dye.

mill-spun yarn Yarn produced in vast quantities by specialized machines in factories.

mordant A chemical additive that bonds dye to fabric.

needle lace A fabric created by knotting a free-end yarn with a needle to create openwork patterns on top of or between fabrics.

openwork Sections of a fabric with openings or voids. Or, the various, often unrelated, techniques by which these open areas are formed during or after the creation of a foundation cloth.

pattern stick A tool used during weaving to facilitate the lifting of selected warps to create sheds for inserting pattern wefts. May also be referred to as a "pick-up stick."

pick A complete or partial pass of a weft yarn across warp yarns. Or, the action of passing weft yarns across warp yarns.

plain weave A fabric with the warp and weft yarns woven in an over-one-under-one structure.

proper left/right The left or right of a work of art according to the object's own point of view.

resist A method of creating surface patterns whereby a material (e.g., wax or threads) is added to yarns or fabrics to temporarily block dyes or other substances from saturating the underlying sections.

satin A woven structure with long, tightly spaced, unaligned floats. Or, the cloth formed by this structure, which has one smooth and shiny face and one matte face.

selvage A self-finished fabric edge commonly found running parallel to the warp. A selvage is created when the weft turns back around the terminal warp(s) during weaving, thus preventing the cloth from unraveling.

sett The number of warps in a measured portion of a woven fabric. Used to describe the density of the warp.

shed A space between unwoven warp yarns temporarily created by a weaver to facilitate the passage of the weft.

supplementary warp Warp yarns that do not participate in a cloth's foundation structure but are added to the loom, held under tension, to produce patterns.

supplementary weft Weft yarns that do not participate in a cloth's foundation structure but are added during the weaving process to produce patterns. Supplementary wefts can be removed from a textile without affecting the integrity of the overall structure.

tapestry A woven structure wherein a design is created by means of differently colored or textured discontinuous weft yarns that usually cover the warp yarns completely. Or, the cloth formed by this structure.

warp A set of yarns secured onto a loom and held under tension during weaving.

warp-face fabric A woven textile with the warp yarns predominating, completely or almost completely covering the underlying wefts.

weft A single or set of free-end yarns that are interlaced with warp yarns to form a fabric.

weft-face fabric A woven textile with the weft yarns predominating, completely or almost completely covering the underlying warps.

yarn A continuous length of spun fibers or twisted filaments. May also be referred to as "thread."

INDEX

Page numbers in *italics* refer to illustrations.

Abakwariga artisans, 116, 117
Abron, Kulango, or Dyula
 artist: man's wrapper
 (no. 14), *2* (detail), 76–77,
 76–77 (details), *78–79*
Àdàmú Òrìṣà or Ẹyọ Plays, 99;
 performers, *99* (fig. 22)
Addis Ababa, Ethiopia, 155
Afro-Shirazi Party (ASP), 159
agbádá robes, 13, 90, 99;
 (no. 22), *104–5, 104–5*
 (details), *106–7*, 120
Ahejo, Amadou: *baban riga*
 (no. 18), 21, 90, *90–91*, 92,
 92–93 (details), 120
ahwepan design, 83
Akan people, 45, 65, 82, 83,
 85, 86
Akinsuroju, Martin Olowu, His
 Royal Majesty Ọba, 104
"akoty" silk yarns, 163
Akwete, Nigeria, 111, 113
àlàárì silk, 98, 102. See also *ẹtù*
 dámọ̀ àlàárì dàńdógó
al-Bakri, 15
Amazigh designs, 57
aMbul aNgoong, Shyaam, 133
Ammere Oyokoman pattern, 83,
 85 (fig. 20)
Ananse, 87
Andrianomearisoa, Joël, 26;
 Les herbes folles du vieux
 logis (no. 38), 160, *161*, 162,
 162 (detail)
ansar al-mahdi (followers of the
 Mahdi), 153
Antananarivo, Madagascar,
 162, 166
architectural spaces defined by
 textiles, 7, 14, 26, 30, 45,
 64, *64* (fig. 17), 65, 83, 119,
 119 (fig. 25)
arkilla kunta (wedding hanging)
 (no. 4), 18, *42–43, 42–43*,
 44 (detail), 45, 64

Asante weavers, 21, *21* (fig. 6),
 76, 86, 87
Asante-Akan artist: royal man's
 kente (no. 16), 82, 83, *83*
 (detail), *84–85*, 85
asantehene (premier monarch),
 83, 85; Prempeh II, 83, 85
 (fig. 20)
asasia structure, 83
aṣọ òkè, 15, 96; head coverings,
 99, *99* (fig. 22); *ìró*
 (woman's wrapper), 98,
 98 (fig. 21); (no. 20), 96,
 96–97, 98–99;

baban riga (man's ceremonial
 robe) (no. 18), 21,
 90, *90–91*, 92, *92–93*
 (details), 120
Bali, *fon* of, 119, *119* (fig. 25)
Bamana artist: *bògòlanfini*, 39,
 40 (figs. 13, 14 [detail])
bama pattern, 41
Bandiagara, Mali, 18, 95
bark cloth, 16, 17, 124, 126, 133
Baule artist: heddle pulley, 22,
 23 (fig. 7)
Baule or Dyula artist: man's
 prestige wrapper (no. 15),
 22, 77, 80, *80–81*, 82,
 82 (detail)
Baule or Guro artist: heddle
 pulley, 22, *23* (fig. 8)
bazin cloth, 21, 31, *31* (fig. 12), 37
beaters, 19, *20* (figs. 4, 5), 21, 126
Beja artists: *badaigaw*, 149, *149*
 (fig. 31); *te saqwit* (no. 34),
 18, *148* (detail), 149–51,
 150–51
bògòlanfini (mud-dyed cloth),
 39, *40* (figs. 13, 14 [detail]);
 (no. 3), *28–29* (detail),
 38–39, 39, 41, *41* (detail)
Bondoukou region, Côte
 D'Ivoire, 76, 77, 85
Bonwire, Ghana, 76, 85
boubou garment, 21, 34, 37, 92,
 122; *kasaba* (no. 2), 21, 34,

34–35, 36 (detail), 37, 92;
 tilbi, 34, 92
British: authorities, 110, 152;
 manufacturers, 13, 16;
 military invasion, 153
British-Egyptian forces, 152, 153
Bushong-Kuba artists: woman's
 overskirt (no. 32), 21,
 142–43, *142–43*

Carstensen, Edward, 86
Chamba bowmen, 120
climate, 56; change, 46
colonialism: era of, 18, 52, 56,
 158; resistance to, 41, 110,
 135, 152, *See also* French
 colonial government;
 Portuguese. *See also under*
 British: authorities
cotton, 15, 21, 26, 31, 34, 39, 45,
 50, 52, 56, 64, 65, 68, 71, 75,
 76, 83, 86, 95, 96, 98, 102,
 104, 110, 112, 120, 122, 150,
 152; cultivation of, 13, 18,
 63, 116, 117, 163; imported,
 16, 37, 92, 116, 158
currency, textiles as, 64, 128,
 133, 144

daliluw (useful bits of
 knowledge), 68
damask, 31, 37, 92, 95
dan Fodio, Usman. *See* ibn Fudi,
 ʿUthman
dance: festivals, 99; garments,
 49, *49* (fig. 15), *126* (fig. 26)
dàńdógó robes, 13, *14* (fig. 1),
 104. See also *ẹtù dámọ̀*
 àlàárì dàńdógó
deceased: enemy soldiers, 152;
 land of the dead, 133;
 shrouded, 13, 17, 52, 133,
 145, 164; venerated, 99,
 142, 145, 164. *See also*
 funerals
Dengese artist(s): prestige panel
 (no. 28), 127–28, *127, 128*
 (detail), 129

dhu al-faqar (double-pronged
 sword), 105
Dida artist: man's wrapper
 (no. 13), 19, 72, *72–73*, 75;
 women's garment, 72, *74*
 (fig. 18)
Diossé, Koumi, 41
donso duloki (hunter's shirt)
 (no. 11), 30, *68–69*, 69
double prestige panel (no. 29),
 130, *130–31*, 132 (detail), 133
dudu (black or cold colors),
 104, 110
Dupuis-Yakouba, Auguste, 34
dyes: fold-and-dye, 80; indigo,
 22, 34, 50, 56, 65, 71, 82,
 101, 110, 117, 122, 158, 163;
 mud, 39, 41; resist, 57,
 71, 116, 122; synthetic,
 22, 31, 71; tie-and-dye, 71,
 75, 82
Dyula people, 22, 76, 82

egúngún performances, 96
Egypt, 18, 48, 149, 152
elégẹ̀gẹ̀ pupa (woman's
 prestige wrapper with
 red band) (no. 23),
 8 (detail), 108–10, *108–9*,
 110 (detail)
elephant symbolism, 86
ẹlẹya (openwork), 96, 98
Essouk-Tadmekka, Mali, 19
ẹtù dámọ̀ àlàárì dàńdógó (man's
 ceremonial robe) (no. 21),
 100, 101–2, *101* (detail),
 102–3, 120
European imports, 19, 65, 85,
 92, 112, 135, 163
Ewe artist: man's kente (no. 17),
 60–61 (detail), 86–87, *87*
 (detail), *88–89*

fast fashion, 22
female specialists: in beadwork,
 15, 16, *16* (fig. 2), 150; in
 preparing indigo dyes, 22,
 56, 71; in preparing mud

dyes, 39, 41; in raffia plaiting, 72; in weaving burial shrouds, 18; tent "engineers," 149, 150
Fofana, Aboubakar, 22
folklore and folktales, 41, 87
fons (kings), 116, 119, 120, 122; of Bali, 119, *119* (fig. 25)
Foumban, Cameroon, 117
French colonial government, 41, 56, 164
Fulani *maabo* (pastoralist weaver): *arkilla kunta* (no. 4), 18, 42–43, *42–43*, *44* (detail), 45, 64; *khasa* or *kaasa* (no. 5), 18, 46, *46–47*, 48, *48* (detail)
funerals, 72, 99, 110, 119, 135, 142
funfun (white or light colors), 104, 110

Galega II, *fon* of Bali, *119* (fig. 25)
Garoua, Cameroon, 117
gereewol celebrations, 49, *49* (fig. 15)
Ghana Empire, 15, 19, 22
Gold Coast (present-day Ghana), 65, 76, 86
Grassfields artists: *ndop* (no. 25), 116–17, *116–17*, *118* (detail), 119; prestige gown (no. 26), 120, *120–21*, 122, *122–23* (details)

Hadendowa-Beja fighters, 153
haingo (decorative embellishments), 164
Harinjaka, Hortense Cecilia, 166, *168* (fig. 33)
Hausa Kingdoms, 90
Hausa, Nupe, and/or Yoruba artist(s): *agbádá* (no. 22), 104–5, *104–5* (details), *106–7*, 120; *wando* (no. 19), *12* (detail), 94–95, *94*, *95*
heirlooms, 22, 52, 63, 71, 72, 75, 83, 104, 110, 122
henaare (man's festival tunic), 49, *49* (fig. 15); (no. 6), *6* (detail), 49–50, *50* (detail), *51*

ibhayi fabric, 16
ibn 'Abd Allah, Muhammad Ahmad, 152, 153
Ibn Battuta, 95
ibn Fudi, 'Uthman (Usman dan Fodio), 90
ibn Muhammad, 'Abd Allah, 153

ihsan (excellence), 152
Ijebu-Yoruba artist: *ẹtù dámò àlàárì dàńdógó* (no. 21), *100*, 101–2, *101* (detail), *102–3*, 120
Ijo people, 22, 111, 112, 113
ikula "peace" knife, 24
Ila-Ọrangun, Nigeria, 13, *14* (fig. 1)
Ilorin, Nigeria, 104
Indian imports, 16, 19, 112, 158, 163
indigo. *See under* dyes
initiation: ceremonies, 71; textiles marking, 64, *64* (fig. 17)
insika wall screens, 26
interior hanging (no. 10), 65–67, 65 (detail), *66–67*
investitures, 83, 119, 135
Isa, Alhaji, 92
Islam, 34, 90, 92, 105
ivory trade, 135
Iwelen, Niger, 18, 48

jewelry, 24, 49
jibba (tunic) (no. 35), 152–53, *152* (detail), *153*

kanga (commemorative wrapper) (no. 37), 157–59, *157*; fabric, 15, *16* (fig. 2), 158, *158–59* (fig. 32)
Kano, Nigeria, 56, 92, 94
Karibu Textile Mills, Dar es Salaam, Tanzania, 159
Keïta, Seydou: three young women, 24, *25* (fig. 10)
kente cloth, *21* (fig. 6), 76, 82, 83, *85* (fig. 20); man's kente (no. 17), *60–61* (detail), 86–87, *87* (detail), *88–89*; royal man's kente (no. 16), 82, 83, *83* (detail), *84–85*, *85*
khasa, or *kaasa* (personal covering) (no. 5), 18, 46, *46–47*, 48, *48* (detail)
ki gbembele (checkerboard) pattern, 64
Konaté, Abdoulaye, 9, 26, *31* (fig. 12); *Bleu no. 1* (no. 1), 30–31, *32–33*
kɔndi-gulɛi ("country cloth"), 63, 64
Kongo artist(s): luxury cloth, *129* (fig. 27)
Kot a-Mbweeky III, wife of, *143* (fig. 30)

kpɔikpɔi cloths, 64, *64* (fig. 17); (prestige hanging) (no. 9), 62–64, *62–63*, 65
Kraban, Ota, 76, 83
Kuba artist: double prestige panel (no. 29), 130, *130–31*, *132* (detail), 133; *mapel* (no. 30), 24, 134–35, *134–35*, *136* (detail), 137; *ncák* (figs. 28, 29 [detail]), 138, *140–41*, 141; *ncák* (no. 31), *114–15* (detail), 138–39, *138–39*, 141. *See also* Bushong-Kuba artists
kujitegemea (self-reliance), 159
kyekye fabrics, 76

labor: exploitation of, 13; forced, 152; gendered division of, 26, 39–41, 56, 63, 117, 128, 137, 138, 142
lace, 37, 92
lamba akotifahana (mantle with supplementary-weft designs) (no. 39), 19, 22, *146–47* (detail), 160, 163–64, *163* (detail), *164–65*, 166
Lamba Mpanjaka Marevaka (King's Bright Mantle) (no. 40), 166, *167*, 168, *169* (detail)
Lamba SARL workshop, Antananarivo, Madagascar, 166, 168
lapoki (king), 104
Legah, Rebecca, *75* (fig. 19)
lela public performances, 119
looms, 19, 22, 45, 87; double-heddle, 19, *20* (fig. 5), 21, *21* (fig. 6), 52, 76, 83, 117; fixed-heddle, 164; hand, 19, *21* (fig. 6); shaft, 166, 168; single-heddle, 19, *20* (fig. 4), 112, 128; treadle, 19, 76, 109, *168* (fig. 33); tripod, *20* (fig. 5), 64, 66; upright-frame, 112; vertical, 109, 110
Lurex, 104, 113
luxury cloth, *129* (fig. 27)

maabube (Fulani weavers), 18, 43, 45, 46, 64, 65
Mahdi, Muhammad Ahmad al-. *See* ibn 'Abd Allah, Muhammad Ahmad
Mahdist artist(s): *jibba* (no. 35), 152–53, *152* (detail), *153*

Malian artist: boubou *kasaba* (no. 2), 21, 34, *34–35*, *36* (detail), 37, 92
Mali Empire, 15, 22
Mande *donso*: *donso duloki* (no. 11), 30, 68–69, *69*
Mangbetu artist: chief's *nogi* (no. 27), 17, 19, 124, *124* (detail), *125*, 126
Manjak artist: *sër-u-rabbal*, or *sër-u-njaago* (no. 7), 52, *52–53*, 54–55, *54* (detail), 55 (fig. 16)
mapel (man's ceremonial skirt) (no. 30), 24, 134–35, *134–35*, *136* (detail), 137
mapinduzi (Zanzibar Revolution), 159
markets, 16, 18, 19, 151, 158, 160; Kejetia, 22, *24* (fig. 9)
marriage contract, symbol of, 43
masquerades, 96, 99
mbala (plain-weave raffia cloths), 133, 138, 139
Mbop aMabiinc maKyeen, wife of (fig. 30), *143*
Mbun artist(s): woman's ceremonial skirt (no. 33), 137, 144–45, *145*
Mende or Vai artist: *kpɔikpɔi* (no. 9), 62–64, *62–63*, 65
Mende, Vai, or Temne artist: interior hanging (no. 10), 65–67, 65 (detail), *66–67*
merchants, 16, 65, 82, 92, 158
merikani (cloth imported from New England), 16
Merina artist, 19, 166, 168, *168* (fig. 33); *lamba akotifahana* (no. 39), 19, 22, *146–47* (detail), 160, 163–64, *163* (detail), *164–65*, 166
migrations, 15, 22, 45, 49, 52, 55, 116, 144, 149
Mossi, Maranse, or Marka artist(s): wrapper (no. 12), 70–71, *70*
motifs: *akotifahana*, 163, 164, 166, 168; *aska biyu*, 105; bird, *54*, 86, 166; *bògòlan*, 41, 68; crocodile, 41, 119, 122; cross, 122; eye, 45, 153; fertility, 46, 151; fish, 54, 86; *hatumere* (also *khatim*, *xaatim*), 37, 68; paisley (*boteh*), 158; spiral, 37, 104
Muhammad, Prophet, 37, 105
Muslim, 34, 37, 92, 105. *See also* Islam

INDEX 179

narratives, 46, 86, 133, 144

ncák (ceremonial skirt), 138, *140–41* (figs. 28, 29 [detail]), 141, *143* (fig. 30); (no. 31), *114–15* (detail), 138–39, *138–39*, 141

Ndoki-Igbo artist: wrapper (fig. 24), 113, *113*; wrapper (no. 24), 19, 111–13, *111*, *112* (details)

ndop (royal display cloth), 119, *119* (fig. 25); (no. 25), 116–17, *116–17*, *118* (detail), 119

New England imports, 16

Njoya, Ibrahim, king of Bamum, 117

nogi, chief's (breechcloth) (no. 27), 17, 19, 124, *124* (detail), *125*, 126; multipaneled (fig. 26), 124, *126*

nsaa textiles, 45

number five, significance of, 37

Nyerere, Julius, 158–59

nyim (king), 133, 137, 143; royal enclosure of, 26, *27* (fig. 11); wives of, *143* (fig. 30)

Ọba (king), 13, *14* (fig. 1), 99, 101, 104

Obamadesara: *elégẹ̀gẹ̀ pupa* (no. 23), *8* (detail), 108–10, *108–9*, *110* (detail)

Ọbasolo, chief, *14* (fig. 1)

Ọdún Ọba rite, 13

Olowu, Duro, 104

Omdurman: Battle of, 153; market, 151

òpámbàtà staffs, *99* (fig. 22)

Ottoman-Egyptian forces, 152

overskirt, woman's (no. 32), 21, 142–43, *142–43*

Owo, Nigeria, 109, 110

panos d'obra cloth, 55, 57

Peers, Simon, 166

Portuguese, 18, 52, 55

Prempeh II, *asantehene*, 83, *85* (fig. 20)

prestige gown (no. 26), 120, *120–21*, 122, *122–23* (details)

prestige panel (no. 28), 127–29, *127*, *128* (detail)

profitability; profitable, 15, 22, 56

propaganda, 158, 159

protective associations of textiles, 14, 17, 30, 46, 52, 55, 64, 68, 153

protective symbols, 37, 122, 151

pulleys, heddle: with elephant, 22, *23* (fig. 8); with opposing faces, 22, *23* (fig. 7)

pupa (red or warm tones), 104, 110

raffia, 17, 18, 19, 72, 75, 117, 126, 128, 129, 133, 135, 137, 138, 142, 143, 144; palms, 17–18, 128, 133, 138; plaiting, 24, 26, 72, *75* (fig. 19), 128

Rakotoarimanana, Martin: *Lamba Mpanjaka Marevaka* (no. 40), 166, *167*, 168, *169* (detail)

Ramarozaka, Maurice, 160

rayon, 83, 104

riga garment, 18, 21, 90, 95, 122. See also *baban riga*

Roberts & Mansfield trading firm, 65

robes, 120: *agbádá* (no. 22), 104–5, *104–5* (details), *106–7*, 120; *dàǹdógó*, 13, 14 (fig. 1); man's ceremonial robe (no. 18), 21, 90, *90–91*, 92, *92–93* (details), 120; man's ceremonial robe (no. 21), *100*, 101–2, *101* (detail), *102–3*, 120; "robes of honor," 90

Sa'di dynasty, 34

Saint-Louis, Senegal, 56

Sammaniyya Sufi order, 152

sányán silk yarns, 18, 98

saris, 158

satin, 37, 95, 122

sër-u-rabbal, or *sër-u-njaago* (woven wrapper), 55, *55* (fig. 16); (no. 7), 52, *52–53*, 54–55, *54* (detail)

sett, warp, 55, 110

shabka mai yanka technique, 92

sheds, 19, *20* (fig. 4), 21, 128

sheep, Macina, 18, 65

shekla seri (Ethiopian potters), 155

shyaam (raffia palm), 133

signares (elite women), 24, 56

silk, 16, 18–19, 83, 86, 96, 166; embroidery, 18, 21, 37, 92, 104, 105; imported, 16, 19, 37, 83, 92, 102, 104, 110, 163, 164; wild, 16, 18, 21, 92, 98, 163, 164

Sime, Elias, 26: *Ants & Ceramicists 4* (no. 36), *154*, 155–56, *156* (detail)

skirts: *mapel* (no. 30), 24, 134–35, *134–35*, *136* (detail), 137; *ncák*, 138, *140–41* (figs. 28, 29 [detail]); *ncák* (no. 31), *114–15* (detail), 138–39, *138–39*, 141; *umbhaco* wrap skirt, 16, *17* (fig. 3); woman's ceremonial skirt (no. 33), 137, 144–45, *145*; woman's overskirt (no. 32), 21, 142–43, *142–43*

slavery: abolition of, 15; enslaved individuals, 15, 16, 45, 55, 133, 158; trade, 135

slippers, 24, 95; ceremonial, 104, 105, *105* (fig. 23)

Sokoto Caliphate, 90

Songhai Empire, 34

Soninke people, 22, 56

Soucko, Djitio, 41

South Asian designs, 112, 158

spider, significance of, 87

state support for handcrafted fabrics, 22

stitch-resist indigo shawl or wrapper (no. 8), 24, 56–57, *56–57* (details), 58–59

storytelling, 46, 155

Sufi, 152

sumptuary laws, 15

Takedda, sultan of, 95

Tanzanian (?) artist: *kanga* (no. 37), 157–59, *157*

tattoos, 49, 50

Teingu, chief, *126* (fig. 26)

Tellem Cave Q, Mali, 95

tents, 149, 151; *badaigaw* (also *bait al-burush*), 149, *149* (fig. 31), 150

te saqwit (tent divider) (no. 34), 18, *148* (detail), 149–51, *150–51*

textile stories, 15; See also narratives; storytelling

tichbok (knotted silk needle lace), 37

tilbi garment, 34, 92

Timbuktu, Mali, 37, 92, 95

Traoré, Gneli: *bògòlanfini* (no. 3), *28–29* (detail), *38–39*, 39, 41, *41* (detail)

tsamiya (wild-silk yarns), 18, 92

ujamaa (socialism), 159

umbhaco wrap skirt, 16, *17* (fig. 3)

Upton, Joseph, 65

Urafiki Textile Company, Dar es Salaam, Tanzania, 159

wando (trousers) (no. 19), *12* (detail), 94–95, *94*, *95*

wedding hangings, 18, 43. See also *arkilla kunta*

weddings, 13, 43, 52, 64, 71, 72

Western-style dress, 163

wisdom, 41, 87, 133

Wodaabe-Fulani artist: *henaare* (no. 6), *6* (detail), 49–50, *50* (detail), *51*

Wolof artist: stitch-resist indigo shawl or wrapper (no. 8), 24, 56–57, *56–57* (details), 58–59

wool, 16, 18, 43, 45, 46, 48, 64, 95, 152; imported, 65, 119

worso festival, 49

wrappers: commemorative wrapper (no. 37), 157–59, *157*; man's prestige wrapper (no. 15), 22, 77, 80, *80–81*, 82, *82* (detail); man's wrapper (no. 13), 19, 72, *72–73*, 75; man's wrapper (no. 14), *2* (detail), 76–77, *76–77* (details), *78–79*; stitch-resist indigo shawl or wrapper (no. 8), 24, 56–57, *56–57* (details), 58–59; woman's prestige wrapper (no. 23), *8* (detail), 108–10, *108–9*, *110* (detail); woman's wrapper, 98, *98* (fig. 21); woven wrapper, 55, *55* (fig. 16); woven wrapper (no. 7), 52, *52–53*, 54–55, *54* (detail); wrapper, 113, *113* (fig. 24); wrapper (no. 12), 70–71, *70*; wrapper (no. 24), 19, 111–13, *111*, *112* (details)

Xhosa or Mfengu artist: *umbhaco* wrap skirt, 16, *17* (fig. 3)

yaake dances, 49

Yavarhoussen, Hasnaine, 162

Yoruba artist: *aṣọ òkè ìró*, 98, *98* (fig. 21); ceremonial slippers, 104, 105, *105* (fig. 23)

Yoruba artist(?): *aṣọ òkè* (no. 20), 96, *96–97*, 98–99, *99* (detail)

Zulu bead worker, 15, *16* (fig. 2)